The Art Institute of Chicago: The Essential Guide

The Art Institute of Chicago

THE ESSENTIAL GUIDE

(REVISED EDITION)

Selected by James N. Wood

The Art Institute of Chicago

The Art Institute of Chicago gratefully acknowledges the Elizabeth F. Cheney Foundation for its early support of this publication.

Revised edition
Second Printing, 2004

Susan F. Rossen, Executive Director of Publications
Elizabeth Stepina, Editor
Amanda Freymann, Associate Director of Publications-Production
Annie Feldmeier, Photo Editor
First edition compiled and written by Sally Ruth May. Revised entries by Bruce Boucher, Stephanie D'Alessandro, Larry Feinberg, Karen Manchester, Elinor Pearlstein, James Rondeau, Betty Seid, David Travis, Martha Wolff, and Ghenete Zelleke.

Photography by the Department of Imaging, Alan B. Newman, Executive Director

Designed by Ed Marquand, assisted by Tomarra LeRoy, Marquand Books, Inc., Seattle, Wash.
Revised cover design by Jeffrey D. Wonderland, The Art Institute of Chicago
Type composition by Paul Baker Typography, Inc., Chicago, Ill.
Color separations and revised type composition by Professional Graphics, Rockford, Ill.
Printed by CS Graphics, Singapore
Cover: Claude Monet, *Water Lilies* (detail), 1906 (p. 246).

Library of Congress Cataloguing-in-Publication Data

Art Institute of Chicago.
The Art Institute of Chicago : the essential guide / selected by James
 N. Wood—Rev. ed.
 p. cm.
 Includes index.
 ISBN 0-86559-206-3 (alk. paper) : $19.95
 1. Art Institute of Chicago—Catalogs. 2. Art—Illinois—Chicago—
Catalogs. I. Wood, James N. II. Title.
N530.A52 2003
338.1'973—dc21 2003048018
 CIP

Contents

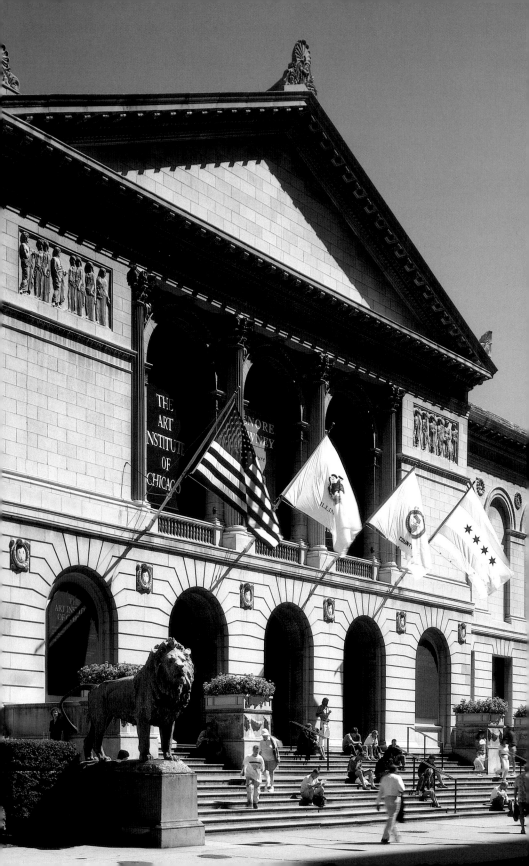

Foreword

"To the East were the moving waters as far as eye could follow. To the West a sea of grass as far as wind might reach." The Chicago writer Nelson Algren began his portrait of the city with these words, locating it in the heart of the continent, bordered by the Great Lakes and the Great Plains.

In 1893, the Art Institute's original Michigan Avenue building opened with the claim that Chicago and its citizens deserved a museum equal to their ambition to build one of the world's leading cities. Civic leaders and museum patrons alike saw the arts as an essential aspect of a metropolis that would be not only a manufacturing center and transportation hub, a city of livestock and grain, but a center of culture and learning. As the very form of the modern city was reinvented across Michigan Avenue in the skyscrapers of the Chicago School, the Art Institute, named to express its combined commitment — to collect the art of the past and present and to train and inspire the artists of the future — set out to build the collections we invite you to enjoy today. In the one hundred years that followed, works of art of every kind, place, time, and style have taken their place in our galleries. This process was by gift more often than by purchase, and, while its spirit from the outset was democratic and its purpose educational, its result is also a monument to the generosity and civic commitment of private individuals.

At the Art Institute, sheer size and grandeur have been viewed skeptically, and the galleries, since the design for the original building in 1893, have been human in scale and intended to welcome rather than awe the visitor. In fact, the most monumental feature of the original plan, a soaring dome designed to rise above the grand staircase in a plan reminiscent of many of the great palace museums of Europe, was never built, as the result of a pragmatic decision to make exhibition, and not ceremonial, space the priority.

One of the many pleasures of visiting the Art Institute is that what one finds is often unexpected: archaic Chinese jades and Japanese prints; choice Peruvian ceramics; virtually a complete history of photography; and a collection of European and American painting, sculpture, and works on paper that is among the finest of its kind. Visitors are often surprised by Chicago's cultural wealth and architectural impact; for its citizens, the Art Institute is both the familiar local museum and, thanks to its size and the diversity of its holdings, a constant source of discovery. Its strengths are such that a definite and unforgettable personality emerges. Over time, as the buildings have grown, installations of our permanent collection have been designed to maximize those strengths. A range of distinct experiences, rather than a uniform architectural environment, has been our goal. Installed in

daylit, classically proportioned galleries, painting is at the center of the Art Institute's identity, while African, American, Asian, and Pre-Columbian art and European decorative arts are presented in a variety of settings intended to provide a conducive context for the viewer to establish a direct and sympathetic relationship with the art. Distinguished collections of textiles, photography, prints and drawings, and architectural drawings — materials sensitive to light and atmosphere — have their own galleries and study facilities where changing selections of their holdings can be enjoyed.

Discovery, no matter how adventuresome and confident the explorer, can be aided by a knowledgeable and sympathetic guide. It is our hope that *The Art Institute of Chicago: The Essential Guide (Revised edition)* will be just such a companion, providing introductions to many of the museum's most celebrated inhabitants and encouraging you to strike out on your own to explore secondary trails that stimulate your imagination. It is both a survey of the collections and a record of more than one hundred years of collecting. True masterpieces are rare in any museum, but we are fortunate to have examples spanning much of the history of art that would clearly satisfy Sir Kenneth Clark's definition: "The work of artists of genius who have been absorbed by the spirit of the time in a way that has made their individual experiences universal."

An endeavor such as this book is realized only with the participation of more people than can be named here — with the efforts, direct or indirect, of the entire museum staff. In particular, we have relied upon the extensive documentation and writings of many members of the curatorial departments, present and former, whose efforts at

understanding and maintaining every aspect of our collections are the cornerstone of this institution.

We hope that this guide to the collections will help you to make this museum your own and to recall favorite works once you have departed. But, more importantly, we hope that the information it contains and the experience of original works of art inside the Art Institute will stimulate you to return repeatedly.

James N. Wood
President and Director
The Art Institute of Chicago

African and
Amerindian Art

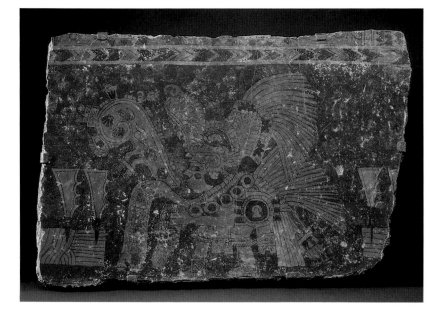

MURAL FRAGMENT DEPICTING A PRIEST

Mexican, Teotihuacán culture, 600/750
Lime plaster with mineral pigment;
24⅜ × 37⅜ × 2⅜ in. (62 × 95 × 6 cm)
African and Amerindian Art Purchase Fund, 1962.702

This richly symbolic fragment from a wall fresco depicts a ceremony that probably took place once every fifty-two years, a "century" of the ancient Mexican calendar. Casting flowers and praying for water, a priest stands before a tied bundle of reeds impaled by the spiny points of maguey cactus leaves. The scene represents both the completion of a cycle of time and a new beginning. Water symbols in the form of shells and flowers are depicted within the scroll curling from the priest's mouth, which represents a speech. Additional flowers and water are sprinkled from one hand, while the other holds an incense bag. The artist was highly concerned with the accurate depiction of ceremonial costume — the plumed headdress, necklace, and other items of attire. The color red was traditionally associated with the forces of life. Like the chants of a religious litany, this complex image was repeated with others around the walls of a chamber in prayers for agricultural fertility, thus combining, in a sense, the functions of writing and visual imagery. Meaning "place of the gods," Teotihuacán was the largest religious, military, and trading city in the Americas between 100 and 750, and was inhabited by some one hundred thousand people at its peak. Designed with colossal pyramids and ritual plazas, the metropolis was built on a grid plan including residential and manufacturing districts.

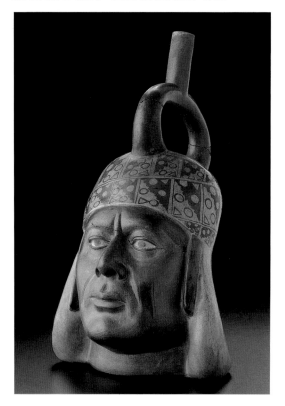

PORTRAIT VESSEL OF A RULER
Peruvian, north coast, Moche culture,
100 B.C./A.D. 500
Earthenware with pigmented clay slip;
h. 14 in. (35.6 cm)
Kate S. Buckingham Endowment, 1955.2338

Among the most distinctive art objects of
the ancient Peruvians were ceramic vessels
produced by artisans of the Moche culture,
which flourished on the north coast of
Peru between about 200 B.C. and A.D.
600. Remarkable for their sculptural
naturalism, these predominantly flat-
bottomed, stirrup-spout jars were molded
without the aid of a potter's wheel and
painted in earth tones. Moche potters
represented everything about their world,
from domestic scenes to architecture,
ritual events and royal personages, and
animals and plants. An exceptional
likeness, this portrait vessel depicts indi-
vidual characteristics — the furrowed
brow, the full, slightly protruding upper
lip — as well as general features recogniz-
able among Peruvian Indians today. With
its commanding expression and strong
bearing, the image conveys an indelible
sense of the power of Moche leaders. The
subject's elite status is further indicated by
his elaborate headdress, decorated with
the geometric motifs of Moche textiles, as
well as by his elongated ear ornaments
and traces of facial paint on his forehead
and cheeks. A vessel such as this was
made to be buried with the man it repre-
sents, but before it accompanied him to
the grave, it may also have been sent as an
emblem of royal authority from a center
of power to neighboring districts with gifts
of textiles and other items.

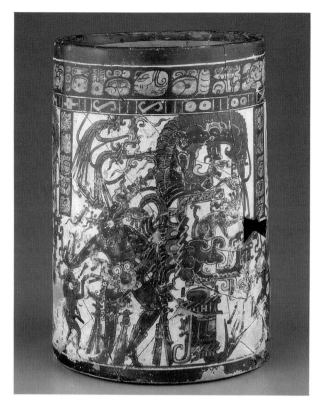

VASE OF THE DANCING LORDS

Guatemalan, Péten region, vicinity of Naranjo, Classic
Maya culture, 700 / 800
Earthenware with pigmented clay slip;
h. 9½ in. (24 cm), diam. 6¾ in. (17 cm)
Ethel T. Scarborough Fund, 1986.1081

According to ancient Maya belief, the gods, after several failed attempts, succeeded in populating the earth only when humanity was finally shaped from maize, or corn, the staff of life. This funerary vase from the Classic period (250–900) depicts a Maya ruler attired as the Maize God in three almost-identical panels. In each, he wears an enormous rack on his back containing masks, brilliant feathers, heraldic beasts, and related emblems. Just as maize plants sway to and fro, so too does the Maize God seem to dance to the rhythm of life – often, as seen here, in the company of a hunchbacked dwarf. To the Maya, especially the aristocracy, dwarfs were special beings, with powerful connections to the earth and the underworld,

land of the ancestral dead. Consequently, this vase may well refer to a rite of passage in which dwarfs assist the soul of the deceased to the domain of the dead. Implied in this scene is the notion of death and renewal. Hieroglyphs naming Maya capitals are seen in the panels, and a ritual introductory text in hieroglyphs decorates the upper rim. The principal dance motif is echoed in the beautiful calligraphic design, the flowing patterns of which surround the red figures in a delicate web of lines. The *Vase of the Dancing Lords* (possibly in a pair with the Art Institute's *Vase of the Water Lilies*) may have been painted as a funerary offering for a noblewoman with dynastic connections in the city of Naranjo, where the vase was made.

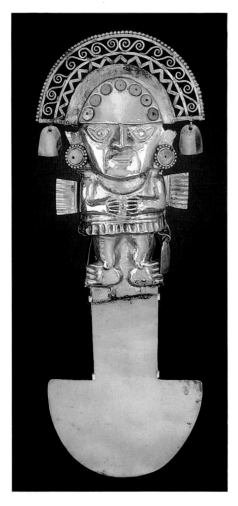

CEREMONIAL KNIFE (*TUMI*)

Peruvian, north coast, Chimú culture, 1100/1450
Cast, hammered, and repoussé gold with turquoise inlay; 13⅜ × 5 in. (34 × 12.7 cm)
Ada Turnbull Hertle Endowment, 1963.841

Naymlap, the heroic founder-colonizer of the Lambayeque valley on the north coast of Peru, is thought to be the legendary figure represented on the top of this striking gold *tumi*, or ceremonial knife. The knife may have been carried by dynastic rulers during state ceremonies to represent, in a more precious form, the copper knives used for animal sacrifices. Naymlap stands arms to abdomen, feet splayed outward. On his head is an elaborate headdress with an open filigree design. Turquoise — for the peoples of ancient Peru, a precious gem related to cults of water and sky — is inlaid around the headdress and in the ear ornaments. The headdress is further festooned with various small gold ornaments hanging from its sides, and they also decorate the lower part of Naymlap's costume. The *tumi* is a veritable repository of metalworking techniques. Solid casting was used to produce the blade. The face and body of Naymlap were created with annealing (heating, shaping, then cooling) and repoussé, in which the design is hammered in relief from the reverse side. Finally, the small ornaments at the top of the headdress were separately hammered and cast, then soldered into place. The *tumi* and many other gold, silver, and textile objects were made in royal workshops and ceremonially given to high officials as emblems of rank and authority.

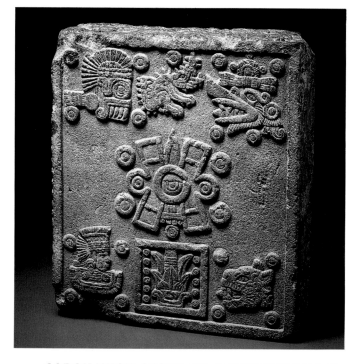

CORONATION STONE OF MOTECUHZOMA II
"STONE OF THE FIVE SUNS"

Mexican, Tenochtitlan, Aztec culture, 1503
Basalt; 22 × 26 × 9 in. (55.9 × 66 × 22.9 cm)
The Art Institute of Chicago Major Acquisition Fund, 1990.21

This stone, commemorating the start of the reign of Emperor Motecuhzoma II (formerly called Montezuma), was originally located within the ritual center of Tenochtitlan, the capital of the extensive empire established by the Aztecs between 1428 and 1519. Destroyed by the Spanish conqueror Hernán Cortés in 1521, this sacred precinct's ruins lie beneath downtown Mexico City. Known as the "Stone of the Five Suns," the monument draws connections between Aztec history and the eternal, cosmic scheme. The quadrangular block was designed to be seen horizontally. Its upper surface is carved with the hieroglyphic signs of five cosmic eras, called "suns" in the Nahuatl language of the Aztecs. The eras were mythic cycles of creation and destruction that began in the time of genesis and continued with the birth of humankind and into the present period of Aztec rule. The eras begin with "4 Jaguar-sun" in the lower right corner, and proceed counterclockwise through "4 Wind-sun," "4 Rain-sun," and "4 Water-sun." The "X" carved in the center represents "4 Movement-sun," the sign of what was then the present era. The year "11 Reed" in the square cartouche refers to 1503, while the day-sign above it — "1 Crocodile" — corresponds to July 15, the date of Emperor Motecuhzoma's coronation. Hieroglyphic figures alluding to the earth goddess also cover the four sides of the stone as well as its underside, where the date "1 Rabbit" is carved, denoting the beginning of the earth's creation. The sculpture thus legitimizes Motecuhzoma's rule as part of the larger cycle of birth, death, and renewal, and shows him as heir to the earth.

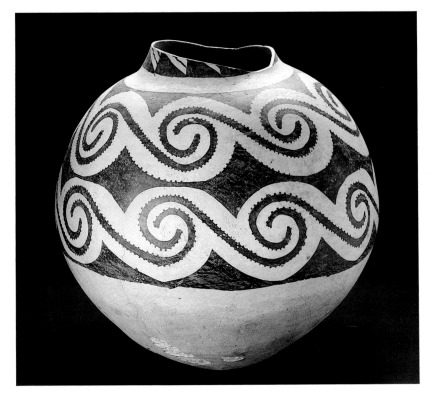

STORAGE JAR *(OLLA)*

American, Anasazi culture, c. 1100
Clay, black and white mineral paint;
17 × 18 in. (43.2 × 45.7 cm)
Tillie C. Cohn Fund, 1976.307

Ancestors of the modern Pueblo Indians, the Anasazi people flourished in the southwestern United States beginning about two thousand years ago. Ruins of their spectacular cliff dwellings and multistory towns of sandstone masonry exist in New Mexico, Colorado, and parts of Utah and Arizona. Skilled farmers, the Anasazi were also creative craftspeople, as seen in this large, striking *olla*, a storage vessel. Dramatically decorated in the black on white ground of the Black Mesa style, the vessel displays a continuous swirling band of barbed, interlocking S-shapes. This strong rhythmic pattern is best perceived from above, suggesting that the *olla*'s usual placement was on the floor of a room. Like most *ollas*, this vessel originally had a taller neck, but it broke off and was ground down by its original owner, presumably a woman. In Anasazi culture, pots and baskets were primarily made and used by women. The potter's wheel was unknown, and skilled artisans created the evenly thin walls of the vessel by the coiling method, which derives from an ancient way of making baskets. In this technique, still in use today, the vessel was built up with successive coils of clay that were then patted and thinned to achieve the full, globular shape.

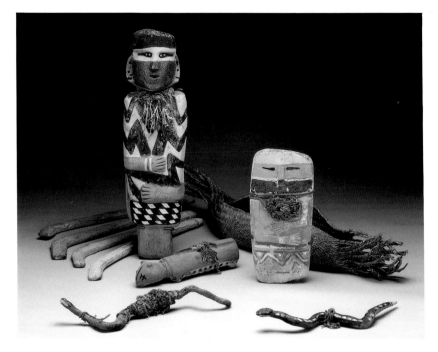

RITUAL CACHE FIGURES

North American, Southwest, New Mexico, Salado culture, c. 1350
Wood, stone, plant fiber, cotton, feathers, leather, and pigment;
basket: 1. 38⅛ in. (97 cm); ritual figures: h. 25¼ in. (64 cm), 14⅛ in.
(36 cm); snakes: 1. 15¾ in. (40 cm), 17⅜ in. (44 cm); mountain lion:
h. 3½ in. (9 cm); four sticks: each 24¼ in. (61.5 cm)
Major Acquisitions Centennial Endowment, 1979.17.1–11

Discovered wrapped and hidden in a remote, dry cave, this cache of ritual
objects comes from the Salado culture, which flourished in the mountains of
west-central New Mexico between the fourteenth and fifteenth centuries.
Brilliantly colored and adorned with feathers and dyed cotton string, these
objects formed an altar for people to commune with the life-giving spirits of
the earth and the sky. The large wooden male figure personifies the sky. His
feather necklace and the bold, black and turquoise zig-zag pattern relate to sky
symbolism. The smaller female figure of stone is a more self-contained form
representing the earth. Her ocher color traditionally refers to corn and pollen,
symbols of sustenance and fertility. The triangular pattern on her skirt may
refer to maize, and like an unhusked ear of maize, she was found encased in
the twilled basket beside her. The accompanying figures are a mountain cat (the
chief animal of prey), and two serpents carved from cottonwood roots, which
were messengers to the earth and its waters. Throwing sticks for the rabbit hunt
complete the ensemble. Testimony to the antiquity and endurance of the cults
of earth and sky, and to sacred connections between people and animals, these
objects bear close resemblance to ritual figures and implements still seen and
used among the Pueblo peoples today.

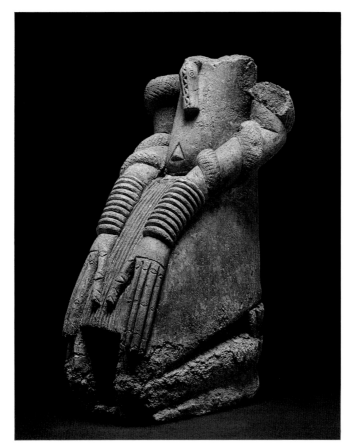

KNEELING FIGURE WITH SNAKES

Malian, Inland Niger Delta, "Djenne" culture, 11th/14th cen.
Terracotta; h. 18¾ in. (47.6 cm)
Maurice D. Galleher, Ada Turnbull Hertle, and Laura T. Magnuson funds, 1983.917

This regal fragment of a terracotta figure originates from in or near the ancient city of Djenne-Jeno, on the fertile inner delta of the Niger River in Mali, West Africa. Composed of geometric shapes recalling cones and cylinders, the male figure kneels in an erect posture. The strict frontality and static forms are complemented by his graceful arms and elongated hands, whose extraordinary, attenuated fingers echo the striations of his skirt. These motifs, in turn, are juxtaposed with an array of rounded bracelets and snakes that coil sinuously around his arms. A snake head dangles like a pendant on his chest. Referring to origin myths, the snake theme is ancient and widespread in western Africa. Tales related to the founding of Djenne-Jeno establish the legitimacy of its people through sacred connections with ancestral snakes and supernatural forces. A cosmopolitan trading capital at its height, Djenne-Jeno had a population of perhaps ten thousand people around 800 and was finally abandoned around 1400. The related culture's wealth of terracotta sculpture, such as the piece shown here, was not discovered until the mid-1970s, after the droughts of the previous decade caused the Niger's water level to drop.

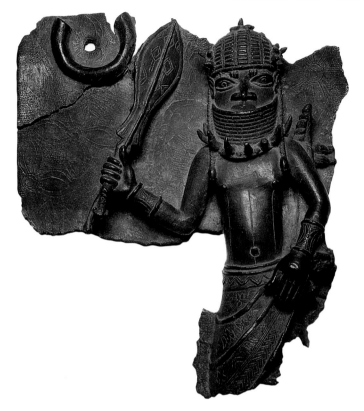

PLAQUE

Nigerian, Court of Benin, Edo peoples, 16th / 17th cen.
Brass; 13¾ × 14⅜ in. (34.9 × 36.3 cm)
Samuel P. Avery Fund, 1933.782

One of the most powerful polities in Africa beginning in the fifteenth century, the Kingdom of Benin is renowned for its plastic arts. For centuries, the art of brass casting (as well as ivory carving) was strictly organized in guilds of highly trained professionals in service to the king, or *oba,* and therefore served to glorify both individual kings and the institution of kingship. Brass plaques such as this were cast in the lost-wax method as architectural ornaments to be hung from the pillars of the *oba*'s palace. Their subjects, drawn from Benin's history, are thought to be both literal and narrative celebrations of the kingdom and specific royal lines. Here, a Benin warrior chief raises the ceremonial *eben,* a broad, leaf-shaped sword, and wears such symbols of high political and social status as armlets, coral-bead necklaces, and a leopard-tooth collar. Another symbol of royalty is the guilloche pattern of interlacing decorating the border of his kilt. Ornamental scars adorn his forehead and torso. The horseshoe-shaped object in the upper left corner represents a brass manilla, which was used as currency and also provided a supply of metal for plaques; here the manilla symbolizes the power and wealth of the Kingdom of Benin.

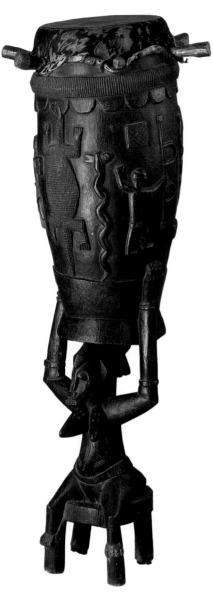

CEREMONIAL DRUM
(PINGE)

Ivorian, Senufo peoples, 1930/50
Wood, hide, and applied color; h.
48⅜ in. (123 cm), diam. at top 25 in.
(63.5 cm)
Robert J. Hall, Herbert R. Molner
Discretionary, Curator's Discretionary,
and Departmental funds; Arnold
Crane, Mrs. Leonard Florsheim, O.
Renard Goltra, Ada Turnbull Hertle,
Marion and Samuel Klasstorner,
Holly and David Ross, Departmental
Acquisitions endowments; through
prior gifts of various donors, 1990.137

Called a *pinge*, this memorial drum was
made by a Senufo artist. The Senufo are
a primarily agricultural people of West
Africa known for their aggressively geo-
metric forms, both abstract and figural.
Here, an iconic female figure sits astride
a four-legged stool. The strongly frontal
figure has triangular thighs, conical
breasts, and symmetrical, vertical fore-
arms. Her jutting, rectangular mouth
bares small, square teeth; her nose is
arrow-shaped; arched lids frame oval
eyes. Scarification adorns her body and
cheeks. Resting on top of her head is the
large wooden drum, covered with hide
and encircled by male warriors, snakes,
and other motifs familiar in Senufo cos-
mology. The sculpture may have evolved
from the ritual practice of the Sandogo
and the Tyekpa, secret funerary societies
of Senufo women. These women, in
charge of honoring the dead, dance with
large figural sculptures balanced on their
heads while playing drums. Like this
instrument, such drums are often lavishly
decorated with images related to bush
spirits carved on the sides in bas-relief.

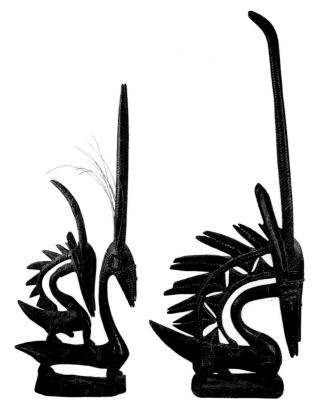

HEADDRESSES *(CI WARA KUNW)*
Malian, Segou, Bamana peoples, mid-19th/early 20th cen.
Wood, brass tacks, metal, and grasses;
h. 38¼ in. (98.4 cm), 31¼ in. (79.4 cm)
Ada Turnbull Hertle Fund, 1965.6–7

According to Bamana legend, it was Ci Wara, the half-man, half-beast born from the first creation, who magically tilled the ground, changing weeds to corn and millet, thereby teaching man how to farm. This noblest of professions was critical to inhabitants of the dry savannah of central Mali, where farming constituted the primary means of livelihood. Carved in a semiabstract style, with flowing lines, angles, and spaces, the headdresses represent composites of two indigenous animals, the antelope and anteater, who embody characteristics most prized in the farming community. The long horns and triangular mane of the antelope suggest its grace and strength. The anteater's tapered face and low-slung body are associated with the animal's determination and endurance. In addition, the large ears of the male figure (the female carries a baby on her back) refer to hearing, for it is through listening that one receives knowledge and encouragement. These distinctive symbolic headdresses were worn by grass-robed male dancers in a ceremonial glorification of agriculture held just prior to planting season. This dance of Ci Wara, which came to mean "excellent farmer," would continue through the day, and sometimes into the evening, in the hope that the mythical creature would be pleased and grant the Bamana abundant harvest.

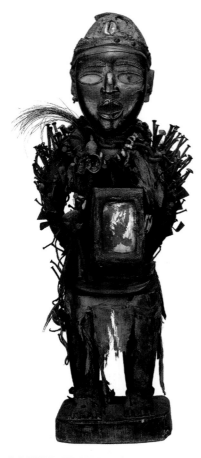

POWER FIGURE *(NKISI NKONDI)*
Congolese, Vili-Kongo, early/mid-19th cen. (collected 1882/94)
Wood, metal, glass, fabric, fiber, cowrie shell, bone, leather, gourd, and feather;
h. 28⅓ in. (72 cm)
Major Acquisition Funds, 1998.502

This striking figure, with its beautifully rendered face and violently pierced
body, was made to contain and control a spirit in order to assist people in need.
Nkondi means hunter in the Kongo language and refers to the spirit's power to
track down offenders. The figure's cap and assertive pose, with hands on hips
and forward thrusting chin, suggest those of a chief; and like a leader, the figure
and its associated spirit were called on to enforce laws and exact punishment.
The spirit was drawn into the sculpture through the application of medicinal
ingredients packed in resin on its head and in the projecting box, sealed by a
mirror, on its abdomen. These contents were selected for their associations with
the ancestral world, such as earth from graves, and for their metaphorical asso-
ciations with the spirit's powers. Medicines may also have been related directly
to the figure's function; for instance, the chain may refer to the spirit's ability to
immobilize its victims. A nail or a blade was driven into the piece each time its
force was invoked through ritual, thereby provoking the spirit into action.

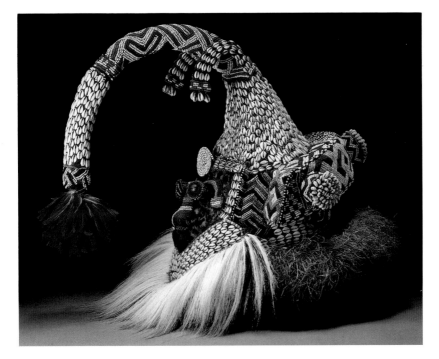

MASK *(MUKENGA)*

Congolese, Western Kasai, Kuba peoples, late 19th / mid-20th cen.
Wood, glass beads, cowrie shells, feathers, raffia, fur, fabric, string, and bells;
h. 27½ in. (70 cm)
Laura T. Magnuson Endowment, 1982.1504

The honoring of important individuals through dance is central in the tradi-
tions of the Kuba people. The Mukenga mask, from the north-central region of
the kingdom, was used in funerals of titled members of the initiation society
known as *babende,* or in celebrations of eminent persons such as Kuba kings or
political dignitaries of the modern state. A rich variety of materials, textures,
and shapes create this fantastical personification of a nature spirit. Leopard fur
covers his face, while his protruding eyes recall the rotating, all-seeing eyes
of a chameleon. His neck is hidden in front by a ruff made from the fur of the
agile colobus monkey, and in back by vegetable fiber. Crowning the whole and
decorated in beads and cowrie shells is a trunklike appendage and two smaller
tusks, representing the mighty power of the elephant. The beads and shells
invest the mask with wealth. A tuft of bright red parrot feathers adorns the tip
of the trunk. These powerful attributes of nature spirits transmitted prestige to
the individuals they honored in dances.

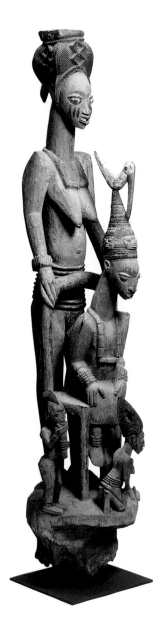

OLOWE OF ISE

(Yoruba, c. 1875–1938)
*Veranda Post of Enthroned King and
Senior Wife (Opo Ogaga)*
Nigerian, Ikere, Ekiti, Yoruba peoples,
from the Palace of the Ogoga (King) of
Ikere, 1910/14
Wood and pigment; h. 60 in. (152.5 cm)
Major Acquisitions Centennial Fund,
1984.550

This veranda post is one of four sculpted
for the palace at Ikere by the renowned
Yoruba artist Olowe of Ise. It is considered
among the artist's masterpieces for the
way it embodies his unique style, includ-
ing the interrelationship of figures, their
exaggerated proportions, and the open
space around them. The composition and
iconography of the work also masterfully
depict Yoruba concepts of divine kingship.
While the king is the focal point, his por-
trayal suggests a ruler's dependence on
others. He sits with lowered gaze and
dangling legs, and is weighted down by
his crown, the ultimate source of his
authority. Such crowns are spiritually
charged accessories in which a ruler's
power is believed to reside. The stately
female figure behind the king represents
his senior wife. Her large scale and pose,
with hands on the king's throne, under-
score her importance; she had the critical
role of placing the power-invested crown
on the king's head during his coronation.
Moreover, the senior wife used political
acumen and spiritual knowledge to
protect the king's interests during his
reign. The small figures at the king's feet
represent a junior wife, the flute playing
trickster-god Esu, and a fan-bearer,
now missing.

American Arts

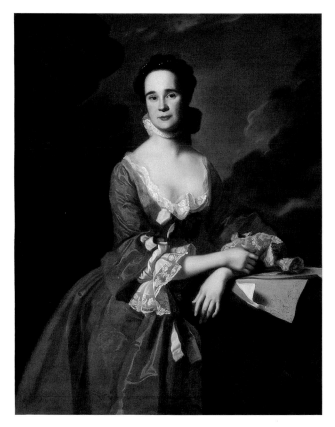

JOHN SINGLETON COPLEY
(American, 1738–1815)

Mrs. Daniel Hubbard, 1764
Oil on canvas; 50¼ × 39¾ in. (127.6 × 101 cm)
Museum Purchase Fund, 1947.28

America's foremost portrait painter before the Revolutionary War, John Singleton Copley had completed his first portraits by the age of fifteen. Largely self-taught, the Bostonian painter often relied, like English artists, on European prints for compositional models and, in particular, on the print collection of his stepfather and teacher, Peter Pelham, a mezzotint engraver. Here, Copley used a mezzotint portrait of an English noblewoman to inspire the pose, gown, and background of the wife of a wealthy businessman. Standing on a balcony or terrace, Mrs. Hubbard rests her arm on an embroidered cloth placed over a pedestal. As in the print, draperies and clouds billow behind her. Even the cherub carved in relief on the parapet is borrowed. But the penetrating directness, vigorous execution, and precision of detail are very much Copley's own; his unique and indigenous sensibility was much appreciated throughout New England. Among the wealthy merchants and professionals he painted (a pendant portrait of Mrs. Hubbard's husband also hangs in the Art Institute), before departing to settle in England on the eve of the Revolution, were some of the colony's most influential personages, including patriots Samuel Adams, John Hancock, and Paul Revere.

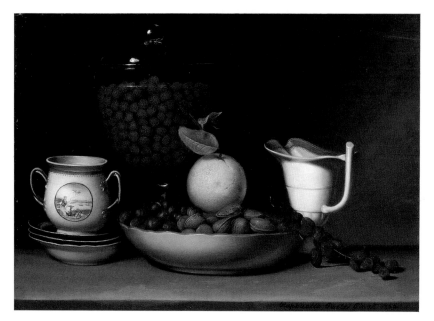

RAPHAELLE PEALE
(American, 1774–1825)
Still Life — Strawberries, Nuts, &c., 1822
Oil on panel; 16⅜ × 22¾ in. (41.6 × 57.8 cm)
Gift of Jamee J. and Marshall Field, 1991.100

Academic dogma of Raphaelle Peale's time relegated still life to the bottom of a hierarchy of painting subjects. Yet Peale ignored — if not deliberately flouted — its low status, with the result that he is now acknowledged as America's first professional still-life painter and master of the genre. Born into an artistic Philadelphia family, Raphaelle was the eldest son of Charles Willson Peale and nephew of James Peale, both artists; his siblings were, like him, freighted with the names of famous Old Master painters (he had brothers named Rembrandt, Titian, and Rubens). Characterized by a crisp form and balanced serenity, most of Peale's still lifes portray food (mainly fruit), crockery, and glassware arranged symmetrically on a plain shelf, parallel to the picture frame. In this particularly fine example, the rhythmic balance of fruit, nuts, and Chinese export porcelain is enlivened by a diagonal branch of raisins and an orange leaf. These objects are brightly illuminated against a bare and basically dark background, reflecting the dramatic still-life compositions of the seventeenth-century Spanish master Juan Sánchez Cotán (see p. 132), whose work Raphaelle may have seen when it was shown at the Pennsylvania Academy of the Fine Arts in 1818.

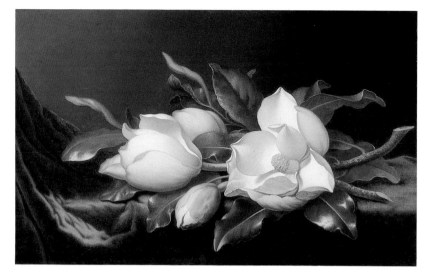

MARTIN JOHNSON HEADE
(American, 1819–1904)
Magnolias, 1885/90
Oil on canvas; 15¼ × 24⅜ in. (38.7 × 61.9 cm)
Restricted gift of Gloria and Richard Manney; Harold L. Stuart Fund, 1983.791

This sensuous and decorative image dates from the later part of Martin Johnson Heade's long, varied, and peripatetic career. Traveling through much of the United States, to England and continental Europe, as well as (three different times) to Brazil, he produced work ranging from pristine views of East Coast salt marshes and lush tropical landscapes to exotic pictures of hummingbirds and orchids. Heade did not settle down until the age of sixty-four, when he moved to St. Augustine, Florida. There he began to paint highly detailed arrangements of native flowers, including the cherokee rose, orange blossom, and, as seen here, the magnolia. Although the majority of these compositions were presented vertically, Heade chose a horizontal format to best display this curvaceous plant. Stretched out like an odalisque on blue velvet cloth, the fleshy white flower is meticulously rendered in pale, subtle hues and illuminated by a light so sharp that the image evokes the hyperintensity of dreams. The warm, steamy atmosphere is almost palpable, as is the blossom's heady, pungent scent. The Art Institute's *Magnolias* is one of several compositions by the artist featuring this dramatic yet delicate white flower.

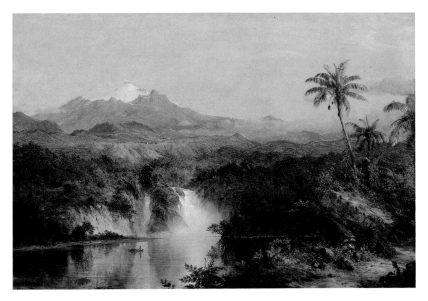

FREDERIC EDWIN CHURCH
(American, 1826–1900)

Cotopaxi, 1857
Oil on canvas; 24½ × 36½ in. (62.2 × 92.7 cm)
Gift of Jennette Hamlin in memory of Mr. and Mrs. Louis Dana Webster,
1919.753

A leading American landscape painter in the second half of the nineteenth
century, Frederic Edwin Church approached his subject matter as both artist
and scientist. Inspired by the writings of the German naturalist and explorer
Alexander von Humboldt, Church visited the mountainous terrain of South
America twice, in 1853 and in 1857. In this untamed "New World" — partic-
ularly what was then the highest active volcano in the world, the mighty
Ecuadoran Cotopaxi — he saw the perfect symbol of primeval nature and the
spiritual renewal it could bring to civilization. This view of the perfectly
shaped, smoldering cone of Cotopaxi ("shining mass" to the Incas) was com-
pleted just before Church's second trip to South America. A dazzling compen-
dium of minutely rendered wildlife, vegetation, and terrain, the canvas
illustrates the fascinating contrasts indigenous to this locale: from the calm lake
water to the explosive cascades; from the lush, green foliage to the frozen,
barren peak. The elevated vantage point, in which the viewer seems suspended
in midair, heightens these evocative juxtapositions. One of at least ten finished
canvases executed over almost two decades that feature the Andean volcano,
this painting represents an intermediate vision between Church's straightfor-
ward, more naturalistic early pieces and the dramatic, transcendental earth-
scapes of the mature period of his career.

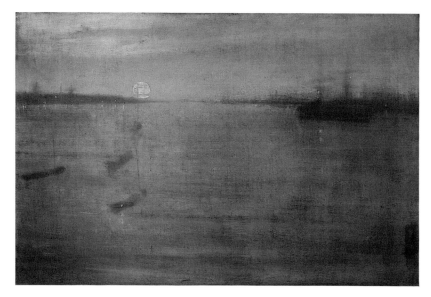

JAMES ABBOTT MCNEILL WHISTLER
(American, 1834–1903)

Nocturne in Gray and Gold, 1872
Oil on canvas; 19⅞ × 30 in. (50.5 × 76 cm)
Stickney Fund, 1900.52

"Art should be independent of all clap-trap — should stand alone and appeal to the artistic sense of eye or ear," said the iconoclastic painter James Abbott McNeill Whistler. Born in the United States, Whistler spent most of his adult life in Paris and London. To emphasize that there are no narrative overtones in his paintings — that instead they are aesthetic arrangements of color and shape on flat surfaces — he gave them titles derived from music, such as "arrangements," "symphonies," and "nocturnes." One of his first such paintings, *Nocturne in Gray and Gold* captures a hazy, moonlit night on Southampton Water. Rather than focusing on the ships in the harbor, Whistler was interested in the mood created by the dense, warm twilight and the subtle harmony of shades of gray and gold. To achieve this, he relegated the boats to either side of the composition, creating a kind of frame for the tranquil expanse of water and sky at the painting's center. Part of a homely piling at the lower right anchors the scene. Much misunderstood, sometimes openly ridiculed when they were first exhibited, Whistler's luminous nocturnal visions were forerunners of the experiments in abstraction that would follow in the next century.

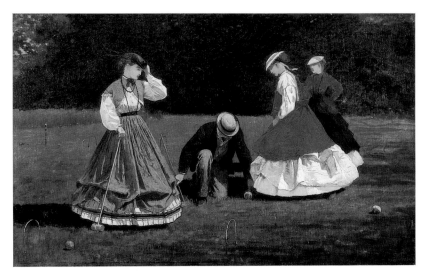

WINSLOW HOMER
(American, 1836–1910)

Croquet Scene, 1866
Oil on canvas; 15⅞ × 26⅛ in. (40.3 × 66.2 cm)
Friends of American Art Collection, 1942.35

One of America's undisputed masters, Winslow Homer made his reputation as an illustrator during the Civil War. During the early 1860s, Homer turned his acute observational and technical skills toward oil painting, preferring to depict figures out-of-doors in bright, natural light. These early paintings, often executed in series, feature aspects of contemporary life — in this case, women and men competing with one another in the popular sport of croquet, which had recently been introduced to the United States from England. In *Croquet Scene*, one of five paintings Homer completed on the subject, progress on "the grand round" seems fairly advanced. The crouching male figure positions the ball belonging to the woman dressed in red. She is about to *croquet* (or "send up the country") the ball probably belonging to the woman in the left foreground, who shields her eyes against the bright afternoon sun. Notable for its broad brushwork, bold patterning, strong contours, and brilliant light effects, the painting epitomizes the spirit of a breezy summer afternoon.

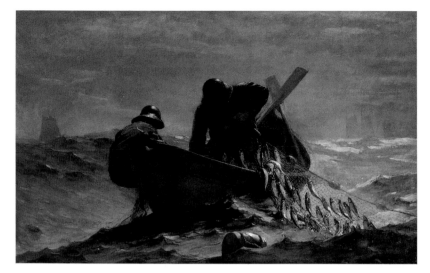

WINSLOW HOMER
(American, 1836–1910)

The Herring Net, 1885
Oil on canvas; 30⅛ × 48⅜ in. (76.5 × 122.9 cm)
Mr. and Mrs. Martin A. Ryerson Collection, 1937.1039

In 1883, Winslow Homer moved to Prout's Neck, Maine, and from this point, where sea meets land, proceeded to create a series of images of the sea unparalleled in American art. Long inspired by the subject, Homer had spent summers visiting New England fishing villages during the 1870s and, in 1881–82, made a trip to a fishing community in Tynemouth, England, that fundamentally changed his work and his life. His late paintings focused almost exclusively on mankind's age-old contest with nature. Here, Homer depicted the heroic efforts of fishermen at their daily work, hauling in an abundant catch of herring. In a small dory, two figures loom large against the mist on the horizon, through which the sails of the mother schooners are dimly visible. While one fisherman hauls in the netted and glistening herring, the other, a boy, unloads the catch. With the teamwork so necessary for survival, both strive to steady the precarious boat as it rides the incoming swells. Homer's broad and masterful isolation of these two central figures underscores the monumentality of their task: the elemental struggle against a sea that both nurtures and deprives.

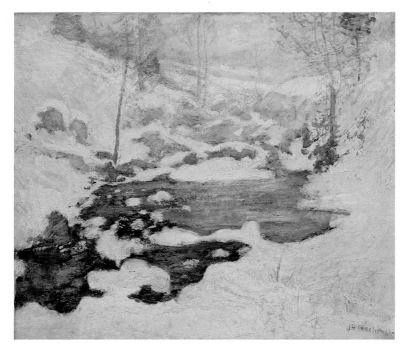

JOHN HENRY TWACHTMAN
(American, 1853–1902)

Icebound, 1889/1900
Oil on canvas; 25¼ × 30⅛ in. (64.1 × 76.5 cm)
Friends of American Art Collection, 1917.200

Around 1889, after years of training and travel, John Henry Twachtman
purchased a seventeen-acre farm in Greenwich, Connecticut, where, during
the next decade or so, he created some of his finest works. Like the French
Impressionists, whose style influenced him deeply, Twachtman found in
familiar surroundings an inexhaustible source of subject and inspiration.
Icebound illustrates a favorite theme: a stream descending from the rocks in the
background to a serene pool, in the foreground, surrounded by hemlock trees.
In the hushed tranquility of this winter scene, Twachtman achieved a fine
compositional balance between spontaneity and control. Movement is implied
despite the frozen stillness suggested by the title and the muted tonal harmo-
nies of the painting's limited, white and blue palette. Sinuous arabesques of
white snow against blue water accentuate the stream's descent. Thick brush-
strokes of white and streaks of violet amid the blue of the water enliven the
picture's surface. Vivid red-orange leaves serve both as distinctive accents
against the dominant white and as reminders of an autumnal life that has not
yet surrendered to the relentless change of seasons.

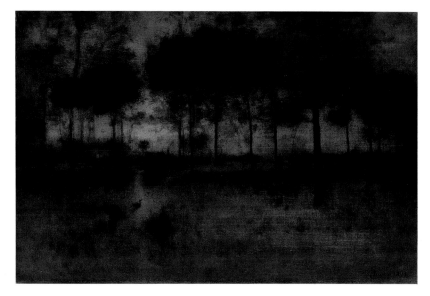

GEORGE INNESS
(American, 1825–1894)
The Home of the Heron, 1893
Oil on canvas; 30 × 45½ in. (76.2 × 115.2 cm)
Edward B. Butler Collection, 1911.31

"The true purpose of the painter is simply to reproduce in other minds the
impression which a scene has made upon him...to awaken an emotion," said
the landscape painter George Inness, who sought, particularly in his later years,
to record not so much the appearance of nature as its poetry. To achieve this,
Inness limited his oeuvre, prolific as it was, to (in his words) "rivers, streams,
the rippling brook, the hillside, the sky, the clouds." For half a century, the
artist captured these moisture-laden subjects in all seasons, during all hours of
day and night. First, he made small, quick sketches in the field or wood and
then, in the seclusion of his atelier, used these studies to create the more than
one thousand oils credited to him. *The Home of the Heron* was completed late in
Inness's career, after he had finally achieved a degree of comfort and success.
Characteristic of his late work, detail is loose, and dim objects seem bathed in
an almost incandescent glow. The painting's blurred outlines, broad handling,
and delicate, subtle tonalities, as well as the solitary presence of the heron,
masterfully evoke nature's stillness and mystery. With thirty-two canvases
by Inness, the Art Institute has one of the most comprehensive collections
of his work.

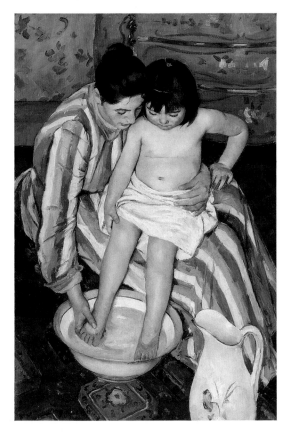

MARY CASSATT
(American, 1844–1926)
The Bath, 1891–92
Oil on canvas; 39½ × 26 in. (100.3 × 66 cm)
Robert A. Waller Fund, 1910.2

The only American artist to become an established member of the Impressionists in Paris, Mary Cassatt was invited to join the group by Edgar Degas in 1877. By that time, she had become disenchanted with the success she had achieved within the traditional circle of the French Salon. Degas, with his consummate draftsmanship and emphasis on innovative composition and gesture, became her artistic mentor. Like him, Cassatt concentrated on the human figure, particularly on the sensitive, yet unsentimental, portrayal of women and children. *The Bath*, with its striking and unorthodox composition, is one of Cassatt's masterworks. In it, she employed such then-unconventional devices — often seen in Japanese prints — as diagonals, cropped forms, bold patterns and outlines, and an elevated vantage point. The lively patterns play off one another and serve to accentuate the nakedness of the child, whose vulnerable white legs are as straight as the lines of her mother's striped dress. The elevated vantage point pitches forward the planes of the picture, permitting the viewer to observe, but not to participate in, this most intimate scene, thereby reinforcing the tender absorption of mother with child, of their interlocking gestures, of their focus on each other and the task at hand.

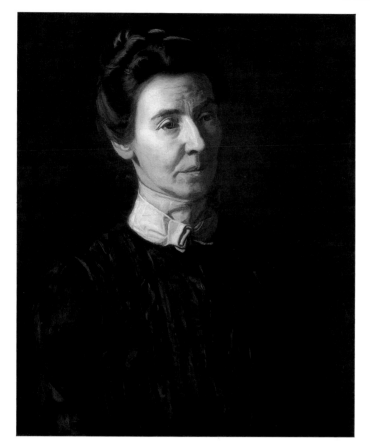

THOMAS EAKINS
(American, 1844–1916)
Mary Adeline Williams, 1899
Oil on canvas; 24 × 20⅛ in. (61 × 51 cm)
Friends of American Art Collection, 1939.548

An uncompromising realism characterizes Thomas Eakins's philosophy of work and life. His rejection of conventional ideas about artistic training (for example, he required all his students — female, as well as male — to draw from the nude) led, in part, to his forced resignation as director of the Pennsylvania Academy of the Fine Arts in 1886. So, too, he rejected traditional ideas of beauty in his honest and revealing portraits. Not surprisingly, these essentially private portrayals were unpopular during Eakins's day. Mary Adeline Williams, or Addie, was a long-time family friend who supported herself as a seamstress and, for a period, even lived in Eakins's household. With a remarkable depth of emotion and characterization, Eakins used a dark background and severe dress and coiffure to throw into relief Addie's plain features. Her erect posture, pursed lips, and furrowed brow are softened by the three-quarter pose that casts her left side in shadow, while the light that illumines her right side reveals the quiet resignation and sincerity of this intimate friend. Like Addie, most of Eakins's subjects were friends, relatives, or personal acquaintances — natives of Philadelphia, where the artist spent almost his entire life.

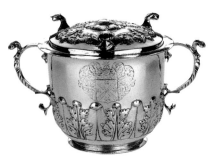

SYLLABUB CUP

American, 1698/1720
Cornelius Kierstede (1675–1757),
New York, N.Y.
Silver; h. 5½ in. (14 cm),
diam. top 5⅝ in. (14.1 cm)
Restricted gift of Mrs. James W.
Alsdorf, Pauline Seipp Armstrong,
Marshall Field, Charles C. Haffner III,
Mrs. Burton W. Hales, Mrs. Harold T.
Martin, Mrs. C. Phillip Miller, Mr. and
Mrs. Milo M. Naeve, Mrs. Eric Oldberg,
Mrs. Frank L. Sulzberger, and the Ethel
T. Scarborough Fund, 1984.1132

This luxurious vessel, by one of New
York's foremost early silversmiths, was
used to serve syllabub, a sweetened
or flavored wine, cider, beer, or ale into
which milk was whipped. The cover
helped preserve the frothy drink and also,
using its three equidistant handles as legs,
could be inverted into a saucer for the cup.
The cup bears the mark, "CK," of Corne-
lius Kierstede, a third-generation New
Yorker of Dutch descent. Kierstede opened
a shop around 1698 in the prosperous and
growing city where he worked, off and on,
until moving to New Haven, Connecticut,
in the early 1720s. Like the Van Cortlandt
family, who commissioned this cup and
whose coat of arms it bears, and the
Stuyvesant family, whose descendants
owned the cup until it was acquired by the
Art Institute, the majority of Kierstede's
patrons were wealthy Dutch colonists.
This cup is one of four nearly identical
vessels made during the same period by
Kierstede and two other well-known New

York silversmiths. Evolving from English
prototypes, all four cups have the same
nearly straight sides, scroll-like handles,
and slightly domed cover, as well as varia-
tions of the embossed acanthus-leaf decor.

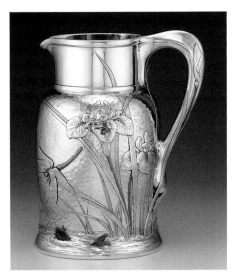

PITCHER

American, 1878
Tiffany & Company, New York, N.Y.
Silver, gold, and copper; h. 8¾ in.
(21 cm), diam. at base 5½ in. (14 cm)
Restricted gift of Mrs. Frank L.
Sulzberger, 1984.240

By the time this elegant pitcher was
created, Tiffany & Company had become
one of the largest and most accomplished
silver manufacturers in the world. With
fish, flowers, and insects applied in gold,
copper, and silver, this pitcher reflects the
late nineteenth-century fascination with
Japan, a nation that had opened to trade
and the outside world just two decades
before. The vessel's surface is hammered
by hand to give it texture, and its organic,
gourdlike shape further reveals the
Japanese emphasis on nature as a source
of design. This pitcher, or a nearly iden-
tical one, received wide acclaim when it
was exhibited at the world's fair in Paris

in 1878. Tiffany's chief designer, Edward C. Moore, received a gold medal, and Charles Louis Tiffany, founder of the company, was made a Knight of the French Legion of Honor for expanding Western taste into new realms. Company records show that several dozen versions of this pitcher were made during the 1870s and 1880s, and were dispersed as far as Russia. At the time, the London *Spectator* lamented: "We confess we were surprised and ashamed to find that a New York firm, Tiffany & Co., had beaten the old country and the old world in domestic silver plate."

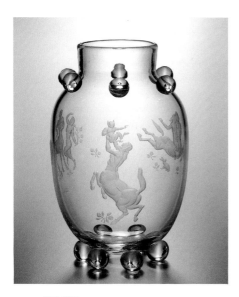

VASE

American, 1940
Designed by Paul Manship (1885–1966),
Steuben Division of the Corning
Glass Works, Corning, N.Y.
Glass; h. 14 in. (35.6 cm), diam. 8⅛ in.
(20.6 cm)
Gift of Mrs. William H. Stanley,
1961.428

At the Paris Exposition of 1937, the French artist Henri Matisse was attracted to the thick crystal pieces, elegantly decorated with engravings, exhibited by the Steuben Division of the Corning Glass Works, and offered to contribute a design himself. This inspired the firm's director, John Gates, to gather the "greatest contemporary artists in Europe and America" to create designs to be engraved in crystal. This novel affiliation of the glassblower, engraver, and artist evolved into a popular exhibition featuring the work of twenty-seven artists that opened in Steuben's New York store in 1940. Each artist's piece was issued in a limited edition of six. The graceful silhouettes of Paul Manship's intaglio designs for the Art Institute's vase (number four of six) were especially admired by Princeton University Art Museum Director Frank Jewett Mather, Jr., who wrote the preface to the exhibition catalogue. Manship was one of the few artists who, according to Mather, decorated most of the vase's surface, "using the transparency instead of ignoring it." A Midwestern sculptor whose colorblindness had led him to work in three dimensions, Manship's elegant style owes much to his study of Archaic Greek art. Here, with clarity, balance, and a classical precision of outline, Manship traced the courting of a female satyr by a male centaur: from the proffering of a bouquet and a gallop together to the celebration of the birth of their infant satyr. An emphasis on fine craftsmanship and on explicit representational content is evident throughout Manship's oeuvre, which includes such famous public sculptures as the Prometheus fountain in New York's Rockefeller Center.

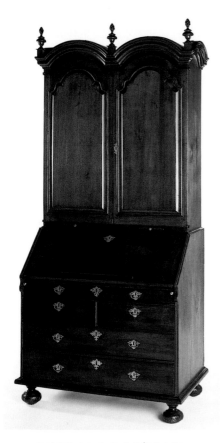

DESK AND BOOKCASE

American, Boston, 1701/35
Walnut and white pine; 90 × 41 × 24⅛
in. (228.6 × 104.1 × 61.3 cm)
Gift of the Antiquarian Society through
the Mr. and Mrs. William Y. Hutchinson
Fund, 1985.517

Few of Boston's residents in 1735 could have afforded this innovative, two-piece desk and bookcase except the wealthiest merchants and land speculators. The cost for materials and labor, as well as the need to own a "modern house" with at least eight-foot ceilings, was prohibitive for most of the thirteen thousand inhabitants of the colonial city. Decorated in the contemporary William and Mary style, with plain, straight sides and front and ball-shaped feet, this type of furniture remained in favor in the North American colonies until the 1730s. This piece is unusual for its classically inspired pediment of two enclosed arches, characteristic of the English Baroque. The space enclosed by these arches was a convenient display area for glass or ceramic objects. Under the bookshelves is a tier of compartments for filing papers. The owner would have stored writing equipment in the desk area, and maps, large papers, and miscellaneous objects in the drawers in the base. The form of this large, complex ensemble, introduced to England from continental Europe during the seventeenth century, is still in use today. It required a hard wood that was easier to work than oak, which had been favored up to this time. Walnut, which in America was available and affordable, became the wood of choice, as evidenced by the extravagantly thick planks used here.

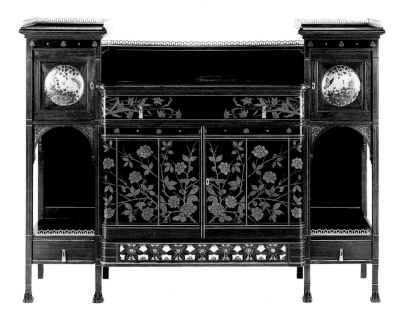

CABINET

American, 1878/80
Herter Brothers, New York, N.Y.
Rosewood, cherry, maple, walnut, and satinwood;
53 × 71 × 16 in. (134.6 × 180.3 × 40.6 cm)
Gift of the Antiquarian Society through the Capital Campaign, 1986.26

Although the original owner of this opulent rosewood cabinet is indicated
only by the order number "238" inscribed on its back, the patron was undoubt-
edly someone of means as well as aesthetic discernment. Clients of Herter
Brothers, New York's foremost decorating firm during the 1870s, included
leaders of art and industry who appreciated carefully designed, made-to-order,
handcrafted American "art furniture," such as this cabinet. Following the
lead of English designers intent on reforming an industry that produced poorly
conceived and constructed furniture, Gustave and Christian Herter advocated
designs that joined the beautiful and the functional. They preferred bold,
rectilinear shapes which, in this case, they enlivened with exquisite surface
decoration inspired by Japanese art, the influence of which was so prevalent at
the time. The tops of two lacquered Japanese mirror boxes featuring flowers
and insects adorn either side of the cabinet, while the floral inlay across the
facade is reminiscent of patterns found in Japanese textiles. Japanese family
crests inspired the bands of inlay across the top of the doors and above the side
compartments, and plum blossoms are carved in the arched spandrels on either
side of the facade.

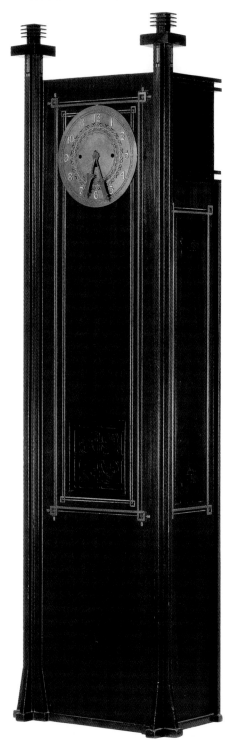

CLOCK

American, 1912
Designed by the firm of George Grant
Elmslie and William Gray Purcell;
manufactured by Niedecken-Walbridge
Company, Milwaukee, Wis.
Mahogany and brass; 84 × 26 × 15¾ in.
(213.3 × 66 × 40 cm)
Restricted gift of Mrs. Theodore D.
Tieken, 1971.322

This handsome tall-case clock with brass
inlay was designed by the firm of George
Grant Elmslie (1871–1952) and William
Gray Purcell (1880–1965), Prairie School
architects of the Henry Babson House in
Riverside, Illinois. Although the house
was nominally designed by Louis Sullivan
in 1907, a large part of the scheme was
actually executed by Elmslie, who was
then working for Sullivan. In 1912, Elms-
lie and his firm made additions to the
house, including eight pieces of furniture.
This elegant clock, whose works and nine
chimes were imported from Germany,
dates from this later commission. Its hands
were executed by Chicago metalsmith
Robert Jarvie according to Elmslie's
design. In his concern with creating an
organic, harmonious relationship between
the interior of a house and its exterior, the
Scottish-born Elmslie found a staunch ally
in designer George Niedecken, president of
the Milwaukee-based firm of Niedecken-
Walbridge, which made the clock's
mahogany case.

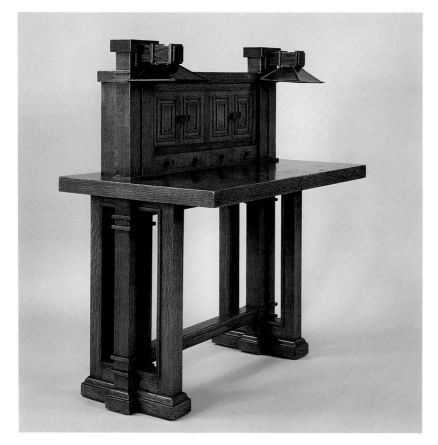

DESK
American, c. 1909
Niedecken-Walbridge Company, Milwaukee, Wis.
Oak; 45¼ × 40⅛ × 23⅞ in. (114.9 × 101.9 × 60.6 cm)
Restricted gift of the Graham Foundation for Advanced Studies
in the Fine Arts, 1972.304

The architect Frank Lloyd Wright considered furniture "architectural sculp-
ture" that should function as part of a larger aesthetic whole. In the largest
commission Wright developed in his Prairie style, the Avery Coonley house in
Riverside, Illinois, all the furniture was custom-designed to be compatible with
the house's unique rectilinear scheme (see p. 54). This desk, by the Milwaukee-
based firm Niedecken-Walbridge, demonstrates well the close relationship the
architect was searching to achieve between exterior and interior. Both house
and desk feature intersecting geometric forms and emphatic cantilevers. Both
emphasize the horizontal plane, and create rhythm by interrupting it with
vertical accents. For example, the doors along the front of the desk, with their
vertical format and horizontal arrangement, echo the banking of the living-
room casement windows. The desk's door panels are articulated in a manner
similar to the exterior wall tiles, and the band of applied molding is used in
both. Wright commissioned George Niedecken to produce most of his early
furniture.

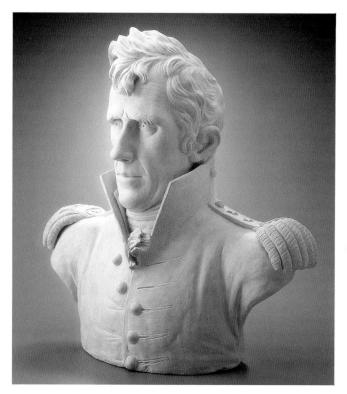

WILLIAM RUSH
(American, 1756–1833)

General Andrew Jackson, 1819
Terracotta; h. 19⅞ in. (50.5 cm)
Restricted gift of Jamee J. and Marshall Field, the Brooks and Hope B.
McCormick Foundation; Bessie Bennett, W. G. Field, Ada Turnbull Hertle,
Laura T. Magnusson, and Major Acquisitions funds, 1985.251

Andrew Jackson was described by a contemporary as having "an erect military bearing, and a head set with considerable *fierté* [pride] upon his shoulders…. His eye is of a dangerous fixedness; … [and] the instant his lips close, a visor of steel would scarcely look more impenetrable." Sculptor William Rush rendered a remarkably similar depiction of the general. Demonstrating a blend of naturalism, subtlety, and strength, Rush avoided grandiosity in this terracotta portrait bust of the fifty-two-year-old national military hero who, ten years later, would begin to serve the first of two consecutive terms as President of the United States. The artist's only concession to idealization was the replacement of the general's well-known stiff, wiry hair with the soft curls that signify noble qualities in neoclassical sculpture. Since there is no documentation that Jackson formally posed for Rush, the artist, a prominent resident of Philadelphia, may have observed Jackson during the general's three-day visit to the city in 1819. Hoping to benefit from Jackson's popularity, Rush followed the European custom of producing plaster replicas of the bust. Despite extensive marketing (an ad in a Virginia paper priced a cast of the bust at twelve dollars), only one of these replicas is known to have survived (Montgomery Place, Annandale-on-Hudson, New York).

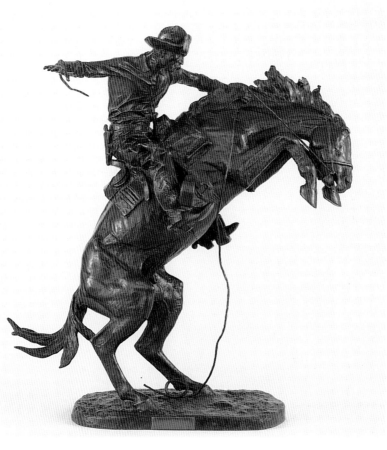

FREDERIC REMINGTON
(American, 1861–1909)

The Bronco Buster, modeled 1895; cast 1895/98 by the Henry-Bonnard Bronze
Company, New York, N.Y.
Bronze; h. 24 in. (61 cm)
George F. Harding Collection, 1982.808

Eastern-bred Frederic Remington had already achieved considerable success as
America's leading illustrator of life on the western frontier when, in 1894, he
turned his skill and energy to sculpture. This vigorous portrayal of a cowboy
taming a wild horse is Remington's first sculpture. With an illustrator's eye for
drama, Remington captured the single most illuminating moment. Though the
horse and rider struggle against one another, they are pulled together at the
instant of utmost exertion. As the bronco rears up, back arched and splayed
tail snapping, the cowboy leans forward, whip suspended midair while he
clutches the reins and horse's mane. This minutely rendered, instantaneously
captured, and technically remarkable depiction of life in the wild Old West
became the most popular American bronze statuette of the early twentieth
century. The Art Institute's version is one of approximately seventy made at
the Henry-Bonnard Bronze Company of New York, using the French sand-
casting method.

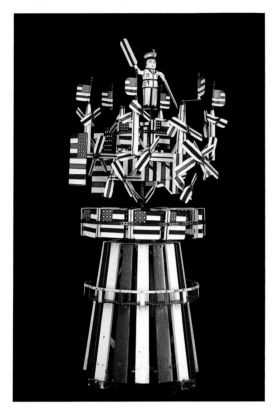

FRANK MEMKUS
(American, 1895–1965)

Whirligig entitled "America," 1938/42
Wood and metal; h. 80¾ in. (205.1 cm)
Restricted gift of Marshall Field, Mr. and Mrs. Robert A. Kubicek, James Raoul
Simmons, Esther Sparks, Mrs. Frank L. Sulzberger, and the Oak Park–River
Forest Associates of the Woman's Board, 1980.166

Since a whirligig's sole function is to amuse, *America* performs its role admirably. Standing over six-and-one-half feet tall (with paddle up), this red, white, and blue contraption features a battalion of patriotic images: a seaman, an airplane, and two dozen flags and propellers. While the seaman salutes, the plane's propeller whirls and the flags flutter round and round. First recorded in Europe in the fifteenth century, whirligigs appeared in the Colonies during Revolutionary times. Few of such early examples have survived. Those from the nineteenth century on range from simple wooden playthings with separate paddlelike arms that spin in the wind to large and elaborate creations, such as this one, that contain separate gears and windmill devices, and stood proudly on display atop roofs or in gardens and front lawns. Never a trade, always a diversion, whirligigs were developed entirely by amateurs. This example was made in Tomahawk, Wisconsin, by Frank Memkus, a Lithuanian immigrant who worked in a tannery. *America* is Memkus's only art object. Created to express his sense of patriotism—he started carving the elements for *America* in the years preceding World War II—it was brought out only for special occasions.

Architecture

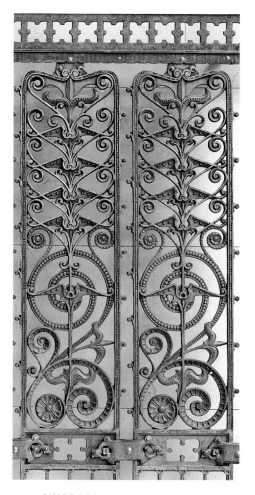

WILLIAM LE BARON JENNEY (American, 1832–1907) and
WILLIAM B. MUNDIE (Canadian, 1863–1939)
Elevator Grille, 1889/91 (detail)
Cast iron and copper-plated cast iron; 89 × 90¼ × 1⅝ in. (226 × 229 × 4 cm)
Gift of the Manhattan Associates, 1981.942–46

Known as the father of the Chicago School of architecture, William Le Baron
Jenney revolutionized building design by adapting metal-frame building
technology to the construction of tall elevator buildings. Jenney, with his
Canadian partner William B. Mundie, perfected the steel-skeleton construction
in the sixteen-story Manhattan Building, 431 South Dearborn Street, Chicago;
this stationary elevator-enclosure grille is from that landmark. Comprising five
cast-iron, copper-plated panels joined by copper buckles, the grille displays a
simple grid on its lower portion that is decorated by spiraling and stacked plant
forms above. Both sides of the grille are ornamented, since early cage elevator
grilles could be viewed from inside the cab as well as from the floor. The grille
was made by Winslow Brothers Company of Chicago, which cast architectural
decorations for most of Chicago's great buildings of the period, including Adler
and Sullivan's Stock Exchange (see pp. 50–51).

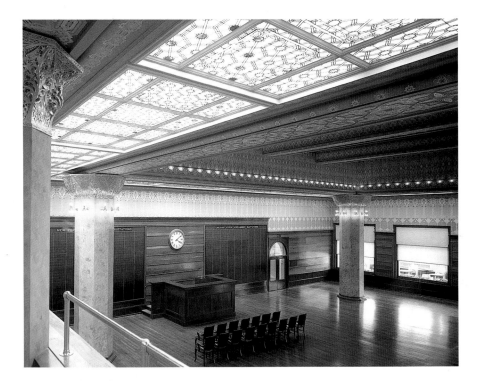

DANKMAR ADLER (American, 1844–1900) and
LOUIS H. SULLIVAN (American, 1856–1924)
The Trading Room of the Chicago Stock Exchange, 1893–94

Among the distinctive and revolutionary buildings created during the twelve-year partnership (1883–95) of German-born Dankmar Adler and Boston-bred Louis H. Sullivan was the thirteen-story, metal-framed Chicago Stock Exchange building. Sullivan's famous dictum "form follows function" was illustrated in the building's facade, whose two-story arcade echoed the magnificent centerpiece: the two-story Trading Room. Located on the second and third floors, the room's opulent, organic ornamentation and verdant color scheme created the impression of a pastoral respite in the heart of the city. Natural light poured through art-glass skylights to enhance the painted stencils, composed of fifty-seven different colors in fifteen related patterns. Despite the singular beauty of this room, it served its original function for just fourteen years and was occupied only sporadically thereafter until the entire building, declared "economically unviable," was demolished in 1971–72, sparking a bitter preservation battle that launched the landmarks-preservation movement in Chicago. Fortunately, sections of Sullivan's elaborate stencils, molded pilaster capitals, and art glass were preserved. From these fragments, the Art Institute undertook reconstruction of this significant room. The re-creation was unveiled in the museum's new East Wing in 1977, at the same time that the two-story entry arch of the Stock Exchange was reerected in an adjacent garden.

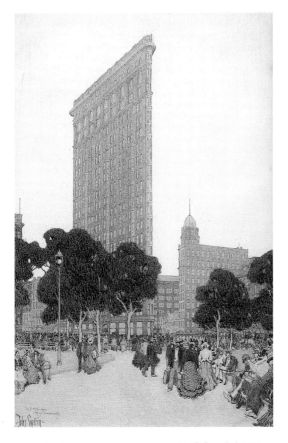

D. H. BURNHAM AND COMPANY

Perspective Rendering of the Flatiron Building, New York, 1902
Delineated by Jules Guerin (American, 1866–1946)
Charcoal and ink wash on underpainted linen; 40 × 30 in. (101.6 × 76.2 cm)
Restricted gift of the Thomas J. and Mary E. Eyerman Foundation, 1983.798

The distinctive triangular Flatiron Building, whose twenty-three stories were among the earliest to be supported by a complete steel cage, was New York City's first lyrical example of the skyscraper. Designed by the firm directed by Daniel H. Burnham, one of the great architectural figures responsible for creating much of Chicago's historic cityscape (see p.53), the building narrows at its north end to a width of only six feet. This dramatic, soaring shape resulted from the unusual V-shaped site, formed by the intersection of Broadway and Fifth Avenue at Twenty-third Street. The building's common name derives from its form, although it was officially called the Fuller Building, after its builder, also a Chicagoan, George B. Fuller. For a brief time, the Flatiron was New York's tallest structure. This striking perspective rendering is by Jules Guerin, one of the most renowned professional renderers of the period.

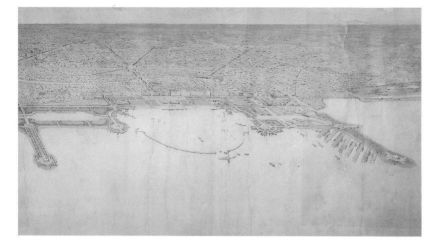

DANIEL H. BURNHAM (American, 1846–1912), and
EDWARD H. BENNETT (American, 1874–1954)
View of Chicago from Jackson Park to Grant Park, 1907, plate 49 from
the *Plan of Chicago,* 1909 (detail)
Rendered by Jules Guerin (American, 1866–1946)
Watercolor and pencil on paper; 41 × 187 7/8 in. (104 × 477 cm)
On permanent loan from the City of Chicago, RX 17016.2

"Make no little plans," Daniel H. Burnham reputedly exclaimed around the
time he made public the pièce de résistance of his career: the *Plan of Chicago,*
the first comprehensive metropolitan plan in the United States. Providing the
vocabulary for Chicago architecture through the 1920s, the plan was the legacy
of Burnham, whose renown in large-scale city planning began when he was
chief of construction for Chicago's 1893 World's Columbian Exposition. Com-
missioned by the Commercial Club of Chicago, the plan was developed with
the assistance of architect and planner Edward H. Bennett, who elaborated
parts of the plan after Burnham's death in 1912 and was responsible for exe-
cuting many of its recommendations. Emulating the grand classical design of
European cities, Chicago was to become "a Paris by the Lake." Features in-
cluded the development of Chicago's lakefront and Lake Shore Drive, the
construction of Grant Park, and the transformation of Michigan Avenue into
a premier commercial boulevard following the completion of the Michigan
Avenue bridge. Eleven of the seventeen perspective views were rendered by
Burnham's frequent collaborator, the Beaux-Arts-trained Jules Guerin (see
p. 52). Guerin's stunning, impressionistic views, with their unusual perspec-
tives and dramatic use of color, bring the Chicago Plan to life, imbuing it, as
Burnham stated about his own aims, with the "magic to stir men's blood."

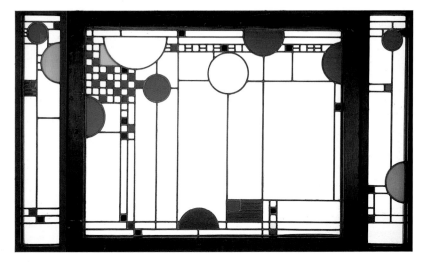

FRANK LLOYD WRIGHT
(American, 1867–1959)

*Triptych Window from a Niche in the Avery Coonley Playhouse,
Riverside, Ill.*, 1912
Leaded glass, oak frame; center panel: 35 × 43 in. (88.9 × 109.2 cm), side panels:
each 36 × 7¾ in. (91.4 × 19.7 cm)
Restricted gift of Dr. and Mrs. Edwin J. DeCosta and the Walter E. Heller
Foundation, 1986.88

This colorful and whimsical triptych window by America's most famous archi-
tect is from the Avery Coonley Playhouse, a small structure that was to serve
as a schoolhouse and playroom for the daughter of Wright's clients. The play-
house was an addition to the suburban estate outside Chicago, where the
architect had earlier completed the Avery Coonley House, one of his major
commissions, in 1908. Louis Sullivan's foremost student (Wright was chief
draftsman for Adler and Sullivan from 1888 to 1893), Wright continued his
teacher's search for an indigenous American architecture; like Sullivan he
drew inspiration from nature and natural forms. The result was the Prairie
style, the low-slung, horizontal lines and rambling, open spaces of which were
a unique response to — and meant as reflections of — the gently rolling land-
scape of the Midwest. Odes to the middle-class American family at the turn of
the century, Wright's residential structures were organic, designed not only to
adapt to a family's changing structure, but to contain the sense of a unified and
harmonious whole. Every detail of the Coonley complex, like all of Wright's
projects, bore his personal imprint, down to the creation and placement of the
furniture and the design of this window. Incorporating into it such Americana
as the flag and colored balloons, Wright explored the use of glass both as a
transparent screen uniting outside and inside and as a decorative element, the
colors and design of which anticipate the later abstractions of Piet Mondrian
(see p. 255).

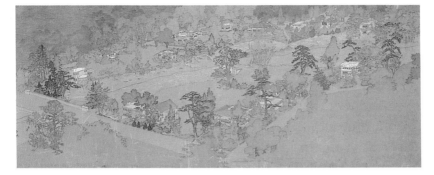

MARION MAHONY GRIFFIN (American, 1871–1962) and
WALTER BURLEY GRIFFIN (American, 1876–1937)
Perspective Rendering of Rock Crest-Rock Glen, Mason City, Iowa, 1912
Lithograph and gouache on green satin; 23¼ × 79⅛ in. (59 × 201 cm)
Gift of Marion Mahony Griffin, 1988.182

Associates of Frank Lloyd Wright's studio in Oak Park, the Griffins were ex-
ceptional figures in the Prairie School, for not only did they design individual
buildings, but also planned housing developments, universities, and entire
cities. In their partnership, formed in 1911 at the time of their marriage, Walter
Burley Griffin was chief designer; Marion Mahony, one of the nation's first
women to distinguish herself in architecture, contributed to design and, more
importantly, produced the spectacular renderings for which the firm was noted.
In this exquisite rendering on silk, Mahony delineated the Griffins' major do-
mestic work and the most important planning scheme of the Prairie School, the
Iowa housing development Rock Crest-Rock Glen, begun in 1912. The vaguely
oriental intertwining of single-family dwellings within the eighteen-acre site in
Mahony's rendering is a perfect encapsulation of the Prairie School's emphasis
on the harmonious integration of suburban domesticity and a tamed, almost
pastoral, nature. Of the sixteen proposed houses, eight were built, with the
Griffins responsible for four of them. Just as construction began, the couple
won the international competition to plan Canberra, the new capital of Austra-
lia; they moved to Australia in 1913, exporting with them the Prairie style and
the new art of city planning.

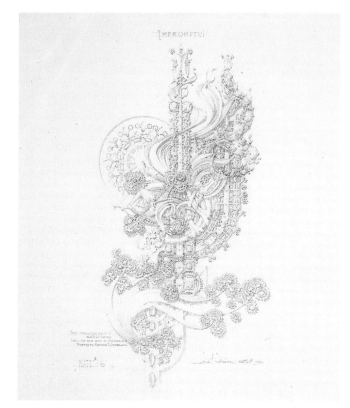

LOUIS H. SULLIVAN
(American, 1856–1924)

Impromptu, 1922, plate 16 for *A System of Architectural Ornament*, 1924
Pencil on paper; 22¾ × 29 in. (57.7 × 73.5 cm)
Commissioned by The Art Institute of Chicago, 1988.15.16

In 1922, the Art Institute's recently opened Burnham Library of Architecture
commissioned the aging and impoverished Louis H. Sullivan to make drawings
illustrating his renowned theories of architectural ornament (see pp. 50–51).
This masterpiece was published as *A System of Architectural Ornament, According
with a Philosophy of Man's Powers* by the American Institute of Architects in 1924
and was Sullivan's final statement about the geometry underlying both nat-
ural and man-made forms. In his search for an original American architecture,
Sullivan drew his inspiration from nature, not unlike the nineteenth-century
American poets and writers whom he emulated. Like them, he intended his or-
nament to function evocatively as well as to represent organic growth, evolving
from closed geometric units to open, efflorescent forms. In *Impromptu*, the six-
teenth of the twenty delicate drawings in his treatise, Sullivan produced one of
his most open, vibrant, and fluent compositions. Giving free rein to expansive
whiplash appendages and spiral stalks, the architect combined nature's infinite
creative variation and incessant change with an intense emotional expression-
ism. To convey these poetic nuances, Sullivan's correlating notation describes
the design as entering "the domain of Virtuosity, Romance and Symbolism."

COMPETITION
FOR
THE NEW TRIBUNE BUILDING

RICHARD YOSHIJIRO MINE
(American, b. Japan, 1894–1981)

Competitive Entry for the Chicago Tribune Tower Competition, Michigan Avenue Elevation, 1922
Ink and wash on paper; 55¼ × 23½ in. (140.3 × 59.7 cm)
Gift of Richard Yoshijiro Mine, 1988.408.5

Richard Yoshijiro Mine was one of a number of emigrants who came to Chicago between World War I and the Great Depression of the 1930s, hoping to practice in a city so celebrated for its architecture. After graduating from the University of Illinois, Champaign-Urbana, where he received his master's degree in architecture and distinguished himself with his beautifully rendered student drawings, Mine decided to see how he would fare in an international contest. The Chicago Tribune Tower Competition of 1922 was a seminal event in the history of architecture. Seeking "to secure for Chicago the most beautiful office building in the world," the competition provided an international forum for prevailing attitudes about the tall office building at a critical juncture in its history. Like the winner (Howells and Hood, New York), Mine designed his entry in a popular contemporary Gothic style with detailing and strong vertical shafts that emphasize the vertical form of the building. Mine's proposal received one of the fifty honorable mentions. All 263 perspective drawing entries were later published, and 135 were selected for an extensive traveling exhibition. Mine, prohibited from registering as an independent architect by immigration laws, produced significant design work for two major corporations, General Motors and Kraft Foods, as well as for leading Chicago architectural firms.

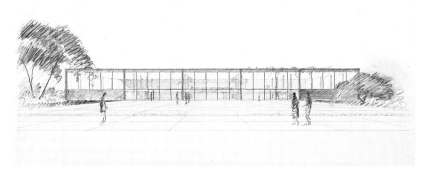

LUDWIG MIES VAN DER ROHE
(American, b. Germany, 1886–1969)
Preliminary Drawing for the Architecture Building,
Illinois Institute of Technology, Chicago, 1955
Pencil and charcoal on tracing paper; 29⅞ × 39½ in. (75.7 × 100.2 cm)
Restricted gift of the Auxiliary Board of The Art Institute of Chicago, 1987.46

One of the most influential architects of the twentieth century, Mies van der
Rohe left Nazi Germany in 1938 to continue his already distinguished career as
an architect and educator in the United States. Former director of the famous
Bauhaus school of architecture and design, Mies came to Chicago to direct the
architecture school of the Armour Institute of Technology (later the Illinois
Institute of Technology). Despite his minimal knowledge of the English lan-
guage, he succeeded in revolutionizing the vocabulary of modern, urban
architecture in his adopted country. Not only did Mies reform the Institute's
architectural curriculum (students first learned about structural building
components, not historical styles), but he was also given the opportunity to
create the master plan for the new campus. This drawing reveals the purity of
design that was to make Mies's style so influential. The architecture building
reflects Mies's basic rectangular organization of space and his philosophy of
revealing the structural components of buildings. Here he established a wide
grid with I-section columns and wrapped it in glass plate and brick. Although
the buildings of the I.I.T. campus are of differing heights and relate asymmet-
rically to one another to define the space, they are arranged symmetrically
around a central axis, and are unified by the painted-steel skeletal structure
and large glass walls they share. In all, twenty-two buildings were constructed
from Mies's designs.

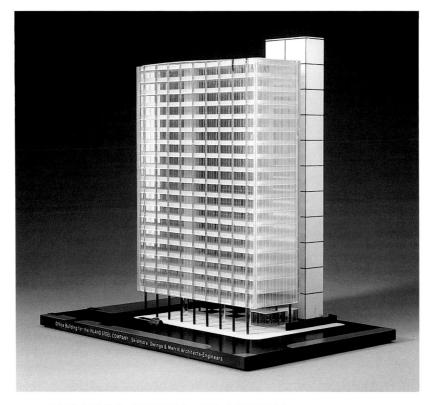

SKIDMORE, OWINGS AND MERRILL

First Model for the Inland Steel Building, 30 West Monroe Street, Chicago,
c. 1954
Preliminary design by Walter A. Netsch (American, b. 1920) for building
designed by Bruce A. Graham (American, b. 1925)
Plexiglas and enameled steel; approx. 28 × 27 × 18 in.
(71.1 × 68.6 × 45.7 cm)
Gift of Walter A. Netsch, 1991.27

Examples of the Miesian tradition (see p. 58) proliferated in the years following
World War II with metal-and-glass towers created by the architectural firm of
Skidmore, Owings and Merrill, founded in Chicago in 1936. The firm's first
major postwar structure in the Chicago Loop was the Inland Steel Building,
completed in 1958, which, with its sleek materials and precise joints, is also one
of the firm's most elegant. The undeviating lines and cantilevers of the final
structure, designed by Chicago architect Bruce A. Graham, form a seamless
whole that seems to defy gravity. The supporting columns placed outside the
curtain wall of the nineteen-story glass prism provide a strong sense of vertical-
ity as well as a column-free interior which, in turn, allows maximum flexibility
in the arrangement of space on each floor. A novel feature of the plan that
contributed further to the interior's freedom of space was the isolation of the
elevators, stairs, and service utilities in a separate vertical core to the east. The
buildings of Skidmore, Owings and Merrill, with their classical proportions,
often mirrorlike exteriors, and formal restraint, had significant impact upon the
course of postwar urban architecture.

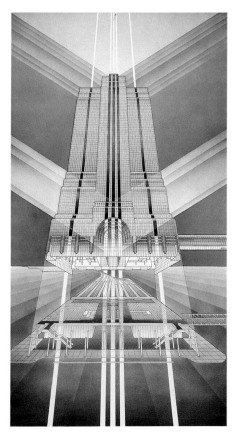

HELMUT JAHN
(American, b. Germany, 1940)

Axonometric Rendering of Northwestern Atrium Center, Madison and Canal Streets, Chicago, 1982
Murphy/Jahn, architects; rendered by Helmut Jahn and Michel Budilovsky
Airbrushed ink on resin-coated paper; 72 × 40 in. (182.9 × 101.6 cm)
Anonymous gift, 1982.629

German-born Helmut Jahn came to the United States in 1966 to study at the Illinois Institute of Technology, where a philosophy of design based on that of Mies van der Rohe still reigned. But the distinctive style Jahn developed incorporates an inventive, even playful, use of color, materials, light, and structural form. As a designer and then as director of design and planning for C. F. Murphy Associates, and, finally, since 1982, as president and chief executive officer of Murphy/Jahn, the architect demonstrates in his work a sensitivity to historical references, symbolism, and building context, as well as to both the rational and the intuitive aspects of design. This rendering depicts the fluid setbacks of his Northwestern Atrium Center, completed in 1987, which rises above a grand entrance arch that recalls the work of Adler and Sullivan (see pp. 50–51). The skyscraper's mass of cascading glass has suggested to some viewers an immense jukebox of the 1950s, while others have seen in it allusions to the streamlined locomotives of the 1920s and 1930s that pulled in and out of the train station that was demolished to make way for Jahn's skyscraper. This drawing for the project is an axonometric view, which shows both elevation and plan of the highrise and new train station, with tracks zooming off into the distance. Typical of Jahn's presentation renderings, the drawing is large in scale, dramatic in composition, and delicately airbrushed with transparent layers of color.

Asian Art

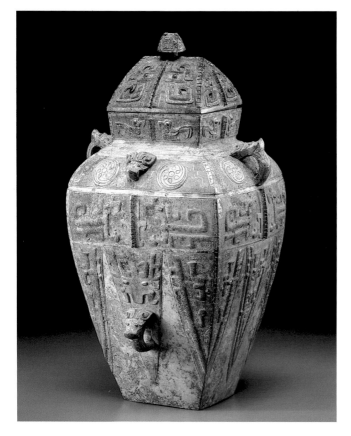

WINE VESSEL *(FANGLEI)*

Chinese, Shang dynasty, 12th/11th cen. B.C.
Bronze; h. 17¾ in. (45.1 cm)
Lucy Maud Buckingham Collection, 1938.17

Not until the excavations at Anyang in northern China, beginning in 1928, was the existence confirmed of the Shang dynasty (c. 1700–c. 1050 B.C.), during which the most highly developed bronze technique of pre-industrial times was developed. Bronze ritual vessels, such as this square-shouldered storage jar, or *fanglei*, are the supreme aesthetic achievement of this culture. Produced with an elaborate ceramic piece-mold casting technique, the vessel was filled with wine during ceremonies of ancestor worship. Such rituals were the exclusive domain of the Shang elite, and the bronzes used in them signified the exalted status of their owners. The vessel was placed in the sumptuous tomb of its deceased owner, or interred later with a descendant.

A menagerie of enigmatic animal motifs, cast in high and low relief, enlivens the jar's surface. The abstracted form of a horned monster mask, or *taotie*, appears on the rooflike lid and within the triangular wedges on the vessel's body. Each triangle also contains a cicada, a traditional symbol of regeneration. (Another image of a cicada is cast inside the vessel's lid.) Birds and dragons encircle the neck, and fully sculpted bovine heads crown the handles. The beautiful patina of blues, greens, and reds on the vessel's surface is the result of centuries of burial in the moist earth.

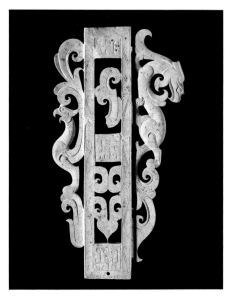

abrasive paste applied with saws, grinders, and drills. The sheath's intricate central oblong was drilled lengthwise to hold a single-edged dagger blade, now lost, thereby creating two superimposed layers of ornament. Flanking this central section are fantastic undulating beasts: a heraldic, long-plumed bird and a lithe, catlike dragon, each anchored by identical legs and claws. These spirited supernatural animals were virtual insignias of the Han ruling house. The fragile delicacy of this piece suggests that it was created purely for decorative purposes, perhaps as a desk implement or a ritual weapon, or as an aristocratic burial gift whose sumptuous-ness demonstrated the owner's social standing.

SHEATH WITH BIRD AND FELINE OR DRAGON

Chinese, Warring States period/Western Han dynasty, 3rd/2nd cen. B.C.
Jade (nephrite); 4⅛ × 2¼ × ⅛ in.
(10.6 × 5.7 × 0.5 cm)
Through prior gifts of Mrs. Chauncey B. Borland, Lucy Maud Buckingham Collection, Emily Crane Chadbourne, Mary Hooker Dole, Edith B. Farnsworth, Mary A. B. MacKenzie, Mr. and Mrs. Chauncey B. McCormick, Fowler McCormick, Mrs. Gordon Palmer, Grace Brown Palmer, Chester D. Tripp, Russell Tyson, H. R. Warner, Joseph Winterbotham, and Mr. and Mrs. Edward Ziff, 1987.141

FUNERARY URN (HUNPING)

Chinese, Western Jin dynasty, late 3rd cen.
Stoneware with olive-green glaze and molded and applied decoration;
h. 19⅛ in. (48.7 cm)
Through prior bequests of Mary Hooker Dole, Grace Brown Palmer; through prior gifts of Josephine P. Albright in memory of Alice Higinbotham Patterson and Mrs. Kent S. Clow; Russell Tyson, Robert C. Ross endowments, 1987.242

The delicate silhouettes, rounded surfaces, and finely incised detail of this elegant openwork jade sheath belie the intracta-bility of a stone considered to be the rarest, most luxurious, and most highly esteemed artistic medium in ancient China. This sheath was created at the dawn of China's imperial era — a period renowned for the technical virtuosity and aesthetic refine-ment of its jadework. Almost painterly in their execution, the fluid contours and subtle surface modeling of the sheath were achieved by a slow, laborious wearing away of its hard, fine-grained surface by

Produced during the brief period of national unity known as the Western Jin dynasty (265–316), this complex funerary urn embodies a mixture of traditions and beliefs. The translucence and uneven streaks of the surface show a formative stage in the development of celadon glaze. Gateways and towers, guards with lances, and monster masks with rings derive from the funerary art of the Western Han dynasty (206 B.C.–A.D. 9). On an upper balcony, birds perch on pots that collect dew from heaven. Below, a tortoise carries a tall funerary tablet, or stele, on its back.

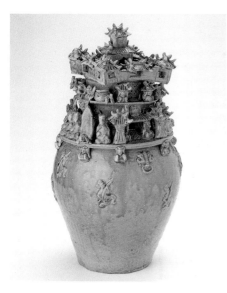

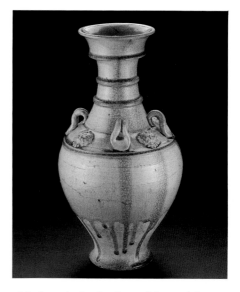

Tucked on this lowest rim of the pavilion, however, is a series of small but unmistakable images of the Buddha. Displaying his distinctive topknot, or *ushnisha,* which signifies enlightenment, he sits cross-legged with his hands folded in a characteristic posture of meditation. These marginal Buddhas thus mark an early stage of the integration of the Indian religion into Chinese culture. This vessel is of a type known as *hunping,* or "urn of the soul," a symbolic resting place for the spirit of the deceased.

VASE *(HU)*

Chinese, Sui dynasty (581–618)
Gray stoneware with pale green glaze
and molded and applied decoration;
h. 16⅜ in. (41.6 cm)
Gift of Russell Tyson, 1951.299

Called a *hu,* this type of vase first appeared after the middle of the sixth century. It is characterized by an ovoid body; slender, flaring neck; cupped mouth; and four loop handles. Decorated with restraint, its upper half displays horizontal bands and lion's-head medallions applied in relief. The reverse curves of its tall form, coupled with the echoing horizontal lines of the mouth and raised ridges, impart both grace and strength to the piece. By the time this vase was created — during the short-lived Sui dynasty — potters had developed a celadon glaze that was nearly uniform in color and texture. As seen here, this thick, opaque covering enhances the vase's harmonious proportions and subdued decoration. Filled with a network of crazing (the fine cracks formed by shrinkage upon cooling), the olive glaze drips down the swelling body, pooling around the raised ridges and base to a glassy powder blue. Such inadvertent effects came to be deliberately induced for their decorative appeal.

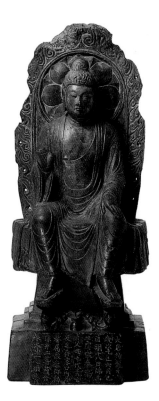

MI-LE BUDDHA

Chinese, Tang dynasty, 705
Limestone; h. 32½ in. (82.6 cm)
Gift of Alice Getty, 1924.115

Reflecting the Chinese ideal of the impe-
rial Buddha, this small, seated stone image
portrays Mi-le (known as Maitreya in
Sanskrit), the Buddha of the Future,

who waits in cosmic heaven until the
appointed hour when he will descend to
earth to inaugurate a new age. With his
right hand signifying "fear not," he sits as
if about to step from his throne into this
world. His feet rest on lotus flowers, and
lotus petals adorn the inner halo, which is
bordered by the flames of Mi-le's radiance.
The *ushnisha*, the mound on top of his
head, indicates enlightenment. The
inscription on the base states that this
sculpture was dedicated in 705 "for the
sake of deceased parents and seven gen-
erations of ancestors" and for living
relatives. The figure was accompa-
nied by the statues (now lost) of two
bodhisattvas, compassionate beings who
have attained enlightenment but who
have postponed entry to the eternal re-
lease of Nirvana to help others. Introduced
to China from India via Central Asia dur-
ing the first century, Buddhism and its
teachings of compassionate action and
contemplative insight were predominant
during the first half of the Tang dynasty, a
period of expansion and unequaled mag-
nificence. Buddhist art of the Tang dynasty
(618–907) developed into an influential
international style characterized, as seen
here, by a sophisticated voluptuousness, a
more naturalistic sense of observation,
and a sinuous, expressive line.

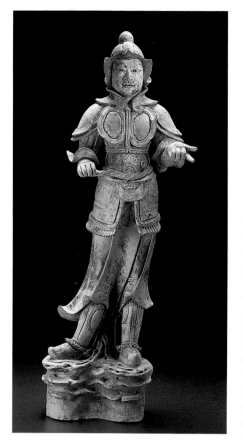

ARMORED GUARDIAN
(TOMB FIGURE)

Chinese, Tang dynasty,
first half of 8th cen.
Buff earthenware with polychromy
and gilding; h. 38 in. (96.5 cm)
Gift of Russell Tyson, 1943.1139

Tang funerary art reached its apogee during the late seventh and early eighth centuries, when this armored guardian was made. The enormous repertoire of subjects — warriors and guardians; officials, grooms, and court ladies; camels and horses — indicates the rich legacy of ceramics produced as burial gifts. This freestanding figure atop a rocky plinth seems totally at ease, every movement balanced by another. Probably stationed close to the burial chamber to ward off evil, the impassive guardian clenches his right fist to hold a weapon, now lost. His uniform is sophisticated and elaborate: multilayered parade armor includes a helmet with upturned earflaps; scalloped breast- and backplates secured by knotted ropes; flared elbow cuffs over long, tight sleeves; and protective leggings under a sweeping skirt. His feet are shod in upturned "cloud-toe" shoes. All of these elements were meticulously modeled in clay, fired, and then embellished with colors and gold pigment. Traces of the graceful painted patterns of curled tendrils and scalloped floral scrolls remain.

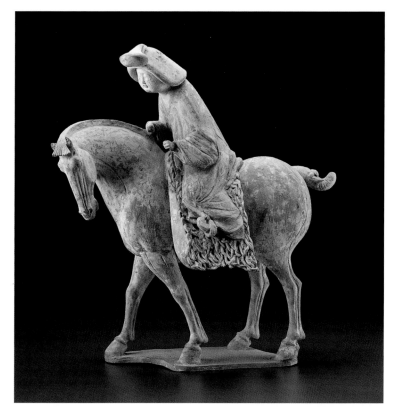

EQUESTRIENNE
Chinese, Tang dynasty, 725/50
Earthenware with traces of polychromy; 22⅛ × 18¹⁵⁄₁₆ in. (56.2 × 48.2 cm)
Mr. and Mrs. Potter Palmer Collection, 1970.1073

Chinese ceramic figures made exclusively for burial vividly evoke the fashions
as well as recreational activities of their aristocratic owners. This figure sensi-
tively captures a quiet moment in the life of a matronly equestrienne, who
gently guides her turning horse. The animal's powerful neck and flanks, long
legs, trimmed mane, and decoratively tied tail illustrate a handsome breed that
was imported from Central Asian borderlands and well groomed in government
stables. Carefully twisted strands of clay realistically depict the furlike texture of
the animal's saddle blanket. The woman's full proportions — evident in the folds
of her flowing, wide-sleeved robe, as well as in her plump cheeks and double
chin — are enhanced by her loosely gathered hairstyle with a dangling forehead
bun. Her weight, costume, and hairstyle reflect ideals of feminine beauty in
the mid-eighth century, when privileged women were avid riders. Stylistically,
she closely resembles figures that archaeologists have recently unearthed
from high-status tombs of this period, the last great era of the Tang dynasty
imperial court.

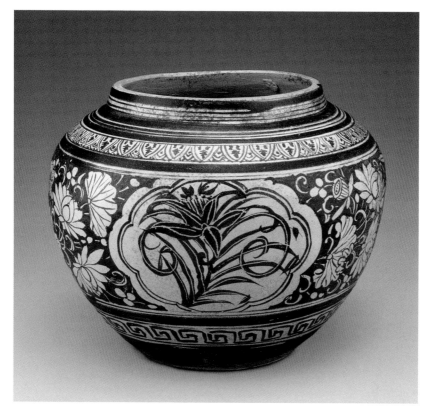

JAR

Chinese, probably Yonghezhen, Jiangxi province; Southern Song dynasty, early 13th cen.
Jizhou ware: buff stoneware painted with underglaze iron slip;
h. 9 in. (22.9 cm)
Restricted gift of the Rice Foundation, 1990.118a–b

The classic Chinese ceramics produced during the Song dynasty achieved a
unity of essentials — of shape, glaze, and decoration — that has rarely been
surpassed. The Song dynasty, founded in 960, was disrupted in 1127 by an
invasion of the northern Jin Tatars, and the remnants of the Song fled south,
regrouping near modern Shanghai as the Southern Song (1127–1279). Despite
the upheaval, the era witnessed a remarkable flourishing of culture. This
jar dates to the Southern Song dynasty, when the prolific and versatile Jizhou
kilns were most active. Here, one sees a perfect accommodation of surface
design to shape, so distinctive to ceramics of China during the high points of
the art. The globular contour of the vessel is encircled by a profusion of flowers:
three lobed reserves enclose single sprays of peony, lily, and plum, gracefully
painted and accented with incised detail; blossoms and leaves of lotus
and plum, unpainted against the iron-brown ground, enhance the jar's
spherical surface.

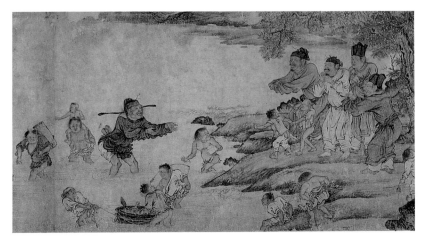

YANG PU MOVING HIS FAMILY (detail)

Chinese, Yuan dynasty, late 13th cen.
Handscroll: ink and light color on paper;
20¾ × 91 in. (52.7 × 231.1 cm)
Kate S. Buckingham Endowment, 1952.9

The hero in this narrative handscroll has been identified as Yang Pu, a cele-
brated "recluse" of the early Song dynasty (960–1127) whose tale was popular
in Song folklore. The Chinese "recluse" was a scholar who refused government
office. Having at last been persuaded to take his government post, Yang Pu has
donned an official hat and girdle to move his family to the capital. Poor and
rustic, with a large, unkempt brood, he is shown here about to ford a river en
route to Kaifeng, bidding farewell to his old neighbors and relatives. The "noble
parting" theme was familiar during the Song dynasty because officials were
transferred regularly, unlikely to ever return home again. However, this ani-
mated scene is hardly tempered with Confucian decorum. Yang is bare-legged
and disheveled; his expression and gestures, like those of his friends, are lively
and impassioned. Already in mid-stream, on the back of a water buffalo, his
wife nurses a baby, while a mischievous child yanks the beast's tail. A swarm of
servants follows, dragging children, belongings, and livestock. Whereas dogs
and poultry normally signify pastoral tranquility and ease in Chinese art and
literature, in this expressively rendered scene, one can almost hear the tumult.
The scroll was painted by an anonymous master during the Yuan dynasty
(1279–1368), the brief rule of China by Mongols from the north.

PAIR OF CUPS

Chinese, Qing dynasty, Yongzheng period (1723–35)
Porcelain with underglaze-blue, polychrome enamel, and iron-red floral design
(doucai); diam. 4 in. (10.2 cm)
Estate of Henry C. Schwab, 1941.701a–b

During the Yongzheng reign of the Qing dynasty (1644–1912), Chinese ceramic craftsmen achieved a peak of technical proficiency that, coupled with a reserved aesthetic sensibility, produced porcelains of extraordinary delicacy and refinement, such as this small, cheerfully decorated pair of cups. The subtle gradation of tone and the airy elegance of the cups' rare brocade design (probably inspired by earlier Japanese textile designs) was made possible by the last great innovation in Chinese ceramics: the use of polychrome enamel on porcelain. The introduction of white to the enameler's palette allowed craftsmen to use these colors much like artists working in European oil paints, with shading from light to dark. Bearing the Yongzheng imperial reign mark, the cups are executed in an exceptionally exacting technique first attempted in the fifteenth century called *doucai,* meaning dovetailing or contending colors. Circular medallions were first outlined in cobalt blue. Following glazing and firing, the medallions were painted in with shades of yellows, reds, blues, and greens, and the cups were refired at a lower temperature. Underglaze-blue outlines enhance form and contour, yet here they are almost overwhelmed by the extraordinary clarity of these vividly colored abstract shapes floating freely on the pure, stark white ground.

VASE *(MAEBYŎNG)*

Korean, Koryŏ dynasty, 12th cen.
Stoneware with celadon glaze and inlaid decoration; h. 13⅛ in. (33.5 cm)
Gift of Russell Tyson, 1950.1626

The Koryŏ dynasty (918–1392) was a golden age for Korean ceramic making, and outstanding among the era's wares are the understatedly elegant celadons. Celadon is an iron-based glaze capable of an almost infinite range of colors depending on the amount of oxygen in the kiln. Although potters initially drew on Chinese models for both vessel shapes and celadon technique, this *maebyŏng* ("plum vase") — with its shallow cuplike lid, swollen shoulders, and constricted waist — is thoroughly Koreanized. The cool beauty of the vase's greenish blue glaze had reached such perfection that even the Chinese admired it as surpassing their own. A unique Korean contribution to ceramic development is the inlay of the vase's delicately rendered designs. In this precise and time-consuming process, designs carved or incised on the body of the vessel were filled in with black or white clays prior to glazing and firing. Here, the appealing and often playful designs are auspicious Korean symbols: the motif of cranes flying through drifting clouds, which separates the three double-trefoil frames, symbolizes longevity. The plump children, who chase a butterfly, signify happiness, prosperity, and abundant progeny, while the tiny duck is associated with marital fidelity.

FLASK

Korean, Chosŏn dynasty, 15th cen.
Punch'ŏng ware: stoneware with carved slip decoration; 8¾ × 7⅞ × 5⅛ in.
(22.3 × 20.2 × 13.1 cm)
Bequest of Russell Tyson, 1964.936

A robust spontaneity characterizes the ceramics made during the early Chosŏn dynasty (1392–1910), in contrast to the refinement of celadon wares of the Koryŏ dynasty (see p. 72). An example of punch'ŏng ware, this stoneware flask is decorated on one side with a school of fish swimming merrily in one direction and a lone renegade heading in the other. A flowering lotus adorns the opposite side. These bold designs are created by carving through the white slip (a mixture of clay and water) covering the flask's surface to reveal the darker clay body. Although punch'ŏng enjoyed an exalted patronage, many of the wares that have survived Korea's turbulent history were made by simple potters for their peers, which explains the almost folk-art quality of the flask shown here. Its earthy shape and simplified design underscore its utilitarian purpose, primarily to contain liquor. Such wares appealed not only to the Confucian elite of the Chosŏn, whose needs were modest, but also to the Japanese, who were so attracted to their casual assurance that they abducted and resettled Korean potters in 1592, and again in 1597, to bolster their own ceramic industry.

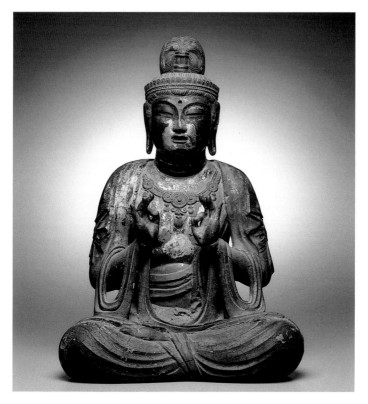

SEATED BODHISATTVA
Japanese, Nara period, c. 775
Wood core, dry lacquer, traces of gold leaf;
h. 24 in. (61 cm)
Kate S. Buckingham Endowment, 1962.356

This rare and important sculpture represents a Buddhist bodhisattva, or bosatsu, an enlightened and compassionate being who postponed Buddhahood in order to help save others. Calm, stately, and full-bodied, the bosatsu is seated in a frontal, meditative pose; his gracefully held hands, raised midair, make a gesture of assurance. Buddhism, which originated in India with the teachings of the Buddha Sakyamuni, or Siddhartha Gautama (c. 563–c. 483 B.C.), was named the official religion of Japan in the beginning of the eighth century by the Emperor Shōmu (701–756), who established Nara as the capital city. This small, finely crafted lacquer figure is the only Buddhist sculpture outside Japan that is firmly attributed to the influential sculpture workshop of Tōdai-ji, the largest and most prestigious of the great state-sponsored Buddhist temples built during the Nara period (710–784). This sculpture represents a dramatic shift in Japanese sculptural tradition, away from the expensive, time-consuming technique of clay and hollow lacquer (a resin extracted from the sap of a tree) to a sculpted wood core overlaid with lacquer-soaked cloth. The innovative sculptors at the Nara temple modeled the wet and pliable surface for fine details such as facial features and jewelry. Gilding was the final step; traces remain on the face and chest.

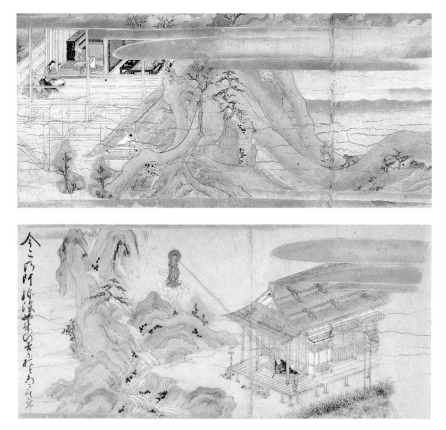

LEGENDS OF THE YŪZŪ NEMBUTSU (two details)

Japanese, Kamakura period, mid-14th cen.
Handscroll: ink, color, and gold on paper;
12 × 463⅜ in. (30.5 × 1176.9 cm)
Kate S. Buckingham Endowment, 1956.1256

One of the most important and beautiful records of the rise of a Buddhist salvation theology called Amidism is this rare narrative handscroll. It recounts details from the life of Ryōnin (1073–1132), a charismatic Tendai monk who founded the *yūzū* sect. The Buddhist concept of *yūzū* refers to the interrelationship or initial oneness of all things. The dynamically new approach to salvation Ryōnin developed from *yūzū* reasoned that if all things are interrelated, then the meritorious action of one individual benefits many. Followers were to register their names in a tally book, pledging to recite the brief *nembutsu* prayer, an invocation of the Amida Buddha, at specific times during the day. Contrasted with the dense and elite ritual of Buddhist teachings of the Heian period (794–1184), this simple, more populist approach had enormous appeal. Commissioned and executed in the mid-fourteenth century, during the revival of the *yūzū* sect, the lengthy horizontal scroll is unrolled from right to left and intended to be studied in successive sections approximately the width of the viewer's shoulders.

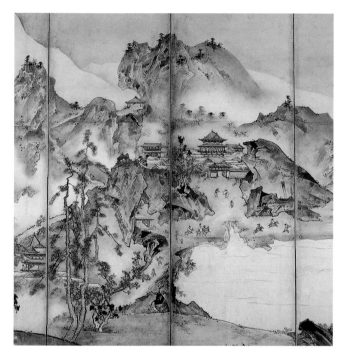

SESSON SHŪKEI
(Japanese, c. 1504–c. 1589)

Landscape of the Four Seasons, second half of 16th cen. (detail)
Pair of six-fold screens: ink and light color on paper; 61⅜ × 132⅝ in.
(156 × 337 cm)
Gift of the Joseph and Helen Regenstein Foundation, 1958.168

One of the most intense and personal visions of the sixteenth century was that
of Sesson Shūkei, an artist from eastern Japan who mastered the era's primary
mode of painting — the ink monochrome — without exposure to the ateliers of
the Muromachi-period capital at Kyōto. Political chaos and warfare during the
Muromachi (1333–1568) had scattered artists — many of whom, like Sesson,
were Zen monks — to the provinces, where they found shelter and patronage
under the increasingly powerful provincial warlords *(daimyō)*. Filled with
nervous energy, *Landscape of the Four Seasons* reflects both the troubled times
and Sesson's highly idiosyncratic vision. In this masterpiece of his middle or
later years, Sesson avoided the genre's more traditional, measured, and flowing
renderings. Although his vision of seasonal shifts from spring to winter can be
read from right to left on this pair of screens, Sesson seems to have focused
more on units of landscape that barely connect to a compositional structure.
Buddhist temples on each screen provide the sole anchors. Shorelines and
mountainous rock formations loom on the screens' surfaces, with only
minimal references to a receding perspective in the distance. Paths seem to
offer no escape, and many of the human figures who populate this unsettled
and foreboding landscape seem to be moving frenetically. Far from pleasant
decoration, these screens are superb examples of a masterful painting technique
applied to the uncompromising spiritual search of Zen.

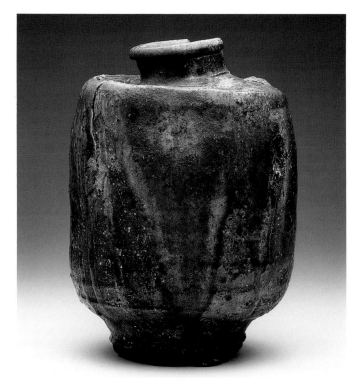

JAR

Japanese, Momoyama period, late 16th cen.
Iga ware: glazed stoneware; h. 13 in. (33 cm)
Through prior gifts of Josephine P. Albright in memory of Alice Higinbotham
Patterson, Tiffany Black, John Carlson, Mrs. Kent S. Clow, Edith Farnsworth,
Alfred E. Hamill, and Mrs. Charles S. Potter and Mrs. Hunnewell in memory of
Mrs. Freeman Hinckley, 1987.146

The tea ceremony, or *cha-no-yu,* "is nothing more than boiling water, making
tea, and drinking it," claimed Sen-no-Rikyu (1521–1591). One of the great tea
masters, he helped shape what was in fact a complex and elaborate ritual that
influenced the aesthetic life of nobility, warriors, and wealthy merchants for
some centuries. The drinking of powdered green tea, which was prepared by
whipping with a bamboo whisk, was originally an aspect of Zen meditation. By
the latter part of the fifteenth century, this simple act had begun to evolve into
a series of nuanced interactions between the host and a small number of guests
in an intimate setting. The ritual involved the judicious selection of often
surprisingly humble wares, such as this rustic and unpretentious stoneware jar.
Its size suggests that the jar, which was produced at the Iga kilns, east of Kyoto,
was probably used as a water container during the ceremony. The collapsed
shoulder was caused either by a mishap in firing or by multiple firings intended
to induce distortion or crackling. The jar's mottled natural glaze was the result
of exposure to flame, smoke, and ash from the pinewood fuel used in the kiln.
In marked contrast to the technical perfection of imported Chinese ware, such
irregularities or imperfections — products of chance — were thought to offer the
tea drinker insight into the nature of reality.

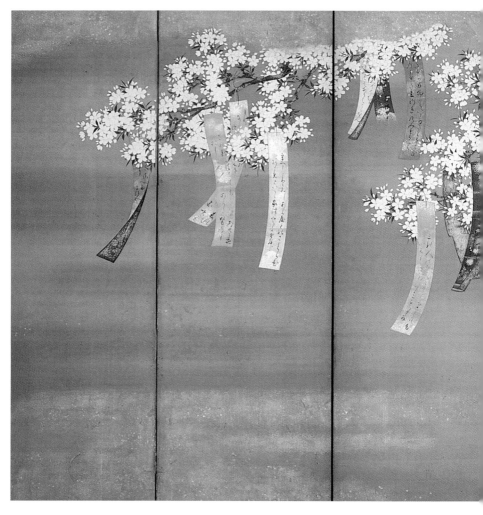

TOSA MITSUOKI
(Japanese, 1617–1691)

Flowering Cherry with Poem Slips, c. 1675
Six-fold screen: ink, color, gold leaf, and powder on silk;
56⅛ × 115⅜ in. (142.5 × 293.2 cm)
Kate S. Buckingham Collection, 1977.156

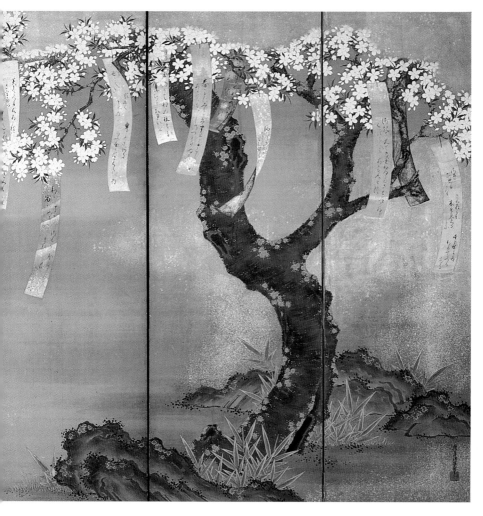

Japanese aristocrats engaged in the elegant custom of recollecting classical poetry while viewing spring and autumn foliage. This delicate screen is one of a pair by the premier court painter Tosa Mitsuoki, who meditates on the inevitable passage of beauty by depicting the melancholy hours after the departure of reveling courtiers. A cherry tree bursts into bloom on this screen; its mate displays the brilliant red and gold foliage of a maple in autumn. Slips of poetry called *tanzaku* waft from the blossoming limbs, the remaining evidence of human presence. Courtiers assisted Mitsuoki (their names are recorded in a seventeenth-century document) by inscribing the narrow strips with legible quotations of appropriate seasonal poetry from twelfth- and thirteenth-century anthologies. The screens were either commissioned by or given to Tofuku-monin (1607–1678), a daughter of the Tokugawa shogun who married the emperor Gomizuno-o (1596–1680). In an era otherwise marked by increasing control of the feudal shogunate over imperial prerogatives, this royal couple encouraged a renaissance of courtly taste that nostalgically evoked the past glories of early-medieval aristocratic life.

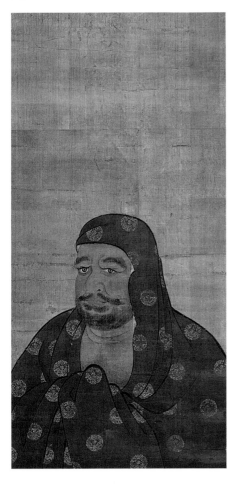

DARUMA

Japanese, Muromachi period, 16th cen.
Hanging scroll: ink and colors on silk;
43 × 21¼ in. (109.2 × 54 cm)
Russell Tyson, Samuel M. Nickerson
endowments, 1992.98

The sixth-century founder of the Zen sect of Buddhism, Bodidharma (called Daruma in Japan; trad. c. 470–c. 573) was the twenty-eighth patriarch in the Indian Buddhist lineage. In pursuit of enlightenment, the Indian prince traveled to the Shaolin monastery in southern China, where, according to legend, he remained seated in meditation before a cave wall for nine years. This rare, sixteenth-century icon is a bust portrait, one of several traditional poses used to depict the semilegendary figure in China as early as the eighth century. In all such imagined portraits, his stern Indian features were intended to convey the unflinching inward eye of Zen's single-minded search. The patriarch's penetrating gaze seems appropriately unrelenting, but the stolid fleshiness of his features suggests the hand of a professional artist experienced in secular portraiture. A red robe emblazoned with phoenix patterns in gold foil drapes around him dramatically, setting off his severity with opulence. This strikingly intense rendering seems to be based on a well-known painting of the thirteenth century, when Chinese Zen monks fleeing political chaos in their homeland emigrated to Japan in large numbers.

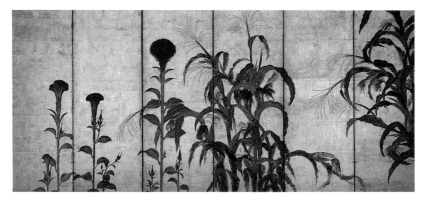

MAIZE AND COCKSCOMB
Japanese, Edo period, mid-17th cen.
Six-fold screen: colors and gold leaf on paper; 23⅜ × 66¾ in. (59.4 × 169.5 cm)
Kate S. Buckingham Endowment, 1959.599

During the Edo period (1603–1868), the prosperity and political unification of Japan under the ruling Tokugawa shoguns saw the emergence of a magnificent Japanese decorative style characterized by a love of bold patterns and bright colors, and patronized by the military class, a disenfranchised aristocracy, and a thriving class of merchants and entrepreneurs. The surviving half of an original pair, this splendid screen celebrating the harvest elegantly embodies both the techniques of ancient court painters and the curiosity and confidence so prevalent at this time. The design of autumnal plants arranged horizontally across the panels of the gold-leafed screen could well be imagined on the hem of a garment, reflecting the connections between painting and textile design during this period. Any suggestion of middle or far distance is dismissed, as the plant forms seem to press against the sumptuous, abstract background. Bursting with sensual fullness, they are rendered with the accuracy of botanical drawing, testimony to the era's interest in natural science. The appearance of maize, a grain not native to Japan, indicates a willingness to assimilate the new on the part of both Edo artists and patrons.

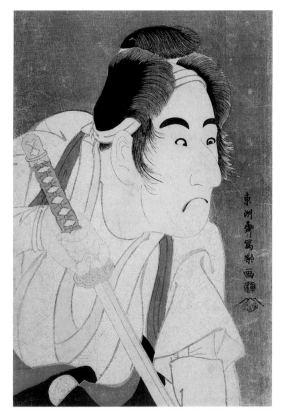

TŌSHŪSAI SHARAKU
(Japanese, active 1794–95)

The Actor Bandō Mitsugoro as Ishii Genzō, 1794/95
Woodblock print; 14¾ × 9¼ in. (37.5 × 24.7 cm)
Clarence Buckingham Collection, 1940.1086

Almost nothing is known of the life of Tōshūsai Sharaku, whose entire oeuvre of bold portraits of Kabuki actors was produced during a ten-month period from 1794 to 1795. Possibly an actor himself, Sharaku used the time-consuming and elaborate color woodblock medium to create frank and piercing prints that combine satire with decorative power. His aggressive style is made all the more dramatic by his use of a dark mica background, which throws the silhouette of the posturing actor into strong relief. Depicted here is the actor Bandō Mitsugoro portraying the character Ishii Genzō at the peak dramatic moment of a play entitled *Hanaayame Bunroku Soga,* when, with a look of intense fury, he draws his sword to aid his two brothers-in-law in avenging their father's murder. The play was based on a true incident of 1701 that disrupted the civil order of the Tokugawa shogunate and scandalized the population of Edo. Commentary on contemporary issues was discouraged by the government, however, and so the play disguises itself as a literary recounting of a famous twelfth-century act of filial revenge that occured in the Soga family. Unlike the elite and highly stylized Nō theater (see p. 230), Kabuki—based in the Yoshiwara pleasure quarters of Edo (Tokyo)—was a popular form of drama that reflected and catered to the tastes and pleasures of the emerging merchant class.

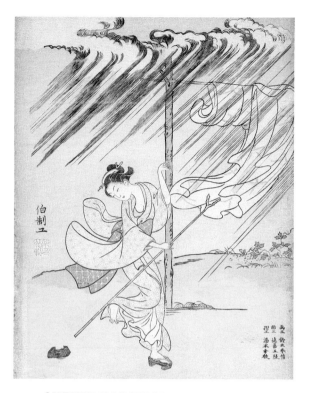

SUZUKI HARUNOBU
(Japanese, 1724–1770)

Young Woman in a Summer Shower, 1765
Woodblock print; 11¼ × 8⅝ in. (28.6 × 22 cm)
Clarence Buckingham Collection, 1957.556

Caught in a sudden rainstorm, a young woman rushes to retrieve her wash, carrying in her tiny hand a forked stick to lift down the bamboo line. In her haste, she loses one of her wooden clogs, exposing a foot and part of her leg. This captivating, coyly revealing image is a calendar print *(egoyomi)* for 1765, the year that marked the meteoric rise to favor of the print's creator, Suzuki Harunobu, master of the color woodblock print. This complex and costly technique, beloved by the newly monied merchant class, involved many carved wooden blocks, each inked with a different color, to produce a single image. Introduced to Japan from China in the eighth century, the simple woodblock had been used chiefly to mass-produce Buddhist texts and icons; by the mid-seventeenth century, the medium had become the format of choice to elicit visions of the "floating world," called *ukiyo-e*. "Floating" in the Buddhist sense means transient or evanescent, and refers to the world of everyday life, especially of pleasure, which Harunobu transformed into idyllic scenes with his graceful line and fresh colors. What at first appear to be tie-dyed patterns on the hanging clothes are in fact ideograms corresponding to the year 1765. Calendar prints were a government-controlled monopoly, and private producers such as Harunobu, unauthorized to give date information outright, resorted to cleverly hiding within the picture the *daisho*, or numerals for the long and short months.

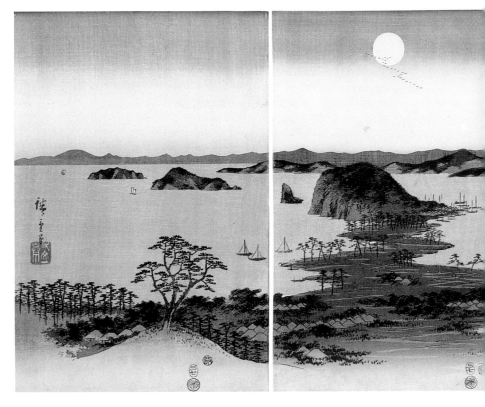

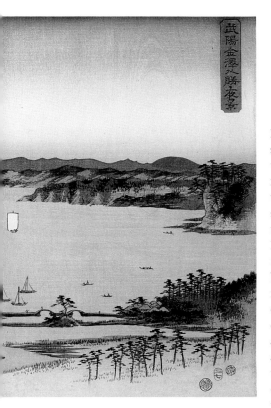

UTAGAWA HIROSHIGE
(Japanese, 1797–1858)

*Panorama of Eight Views of Kanazawa
under the Full Moon,* 1857
Woodblock print; 14⅛ × 29½ in.
(35.9 × 74.9 cm)
Clarence Buckingham Collection,
1925.2305

Like the older master Katsushika Hokusai (see p. 86), Utagawa Hiroshige often used prints to chronicle scenery along major Japanese travel routes, as well as to celebrate the vistas of the cities themselves. This idyllic panorama features the scattered islands and rolling hills of Kanazawa, a port in central Japan off the Sea of Japan. The elegant moon crossed by a thin line of geese, the melancholy reed banks, and fishing boats at anchor or coming back to port before dark all evocatively convey the calm beauty of approaching night. The human elements are reduced to mere specks. Reinforcing this tranquil atmospheric effect is the use of velvety colors and masterful perspective. Produced in the year before Hiroshige's death, the sweeping triptych is probably part of a grand trilogy of landscape prints on the traditional themes of snow, flowers, and, represented here, moonlight. The other two works in the trilogy — often considered Hiroshige's culminating masterpiece — are *The Rapids at Naruto,* depicting snow, and *Mountain and River on the Kiso Road,* representing a floral subject, both in the collection of the Art Institute.

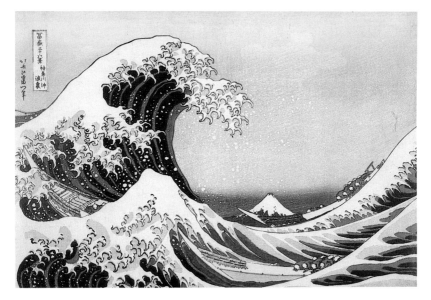

KATSUSHIKA HOKUSAI
(Japanese, 1760–1849)

The Great Wave off Kanagawa, from the series *Thirty-six Views of Mount Fuji*,
c. 1831
Woodblock print; 10⅛ × 14¾ in. (25.4 × 37.6 cm)
Clarence Buckingham Collection, 1925.3245

In the early nineteenth century, increasing political and moral censorship on
the part of the Tokugawa government led artists such as Katsushika Hokusai to
adopt landscape as their *ukiyo-e* ("floating world") subjects (see p. 83). These
eventually replaced figure prints as the preferred theme for woodblock prints.
Produced between the late 1820s and early 1830s, Hokusai's series of prints
studying the ancient pilgrimage site of Mount Fuji is among the most cele-
brated and majestic of nineteenth-century works of art. Whether the volcano
is visually dominant, as in many of the prints, or reduced in scale as here, the
series is a virtuoso display of Hokusai's compositional skill. With its bold linear
design, striking juxtapositions, and simple use of color, *The Great Wave* is one of
the most compelling images of the mountain. Not only do the surging breakers
seem to swamp the boaters but, to the Japanese eye, accustomed to reading
from right to left, the great claw of a wave appears almost to tumble in the
viewer's face. Even Mount Fuji appears fragile, about to be engulfed. Possessing
a nearly demonic energy Hokusai saw as inherent in nature, the image dramat-
ically places man in a larger, more potent context. This iconic image has been
used widely in contemporary designs, ranging from comics and advertisements
to book jackets and record covers.

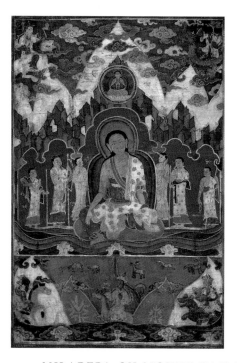

MILAREPA ON MOUNT KAILASH
Eastern Tibetan (?), c. 1500
Pigment and gold on cotton; 17¹⁵⁄₁₆ × 11¹³⁄₁₆ in. (45.5 × 30 cm)
Asian Purchase Campaign Endowment; Robert Ross Fund, 1995.277

The poet-monk Milarepa, who lived in the early twelfth century, spent his life as a wandering mendicant in Tibet, performing miracles and converting nomads to Buddhism. On this *thangka,* a painted cloth that can be rolled up and carried from one place to another, he is portrayed as an ascetic in a cave in Mount Kailash, a mountain sacred to both Hindus and Buddhists. He is surrounded by his disciples; directly over Milarepa is his teacher Marpa, who is regarded as the founder of the Kagyu order of Tibetan Buddhism. Also shown above and below Milarepa are the five sisters of long life, who often attended the master's sermons. His snow-capped Himalayan abode is depicted here in two different styles — soaring white peaks that resemble the hats worn by lamas, and below them multihued, crystalline spikes that appear to demonstrate the prismatic effect of the sun on ice. Milarepa is represented in his youth, in the posture of Buddha Shakyamuni touching the earth to indicate his victory over the forces of temptation. The sacred peaks and lakes of the Himalayas have inspired extraordinary works of art — Milarepa, for example, wrote one hundred thousand songs that have recently been translated into English.

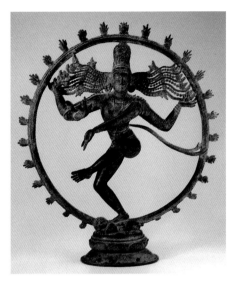

Himalayas, his matted locks dividing the falling waters into the seven holy rivers of India. Exquisitely balanced, yet full of movement, this figure characterizes the masterful bronzes made in the South Indian kingdom of the Chola rulers. Poles were probably inserted into holes in the sculpture's base, allowing it to be carried in ceremonial processions.

SHIVA NATARAJA
Indian, Tamil Nadu; Chola dynasty,
10th / 11th cen.
Bronze; h. 27¼ in. (69.4 cm)
Kate S. Buckingham Endowment,
1965.1130

As the embodiment of the inscrutable, ever-changing life force, Shiva is one of the two most important divinities in the Hindu pantheon. Here, represented as Nataraja, king of dance, Shiva performs the cosmic dance that generates the cyclic movement of the universe and sets the rhythm of life and death. Every aspect of this graceful figure has symbolic meaning. The ring of fire encircling him represents the vital forces of nature. His upper arms balance the flame of destruction and the hand drum that determines the cadence of life. His raised lower right hand gestures "fear not," while the other *(gajahasta)* points downward to his raised foot, symbolizing release from the ignorance that hinders ultimate knowledge. Shiva's other foot, planted on the back of the demon-dwarf *(apasmara),* stamps out ignorance. A small image of Ganga, goddess of the river Ganges, floats on the god's right, amidst his streaming, snakelike hair. According to myth, Shiva stands beneath the torrents of the great Ganges as it descends from the

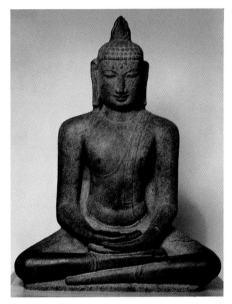

BUDDHA
Indian, Tamil Nadu, Nagapattinam;
Chola dynasty, 12th cen.
Granite; h. 63 in. (160 cm)
Restricted gift of Mr. and Mrs. Robert
Andrew Brown, 1964.556

By the time this large granite statue was made, Buddhism had almost disappeared in India, ultimately to be replaced by Hinduism as the dominant religion. One of several exceptions was the southern region of Tamil Nadu, where a small group of Indonesian merchants practiced Buddhism in the coastal town of Nagapattinam. Although its Chola rulers were Hindu, they nonetheless provided stone sculptors to decorate Buddhist monuments of Nagapattinam. This seated

frontal icon, conveying spiritual strength and solidity, was intended either for a Buddhist memorial reliquary mound *(stupa)* or for an honored place in a monastery. He sits in the traditional lotus pose with his hands resting in the gesture of meditation. Further identifying him as the image of Buddha are the lotus marks on his palms, the third eye of insight *(urna)*, and the cranial bump with a flame of wisdom *(ushnisha)*. His elongated earlobes recall the heavy jeweled earrings that prince Siddhartha Gautama (c. 563– c. 483 B.C.), the historical Buddha Sakyamuni, wore before he renounced all worldly luxuries. At the same time, he cut his long flowing hair, hence the tight cap of curls. But whereas his curls in traditional representations usually turn clockwise, here, carved by uninformed Hindu sculptors, they swirl in both directions. A long inscription on the Buddha's back in Tamil, a language of southern India, is no longer legible.

HEAD OF A GOD

Cambodian, Angkor, late 12th/early 13th cen.
Sandstone; h. 34¼ in. (85 cm)
Samuel M. Nickerson Endowment, 1924.41

This imposing sandstone head of a god was extracted from two rows of giant god and demon figures that line the south approach to Angkor Thom, one of the two great temples of the Khmer empire of Cambodia. With gods on the right and demons on the left, the eight-foot tall statues kneel to form the railing of a causeway along the path leading to the central Buddhist shrine, a mass of carved towers called the Bayon. In their arms is the huge body of the serpent Vasuki, which coils symbolically round the Bayon, head and tail rearing majestically at the ends of the causeway. Enacting the Hindu cosmic myth of the Churning of the

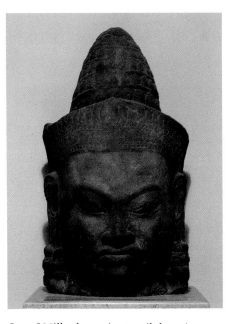

Sea of Milk, these giants roil the primordial ocean in a tug-of-war between gods and demons to win its treasures — chief among them *amrita,* the nectar of immortality. Located in Angkor (meaning "the city" or "the capital" in the Khmer language), Angkor Thom was built by and dedicated to Jayavarman VII, who reigned as god-king *(devaraja)* from around 1181 until early in the thirteenth century. An architectural masterpiece of moats, causeways, towers, and courtyards combining both Buddhist and Hindu motifs, Angkor Thom illustrates the syncretic relationship of the two major belief systems of Southeast Asia.

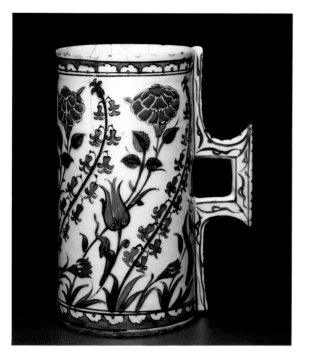

MUG

Turkish (Ottoman Empire), Iznik, second half of 16th cen.
Earthenware with underglaze painted decoration;
h. 7⅝ in. (19.6 cm), diam. 4¼ in. (10.7 cm)
Mary Jane Gunsaulus Collection, 1913.342

This lyrically decorated mug was made at the Iznik imperial kilns, south of modern Istanbul, which produced some of the finest pottery and ceramic tiles of the sixteenth and seventeenth centuries. The mug's distinctive shape — a tall cylinder tapering slightly inward toward the top — is known as a *hanap*; being too large for drinking, the vessel may have been used to contain flowers. Its visual brilliance derives from the striking color contrasts of rich blue, green, and orange-red against a viscous white. The use of the vivid, thickly applied red indicates that the piece was not made before the 1550s, when Iznik potters adopted the color known as Armenian bole. The design — an elegant combination of roses, tulips, hyacinths, and long, serrated leaves known as *sciz* — reflects a fascination with floral motifs prevalent at that time. A craze for tulips, in fact, extended to Europe, prompting exorbitant prices and rampant speculation for bulbs, thanks to their introduction into Holland from Constantinople in the sixteenth century. This floral vogue was not limited to ceramics. The same vocabulary can be seen in painting, manuscript illumination, and textiles — as well as in romantic poetry, where roses, tulips, and hyacinths became standard similes for admirable aspects of the beloved.

European
Decorative Arts
and Sculpture, and
Ancient Art

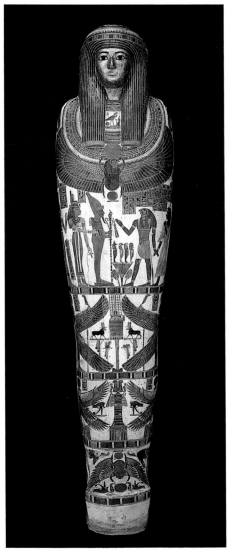

MUMMY CASE OF PAANKHENAMUN

Egyptian, Third Intermediate
Period, Twenty-second Dynasty
(c. 945–715 B.C.)
Cartonnage (gum linen and papyrus
with gold leaf and pigment)
h. 67 in. (170.2 cm)
William M. Willner Fund, 1910.238

Mummification is the ancient Egyptian funerary practice of drying out a corpse for preservation. Anointed with oils and spices and protected with amulets, the linen-wrapped body was then placed in a series of nesting coffins; this vividly painted cartonnage was the innermost shell. Across the surface of the mummy case, inscriptions and painted scenes and symbols identify the deceased and proclaim his wish to live well in the afterlife. He was Paankhenamun ("The one who lives for Amun"); another inscription records that he was the doorkeeper of the estate of Amun. The names and titles suggest that he lived at Thebes. The central scene depicts the presentation of the deceased by the falcon-headed deity Horus to Osiris, ruler of eternity (shown, as was common, as a mummy). Other divinities help the deceased in his journey to the afterlife. Despite the youthful features of the gilded face, X-rays reveal that Paankhenamun was a man in middle age.

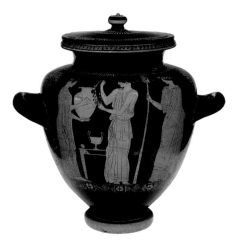

a master potter whose vases were individually shaped in a prescribed range of configurations. With its refined designs so gracefully adapted to its shape, this *stamnos* embodies the finest achievements of red-figure pottery.

WINE CONTAINER
(*STAMNOS*)

Greek, c. 450 B.C.
Chicago Painter
Earthenware; h. 14½ in. (37 cm), max.
diam. 12⅛ in. (30.9 cm)
Gift of Philip D. Armour and Charles L.
Hutchinson, 1889.22

This refined Athenian *stamnos* was used to hold water or wine. Valued as well for its beauty, this red-figure vessel (so-called because the figures have been left the natural color of the clay) portrays maenads, women participants in rites celebrating Dionysos, the god of wine. But unlike the frenzied and whirling figures of other Greek painters, there is a calmness, even an elegance, depicted here. This tender serenity, coupled with a softer, somewhat freer form, is a stylistic hallmark of this artist (referred to as the Chicago Painter because of this vase), and has been used to identify other works by him, principally similar *stamnoi* with Dionysian scenes. Working in Periclean Athens, in the potter's quarter, the unknown master painter was active during the construction of the Parthenon, the stylistic influence of which can be seen here. He worked closely with

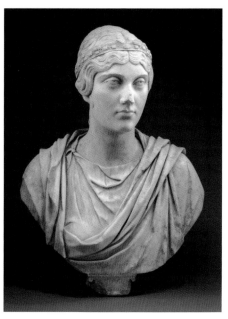

PORTRAIT BUST
OF A WOMAN

Roman, Antonine Period, A.D. 138–92
Marble; h. 24¹³⁄₁₆ in. (62 cm)
Restricted gifts of the Antiquarian Society in honor of Ian Wardropper, the Classical Art Society, Mr. and Mrs. Isak V. Gerson, James and Bonnie Pritchard, and Mrs. Hugo Sonnenschein; Mr. and Mrs. Kenneth Bro Fund; Katherine K. Adler, Mr. and Mrs. Walter Alexander in honor of Ian Wardropper, David Earle III, William A. and Renda H. Lederer Family, Chester D. Tripp, and Jane B. Tripp endowments, 2002.11

This exquisite portrait bust depicts an elegant Roman matron of timeless beauty. It was carved during the Antonine Period (A.D. 138–92), when the Roman Empire

was at the height of peace, prosperity, and extent. The subject is probably a private individual; she looks to the left, which affords a tantalizing glimpse of her complex coiffure. The diadem, or crown, evokes an original that would have been fashioned in gold, set with precious stones, and held in place by a thick fabric cord. The sitter wears a crisply pleated, gap-sleeved tunic, its neckline so thinly carved that light passes through the marble. For modesty's sake, she also wears an overgarment, its deep folds indicating a thick material, possibly wool. Draped low across her torso, the mantle reveals the gentle swell of her right breast, an unusual feature of Roman busts of this period. Although portraiture is one of ancient Rome's greatest contributions to the visual arts and one of the empire's most enduring legacies, the names of its practitioners remain unknown. This sculpture survives as an enduring testament to the extraordinary talent of its sculptor and a tribute to his stately subject.

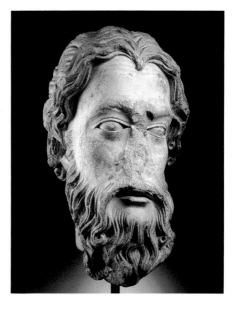

HEAD OF APOSTLE OR PROPHET

French, c. 1200
Limestone; h. 17 in. (43.2 cm)
Lucy Maud Buckingham Collection, 1944.413

Once thought to have been unearthed during the restoration of Paris in the mid-nineteenth century, the origin and identity of this impressive and stately medieval sculpture head remain a mystery. It comes from a columnlike biblical figure that was attached to the door jamb of a Gothic cathedral. Such figures were often mutilated during the French Revolution because of their association with the mon-

archy. They also suffered damage during the sixteenth-century Reformation, through exposure to the elements, and at the hands of overzealous restorers in the nineteenth century. Largely intact except for the defacement of the nose and some damage to the beard, this noble head has been attributed to various cathedrals in the Île-de-France. Characteristic of stylistically transitional works produced around 1200, the head exudes the powerful spirituality of the older Romanesque style and also shows the beginnings of the more naturalistic, personalized depiction of the emerging Gothic aesthetic. Several stylized features, such as the elongation of the lower face and the unnaturally high furrowed brow, are combined with more subtly shifting facial planes. Although the hair and beard are sinuously patterned, the deep gouging indicates the Gothic's emphasis on the three-dimensional effects of form.

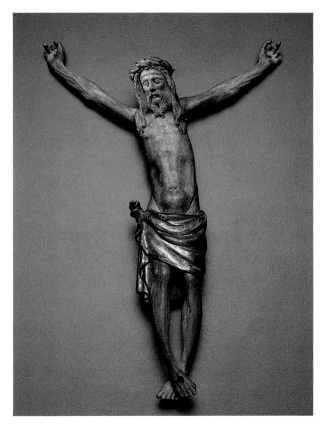

JACQUES DE BAERZE
(Flemish, active c. 1383–92)
Christ Crucified, c. 1390
Walnut; h. 11 in. (27.9 cm)
Gift of Honoré Palmer, 1944.1370

An outstanding monument of medieval art, *Christ Crucified* was originally the central figure in a large, elaborate altarpiece commissioned in 1390 by Philip the Bold, duke of Burgundy, for the newly founded Chartreuse de Champol in Dijon. The altarpiece was of a type called *schnitzaltar*; when open, the central panel displayed carved reliefs of scenes from the Calvary and Passion, flanked by five saints on each movable wing. When closed, the wings showed paintings by the renowned Flemish artist Melchior Broederlam, who was also responsible for painting and gilding the carved figures. The work was carved by Jacques de Baerze, a sculptor whose harsh realism influenced a general stylistic shift in France. Though it has lost its context within the altarpiece, as well as most of its paint, the corpus remains a powerfully expressive work. The weight of Christ's suspended body distends his abdomen and causes veins to bulge in his thin arms. His legs contort around the nail impaled in his homely feet. The altar embellished the famous Carthusian church and ducal mausoleum from its completion in 1399 until the French Revolution, when it was dismantled and several parts lost. In 1819, the altarpiece was carefully restored and is today preserved — with a replacement centerpiece — in the Musée des Beaux-Arts of Dijon.

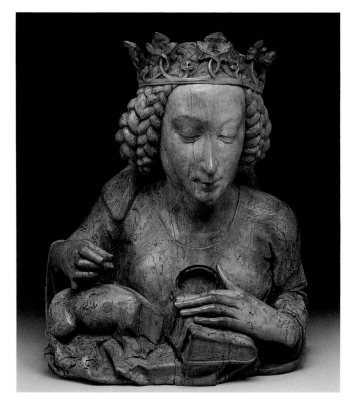

NICOLAUS GERHAERT and WORKSHOP
(German, active 1462–73)

Bust of Saint Margaret of Antioch, 1465/70
Walnut; h. 20 in. (50.8 cm)
Lucy Maud Buckingham Collection, 1943.1001

Margaret was a convert to Christianity during the great persecutions that
preceded the reign of the Roman emperor Constantine (r. 324–337). While
imprisoned for her faith, she prayed that the principle of evil be revealed. A
dragon suddenly appeared and tried to consume her, but she tamed it with the
sign of the cross and the Holy Word of her book. Here she is shown with her
attributes, a tiny chained dragon (now missing its head) and a book; originally
she held a cross in her right hand. The cavity in her chest contained a small
casket, which held relics of the saint. The bust's animated quality, naturalistic
physiognomy, and sense of texture indicate Nicolaus Gerhaert and his work-
shop as the creators. One of the most innovative northern sculptors of the late
Gothic period, Gerhaert popularized this form, *buste accoudé* (bust leaning on
elbows), transforming the traditional reliquary bust from a static, stereotypical
image of a saint to an eloquent, lifelike image of an individual. Originally, the
work belonged to a group of reliquary busts as part of an altarpiece from the
Church of Saints Peter and Paul in Weissenburg, Germany. The others included
Saints Barbara and Catherine (Metropolitan Museum of Art, New York) and
Saint Agnes (known only in a plaster cast at the Frauenhaus, Strasbourg).

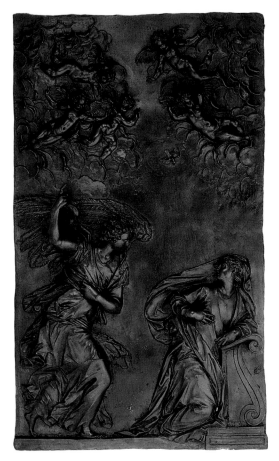

ALESSANDRO VITTORIA
(Italian, 1525–1608)
The Annunciation, c. 1583
Bronze; 38½ × 24¼ in. (97.8 × 61.6 cm)
Edward E. Ayer Fund, 1942.249

This masterpiece of Renaissance relief sculpture by the Venetian sculptor Alessandro Vittoria was commissioned in 1580 by Hans Fugger, a member of a noted Augsburg banking family, to decorate an altarpiece for the Fugger family chapel in Swabia, Germany. Here, Vittoria has translated into bronze the flickering light and colorful palette of the great Venetian painters of his period. His composition is specifically adapted from altarpieces by Titian. Working in wax (from which the finished relief was then cast in bronze), Vittoria manipulated the relief's form and edges to catch the light. The result is a highly animated surface in which everything — figures, drapery, clouds, and sky — seems to vibrate with movement and excitement, heightening the dramatic scene between the sharply turned, startled Virgin and the powerful figure of Gabriel, who has suddenly descended from heaven. Fully sculpted in the round, the Archangel's arm points to the smallest, but essential, feature in the scene: the dove, the Holy Ghost of the Christian Trinity. The plasticity and depth of the relief, the dramatic movement, and the handling of detail make this one of the artist's finest creations.

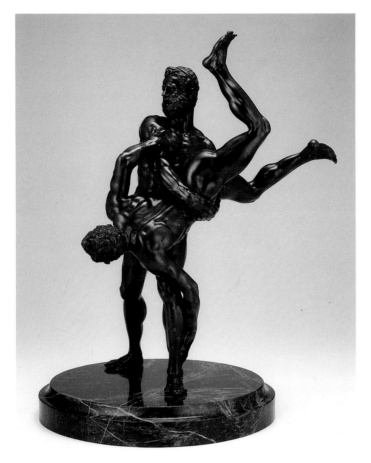

After GIOVANNI DA BOLOGNA
(Flemish, 1529–1608)
Hercules and Lichas, c. 1590
Bronze on marble base; h. (without base) 19⅝ in. (49.9 cm)
Robert Allerton Endowment, 1968.613

The Flemish-born sculptor Giovanni da Bologna (Giambologna) was a master of the bronze statuette, produced in large numbers with a high level of quality by his Florentine workshop. Among his patrons was the powerful Medici family of Florence. Depicted here is the fateful story of the mythical Greek hero Hercules hurling his friend, the messenger Lichas, to his death in the sea. Lichas had delivered a poisoned tunic given to him by Hercules's wife which led to the hero's madness and death. Apparently unique, this bronze, with its pair *Hercules and Antaeus* (also in the Art Institute), is thought to reflect lost models by Giambologna. It exhibits the sculptor's characteristic intricate play of curving and zigzag lines running from limb to muscular limb through both wrestling figures. Giovanni da Bologna was responsible for a major aesthetic development in sculpture: figures designed to be viewed from all sides with equal appreciation, what is known as sculpture in the round.

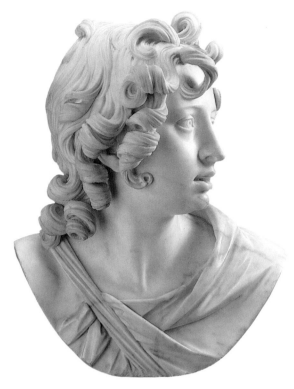

FRANCESCO MOCHI
(Italian, 1580–1654)

Bust of a Youth (possibly Saint John the Baptist), c. 1630
Marble; h. (without base) 16 in. (40.5 cm)
Restricted gift of Mrs. Harold T. Martin through the Antiquarian Society; Major
Acquisitions Centennial Endowment; through prior gift of Arthur Rubloff;
European Decorative Arts Purchase funds, 1989.1

Although his output was relatively small, Francesco Mochi was one of the most original and creative artists of the emerging Italian Baroque era. His art is distinguished by an energetic linearism, dramatic movement, and subtle psychology. Here, a taut, almost mathematical precision characterizes the youth's garment, and a carefully composed rhythm governs Mochi's virtuosic treatment of the hair, even with the apparent abandon of its spirals. Juxtaposed with this precise linear frame of drapery and hair is the dreamy, longing look of the youth, with his slightly parted lips. The distant, transcendent expression, that of a seer longing for heaven, suggests that the sculpture may represent a youthful Saint John the Baptist. John played an important role in the artist's life: he was patron saint of Florence, where Mochi first trained, and was a favored theme of Mochi as well as of his principal patrons, the Barberini family.

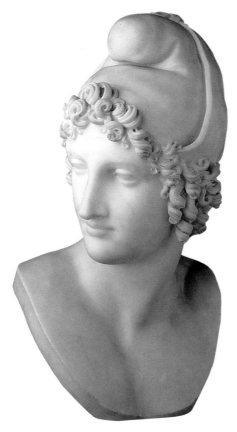

ANTONIO CANOVA
(Italian, 1757–1822)

Bust of Paris, 1809
Marble; h. 26 in. (66 cm)
Harold Stuart Fund; restricted gift of
Mrs. Harold T. Martin, 1984.530

The enormously popular Neoclassical
sculptor Antonio Canova frequently made
replicas or variants of major works to sat-
isfy the demand for his art. While execut-
ing a commission by Empress Josephine of
France for a full-length *Paris* (Hermitage
Museum, St. Petersburg), Canova also
carved this bust for his friend Antonio
Quatremère de Quincy, the leading French
Neoclassical theorist and critic who had
greatly influenced the sculptor's artistic
ideals. Upon receipt of the gift, Quatre-
mère stated: "There is in [the bust] a mix-
ture of the heroic and the voluptuous, the
noble and the amorous. I do not believe
that in any other work you have ever
combined such life, softness, and chaste
purity." The Empress Josephine shared the
critic's enthusiasm, to the point of asking
him to place his bust of Paris on her statue.
He tactfully refused. The bust depicts that
decisive moment in Greek epic mythology
when the shepherd Paris, called upon by
Zeus to judge who was the most beautiful
among Hera, Athena, and Aphrodite,
turns his head to gaze at the three god-
desses. Unaware of the grave repercus-
sions of his decision — which led, the story
goes, to the disastrous Trojan Wars — a
smile flickers across his smooth, idealized
features. Documents indicate that this
preeminent Italian sculptor made four
full-length marble statues and at least
seven busts depicting the man reputed
to be the handsomest mortal.

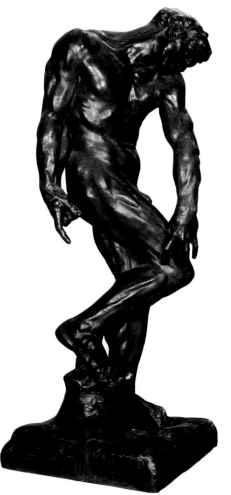

AUGUSTE RODIN
(French, 1840–1917)

Adam, c. 1881
Cast by the Alexis Rudier foundry, Paris
Bronze; h. 78 in. (198.1 cm)
Gift of Robert Allerton, 1924.4

Auguste Rodin's powerfully expressive figure of creation's first man was originally intended to be paired with Eve to flank a sculptured bronze portal commissioned by the French government for the Musée des Arts Décoratifs. For this monumental undertaking, which he entitled *The Gates of Hell*, Rodin turned to past Italian masters, first to Michelangelo for his subject's pose. From the *Creation of Adam* on the ceiling of the Sistine Chapel in Rome (1508–12), Rodin rotated Michelangelo's reclining Adam upright, and transferred the frescoed figure's gesture of receiving life from God from the left arm to this Adam's right. The pronated attitude of Adam's left arm came from Michelangelo's sculpture of the dead Christ in his *Pietà* (1548–55; Museo del Duomo, Florence). Rodin chose the portal's theme from Dante's fourteenth-century *Inferno*; here, Adam's agonized body strikingly conveys an endless reenactment of the sufferings caused by original sin. Although the building was never constructed and the portal not completed as originally conceived, the project functioned as an enormous seedbed of invention for Rodin, in which he explored the expressive potential of the human body as few artists had dared before him. As independent statues, *Adam* and *Eve* are among *The Gates of Hell's* numerous progeny. Not until 1938 was the gate cast in bronze and placed at the entrance to the grounds of the Musée Rodin, Paris.

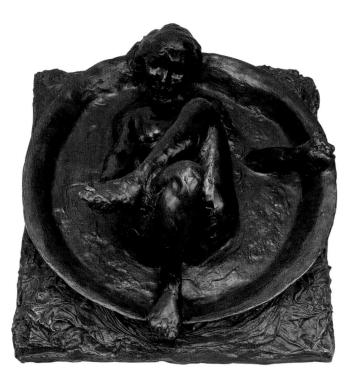

HILAIRE GERMAINE EDGAR DEGAS
(French, 1834–1917)

The Tub, 1889
Bronze; 18½ × 16⁹⁄₁₆ in. (47 × 42 cm)
Wirt D. Walker Fund, 1950.114

Although not generally thought of as a sculptor, Edgar Degas ranks among the greatest in this field during the nineteenth century. His sculptures — depicting dancers, bathers, and racehorses — are small, intimate studies of movement. One of his most brilliant creations, *The Tub* reflects Degas's incessant preoccupation with the volumetric forms of the female nude. Originally modeled in wax and subsequently cast in bronze, this work was part of a series of bathers, also executed in pastels, oils, and prints. Here, Degas employed a three-dimensional medium to convey a woman who appears to merge with and emerge from water. Indeed, the work's appearance changes depending upon whether it is viewed from above or from the side. The artist exploited the illusionistic qualities of his material in the original wax model through the use of a cloth draped around the bottom of the tub and a sponge held in the woman's left hand, two details that are all but indiscernible in the final bronze version. *The Tub* draws upon a rich artistic tradition of depicting nude female bathers that goes back to old masters like Titian and Rembrandt, and continued into the nineteenth century by such contemporaries as Paul Cézanne and Pierre Auguste Renoir.

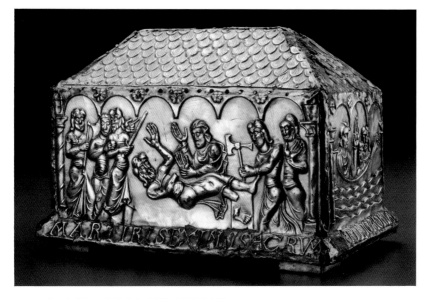

CHASSE OF SAINT ADRIAN

Spanish, 1100/35
Repoussé silver on oak core; 6³⁄₈ × 10 × 5³⁄₄ in. (16.2 × 25.4 × 14.5 cm)
Kate S. Buckingham Endowment, 1943.65

Like a miniature tomb, complete with tiled roof and Romanesque columns, this
rare casket, or chasse, was made to contain the sacred relics of Saint Adrian.
A Roman officer in charge of the persecution of Christians, Adrian so admired
the virtues of those whom he oppressed that he converted to their faith. After
declaring himself a Christian, Adrian was arrested and brutally martyred in
304. Unflinchingly illustrated on the sides of the reliquary (and reinforced by
inscription) is the story of Adrian's trial, his dismemberment, and the transport
of his remains to a city near Constantinople by his devoted wife, Saint Natalie.
The chasse's design was hammered out from behind on thin sheets of silver,
a technique called repoussé. The figures are reduced to simple, monumental
forms composed of convex bulges, reflecting the style of Romanesque relief
sculpture in the Spanish cities of Léon or Toledo, where the chasse may have
originated. Saint Adrian's popularity reached its peak during the twelfth
century. He was revered as the patron of soldiers and a protector against the
plague. At least thirty-six parishes and monasteries were named after him in
Spain alone. His relics are preserved in the Abbey of San Claudio in León and
in the Abbey of Cormery in Touraine, France.

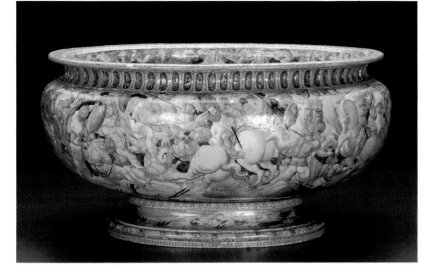

WINE CISTERN

Italian, 1553
Painted by Francesco Durantino (active 1543–53)
Tin-glazed earthenware (maiolica); 10¼ × 20¼ × 16¼ in. (26 × 51.4 × 41.3 cm)
Anonymous Fund, 1966.395

Displayed on the banquet tables of the Italian Renaissance was a wealth of
elaborately crafted platters, vessels, and containers, often with decorative
embellishments that indicated their specialized function or their owner's social
status. Cisterns such as this were filled with cold water and used to cool wine
bottles at feasts. Skillfully decorated by the Italian ceramic painter Francesco
Durantino, this celebrated work typifies the Renaissance interest in both
Christian imagery and scenes from pagan antiquity. It is covered with depic-
tions of two famous battle scenes, one on land, one at sea. While the exterior,
adapted from Giulio Romano's mural in the Vatican (c. 1524), represents a
land battle culminating in the conversion of the Roman emperor Constantine
to Christianity, the cistern's interior — inventively illustrating its liquid-
bearing function — depicts a legendary naval disaster: the sinking of the Greek
hero Aeneas's ships by the jealous goddess Hera. At the cistern's center, the
ships disappear beneath the waves, a playful conceit that was no doubt even
more effective when the cistern was filled with water. The generously sized
vessel displays all the characteristics that made maiolica, a tin-glazed earthen-
ware, popular: brilliant colors, lively painting, and storytelling images mixed
with fanciful design. The term maiolica is probably a corruption of Majorca,
referring to the port through which pottery from Moorish Spain was exported
to Italy.

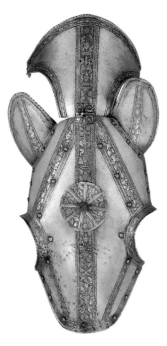

HALF-SHAFFRON
Italian, Milan, 1570/80
Steel, chiseled, etched, and gilded;
l. 16 in. (40.6 cm)
George F. Harding Collection,
1982.2102q

Chivalry — with its connotation of the knightly ideal — was intimately connected with the horse (*cheval* in French). A knight took care to protect his mount, on which he was dependent for the mobility and speed required in both attack and retreat. In Roman times, some heavy cavalry used armor of iron or bronze scales to protect their horses. From the twelfth century on, knights covered their steeds in bards of iron mail (a network of interlocking rings). By the fifteenth century, full-plate armors of iron or steel were not uncommon for horses. This shaffron, or head-

piece, is etched in gilded bands with decoration on a finely dotted ground. Riveted between the eyes is an elongated conical spike, perhaps inspired by the horn of the mythical unicorn. A manifestation of great power and wealth, this shaffron has been valued for centuries as an object of beauty, not just as a tool of warfare and sport. The Art Institute's George F. Harding Collection of Arms and Armor is among the most important collections of its kind in the United States.

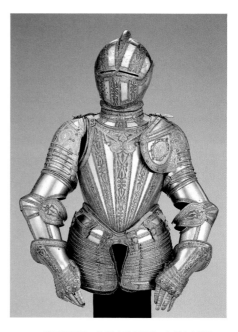

THREE-QUARTER ARMOR
Italian, Milan, 1570/80
Steel, chiseled, etched, and gilded;
brass, leather, velvet with gold lace;
h. approx. 62 in. (157.5 cm)
George F. Harding Collection,
1982.2102a–n

By the time this striking suit of armor was produced — toward the end of the sixteenth century — body armor as a means of protection in battle was becoming obsolete. Firearms had progressed to a point that would soon require armor to be so thick and heavy that it would be impractical to wear (the total weight of this suit — reaching only to the knees — is over forty-three pounds). Armor continued to be produced, however, as both a body defense and an ornamental costume for the male, used to display wealth and rank in court ceremonies, parades, and tournaments. As the symbolic role of armor eclipsed its defensive function, the degree of decoration became increasingly lavish. This garniture, a multipurpose armor, is ornamented with etched decorative bands enclosing trophies of armor. Spiral scrolls, which enclose male and female portrait busts, adorn the breastplate and pauldrons (shoulder defenses). The latter are asymmetrical, the right being narrower than the left, allowing the lance to pass under the armpit. The vertical protrusion was intended to deflect the lance. By the eighteenth century, full armor was only seen in portraits of monarchs eager to present a warlike image, or of generals yearning for lost glories of the past.

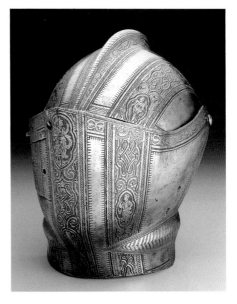

VISOR AND BEVOR OF A JOUSTING HELMET
Italian, 1585/95
Made by the armorer with the sign of the triple-towered castle
Steel, etched and gilded; h. 12 in. (30.5 cm)
George F. Harding Collection, 1982.2493

The manufacture of armor was a highly complex task, requiring great skill and expertise. These elements were part of an armor worn in the joust, a type of sporting combat fought between pairs of mounted contestants who tried to unhorse each other using lances. The right side of the bevor is fitted with a small door that could be opened by the wearer for additional ventilation between jousts. While designed primarily with protection in mind, the pieces are also decorated with etched and gilded motifs of figures and foliate strapwork.

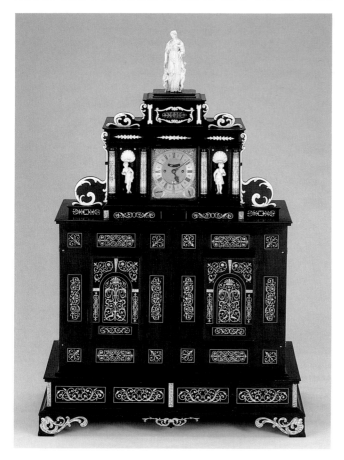

AUGSBURG CABINET

German, c. 1640
Ebony, carved and inlaid ivory, stained and carved wood relief, gilt bronze,
iron implements; 63 × 43½ × 25½ in. (160 × 110.5 × 64.8 cm)
Anonymous Purchase Fund, 1970.404

Cabinets made in the Southern German town of Augsburg during the sixteenth and seventeenth centuries are famous for their showy decoration, which was typically executed in ebony veneer and ivory inlay. This exceptional example also includes lavish carved figures, bronze mounts, and narrative panels depicted in ivory and in stained wood relief. The exquisite craftsmanship of this decoration is matched in inventiveness by the cabinet's interior structure, which is part display case, part tool chest, and part safe-deposit box. Hidden compartments to the right of a built-in clock (a 1715 replace-ment of an earlier timepiece) contain a set of five medicine canisters and at least twenty-two other utensils, including hammers, scissors, and a mortar and pestle. Thematically, the decoration ranges from pure patterns to hunting themes (especially the then-popular sport of falconry, which may have been a favorite pastime of the cabinet's owner) and from specific mythological tales (which also revolve around flight) to the allegorical figure of the Christian virtue Charity, who crowns the whole. Like safe-deposit boxes, the intricate and lavish compartments often housed jewelry, gems, and special papers.

WALL CLOCK

French, 1735/40
Jean Pierre Latz (c. 1691–1754)
Oak veneered with tortoiseshell and
kingwood, brass inlay, gilt bronze,
glass; musical movement;
58 × 20⅝ × 14⅜ in.
(147.3 × 52.3 × 36.4 cm)
Ada Turnbull Hertle Fund, 1975.172

An exuberant and lavish example of the
French Rococo style, this sculptural wall
clock epitomizes the extravagant era of
Louis XV (r. 1715–74). Costly and com-
plicated, festooned with ormolu, or gilt-
bronze, swirls and floral swags, the clock
required the collaboration of numerous
specialized branches of artisanry. Its case,
candelabra, and wall bracket were created
by the eminent German-born Jean Pierre
Latz who, in 1741, was appointed *ébéniste*
(furniture maker) to the king. The clock's
eight-day movement was manufactured
in the Flemish city of Ghent by Francis
Bayley, possibly a member of the large
London dynasty of clockmakers of that
name. Opulent clocks such as this did
more than tell the time; they delighted
the ear with music (six melody titles are
engraved in the dial's arch) and dazzled
the eye with such dramatic episodes as
that of the Greek god Apollo, here, poised
to slay the serpent Python. The space be-
tween the clock and the wall bracket is
cleverly used to suggest the beast's home,
the cave of Mount Parnassus in Greece.
In the triangular base are the faces of Zeus,
manifesting time, and Hera, presiding over
marriage and childbirth, surmounted by
two small coats of arms of the Flemish
bride and groom whose union the wall
clock was probably created to celebrate.

CENTERPIECE AND STAND

German, 1737
Modeled by Johann Joachim Kändler
(active 1731–75), Meissen porcelain
factory
Hard-paste porcelain with enameling
and gilding, chased and engraved
gilt-bronze mounts; bowl:
11 × 17½ × 10 in. (28 × 44.4 × 25.4 cm);
stand: 6 × 26 × 20 in. (15.2 × 66 ×
50.8 cm)
Atlan Ceramic Club, Buckingham
Luster, Decorative Arts Purchase funds,
1958.405

Typifying the resplendence of the Saxon
court at Dresden during the eighteenth
century, this magnificent porcelain center-
piece would have been part of an elabo-
rate dinner service gracing ceremonial
court banquet tables that were memorable
in their extravagance. Remarkable for its
large size and lively, luxurious decoration,
it was designed and modeled by Johann
Joachim Kändler for Count Heinrich von
Brühl, who was both administrator of the
Royal Saxon Porcelain Manufactory at
Meissen and prime minister to Frederick
Augustus III (r. 1733–63), elector of
Saxony and king of Poland. A large, flat
plateau was made in sections and fitted

together to support a tall, four-legged,
open basket decorated with fanciful
roosters and pairs of Chinese figures.
The container would have been artfully
stacked with lemons, a novelty in eigh-
teenth-century Germany. At either end of
the plateau were sugar casters in the form
of Chinese figures embracing under a
canopy. Established in 1710 by Augustus
the Strong after a German scientist suc-
ceeded in replicating Chinese porcelain,
the Meissen factory dominated porcelain
production in Europe until the mid-
eighteenth-century and, relocated, con-
tinues to produce to this day.

EWER AND BASIN

Italian, c. 1745
Modeling attributed to Giuseppe Gricci
(active 1743–59), Capodimonte
porcelain factory, Naples
Soft-paste porcelain with enameling
and gilding; ewer: h. 12 in. (30.5 cm);
basin: 6½ × 15¼ × 13½ in.
(16.5 × 38.7 × 34.3 cm)
Gift of Mr. and Mrs. Robert Norman
Chatain in memory of Professor Alfred
Chatain, 1957.490

Made during the earliest years of the royal
porcelain factory in Capodimonte, this
rare set is one of the great masterpieces of

European porcelain. With its malleability and whiteness, this remarkable substance was especially suited to the Rococo emphasis on invention, asymmetry, natural motifs, and a palette that was lucid and light. These soft-paste porcelain surfaces, probably designed by Capodimonte's master modeler, Giuseppe Gricci, conjure up the textures and luminescence of sea-washed shells and natural mother-of-pearl. This conceit of the marine world — so appropriate to these water-bearing vessels — is furthered by the use of shell-like forms for both the shape and decoration of the ewer and basin. Marine forms, unique to the factory, encrust their surfaces, and a trompe-l'oeil coral branch cleverly serves as the ewer's handle. Swirling lines and irregular surfaces contribute to the ewer's sense of lightness and complete the illusion of the sea.

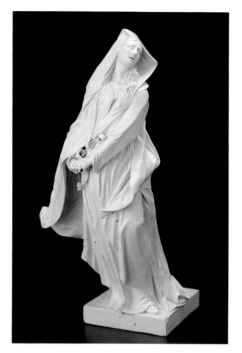

MOURNING MADONNA

German, 1756/58
Modeled by Franz Anton Bustelli
(Swiss, active 1753–63), manufactured
at Nymphenburg porcelain factory
Hard-paste porcelain; h. 12⅛ in.
(30.6 cm)
Gift of the Antiquarian Society through
the Mrs. Harold T. Martin Fund,
1986.1009

Like actors on a stage, German Rococo devotional objects adopted animated, grandiloquent poses calculated to provoke emotional responses. Like the *Mourning Madonna*, these images were usually part of a carefully arranged environment — in this case, a group portraying the Crucifixion that included Saint John the Evan-

gelist and the crucified Christ. Franz Anton Bustelli, who created this dramatic, swirling form, was the period's greatest modeler of porcelain figures. He was best known for a series based on Italian comedy theater; but here, like a tragedian, Bustelli's grieving Mary clasps her hands awkwardly and throws her head up to gaze at her dying son. The expressive flow of drapery, with its sharply delineated folds, characteristic of Bustelli's work, suggests Mary's inner turmoil. While many of Bustelli's figures are enlivened by touches of brilliant color, here the pure, white porcelain of the *Mourning Madonna* lends it a ghostly quality.

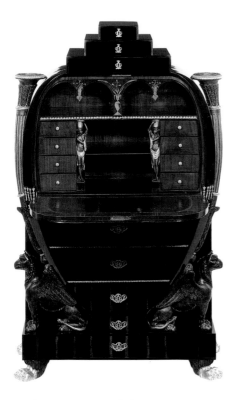

SECRETARY DESK

Austrian, 1810/12
Unidentified woods, limewood, carved, gilded, and painted in patinated bronze
color, with gilt-bronze mounts; interior: copper, brass, and maple-wood
marquetry, with mahogany and yew; 57⅝ × 35⅞ × 15⅜ in.
(146.5 × 91.2 × 39.2 cm)
Antiquarian Society Centennial Fund, 1976.39

The inventive lyre form of this secretary, surmounted by three stepped drawers and supported by griffons, identify it as an elaborate, complex case form made in Vienna during the Napoleonic era. The upper half of the front falls forward to serve as a writing surface, revealing interior compartments, drawers, and shelves. The bold, severe forms of the Empire style in France brought a new rigor to the Neoclassical pursuit of the authority of ancient Greek and Roman art. Though handbooks detailing the new designs were studied by craftsmen throughout Europe, this secretary indicates that the models were by no means slavishly imitated. This Austrian example was made with materials and techniques typical of Viennese workshops, and its form has no direct source in antiquity. But its lyre shape and abundant decorative details — griffons (looking rather like domesticated pets), cornucopias, paw feet, and interior caryatid figure — are familiar classical motifs. The variety of woods, selected to create contrasts between light areas and dark borders, matches the pastiche of decorative motifs. Vienna was a major European design center, and this desk type enjoyed wide popularity, with variants occurring all over Austria-Hungary. Production continued throughout the ensuing Biedermeier era, into the 1840s.

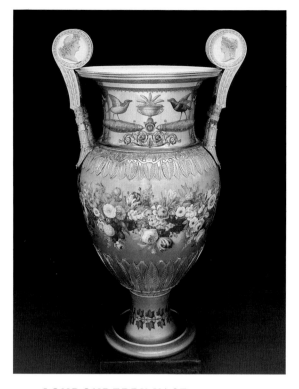

LONDONDERRY VASE

French, 1813
Designed by Charles Percier (1764–1838); decoration designed by Alexandre
Théodore Brongniart (1739–1813); Sèvres porcelain factory
Hard-paste porcelain, polychrome enamel, gilding, gilt-bronze mounts;
h. 54 in. (137.2 cm)
Harry and Maribel G. Blum Foundation, Harold L. Stuart funds, 1987.1

This gilded and enameled porcelain vase epitomizes the great achievements accomplished by the royal porcelain factory at Sèvres during the Napoleonic period. Sèvres was a chief beneficiary of Napoleon's policy of resuscitating factories after the trauma of the Revolution: demonstrating the supremacy of French craftsmanship, the emperor used sumptuous porcelain for his grand refurnishing plan as well as for state gifts. With its commanding contours, monumental size, rigorous symmetry, and unabashed splendor, the vase is a superb example of the Empire style, inspired by Greco-Roman art. It is a triumph of the collaborative practice of the Sèvres porcelain factory; documents reveal the precise roles played by each artist—painters of birds and of flowers, gilders, and burnishers—in its creation. Napoleon's chief architect, Charles Percier, who helped establish this new style, created the Etruscan scroll-handled design. This vase, commissioned by Napoleon around 1805, ironically cemented a relationship that sealed the French emperor's defeat. Held by the factory until 1814, after Napoleon's exile, the vase was used as a diplomatic gift from his successor, King Louis XVIII, to Viscount Castlereagh, the English secretary for foreign affairs, on the eve of the Congress of Vienna, where the major powers of Europe met to decide France's fate after the collapse of the empire.

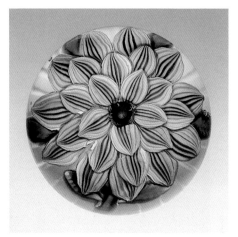

MILLEFIORI PAPERWEIGHT

French, 1845/55
L. J. Maës, Clichy-la-Garenne
Glass, millefiori; diam. 2¾ in. (7 cm)
Gift of Arthur Rubloff, 1978.1300

DAHLIA PAPERWEIGHT

French, 1848/55
Saint-Louis glass factory
Glass, lampwork; diam. 2⅞ in. (7.4 cm)
Bequest of Arthur Rubloff,
1988.541.580

Glass paperweights became popular in the mid-nineteenth century, when the establishment of a dependable mail service led to an increase in letter writing and a vogue for writing products and desk accessories. This exuberant paperweight was produced in the L. J. Maës factory, known as Clichy for its location in a suburb of Paris. This example employs the technique called millefiori, from the Italian term meaning "thousand flowers," referring to the gardenlike patterns of colorful, thin sticks of glass. Each glass "cane" is the cross-section of a glass rod with an embedded design, heated and stretched thin. Millefiori weights, in over fifty different patterns and numerous color combinations, were about eighty percent of Clichy's paperweight production. Here, a rich variety of pastry-mold canes (millefiori canes that flare out at the base) includes a pink rose and a rare yellow rose. Millefiori derives from an ancient Roman glass-making technique; this type of rose cane, developed by Venetian glassmakers, became practically a Clichy trademark and is known as the Clichy rose.

More decorative than utilitarian, glass paperweights were tremendously popular in mid-nineteenth-century Europe, and in the United States until late in the century. This vibrant lampwork example was one of the specialties of the Saint-Louis factory. In lampwork, an artisan uses a flame to heat glass rods and shape them into a variety of minute glass sculptures that are then covered by a dome of clear crystal. Single flowers and flat sprays were the most frequent motifs; detailed animals sometimes sat in delicate dioramas. With its rare amber coloring and the clear contours of the overlapping petals, this sprightly upright bouquet conveys a remarkable sense of depth and texture. Late in 1845, Saint-Louis became the first firm in France to produce signed and dated millefiori paperweights and vases. This lampwork dahlia and the other example on this page are part of the Art Institute's famous Arthur Rubloff Collection, a grouping of over 1,400 paperweights comprising examples from all periods, techniques, designs, and manufacturers.

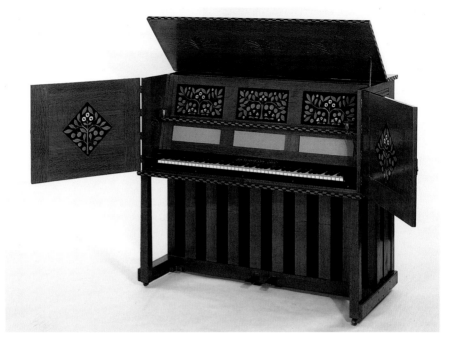

MANXMAN PIANOFORTE

English, 1897
Designed by Mackay Hugh Baillie Scott (Scottish, 1865–1945);
case and metalwork by Charles Robert Ashbee (1863–1942); movement
by John Broadwood and Sons, London; manufactured at Guild of Handicraft
Ltd., London
Oak, ebony, mother-of-pearl, ivory, copper fittings; 51 × 27½ in.
(129.5 × 69.9 cm)
Through prior restricted gifts of Robert Allerton, Margaret Day Blake, Mr. and
Mrs. Leopold Blumka, Walter S. Brewster, Emily Crane Chadbourne, Richard
T. Crane, Jr., Jack Linsky, Harry Manaster, Mrs. Joseph Regenstein, Sr., Mr.
and Mrs. John Wilson, Mrs. Henry C. Woods; through prior acquisition of the
Florene May Schoenborn and Samuel A. Marx Fund; European Decorative Arts
Purchase Fund, 1985.99

A product of the Arts and Crafts movement in Britain, the *Manxman Pianoforte* represents an innovative solution to the somewhat awkward form of the upright piano—enclosing it as in a cabinet. Motivated by the shoddy results of industrial mass production, the revolutionary movement stressed the recognition of furniture and decorative arts as works of art. Here, the celebrated Scottish architect and designer Mackay Hugh Baillie Scott created an object both cleverly functional and aesthetically pleasing. When opened, the lid and doors of the strikingly decorated cabinet act as acoustical sounding boards. Revealed inside is the musical instrument itself, as well as a profusion of exquisite handcrafted metalwork, including candle holders fixed to the sides of the case. The design, like the keyboard, is a study in contrasts of light and dark, especially the witty handling of the lower section's alternating pattern, which echoes the piano's keys. The name "Manxman" derives from Scott's early residence in the Isle of Man. This piano is one of several executed around 1900 with John Broadwood and Sons of London, who made the musical movements.

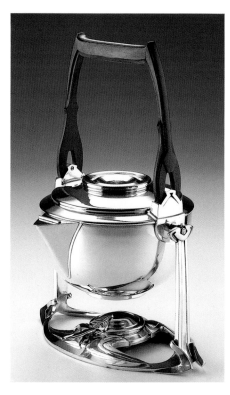

SAMOVAR

German, 1902/03
Designed by Henry van de Velde
(Belgian, 1863–1957), manufactured
at Theodore Müller, Weimar
Silvered brass, teak; h. 14⅞ in.
(37.9 cm)
Gift of the Historical Design Collection
and an anonymous donor; Mr. and Mrs.
F. Lee Wendell, European Decorative
Arts Purchase funds; Edward E. Ayer
in memory of Charles L. Hutchinson,
Bessie Bennett endowments; through
prior gifts of Walter C. Clark, Mrs. Oscar
Klein, Mrs. R. W. Morris, Mrs. I. Newton
Perry; through prior acquisition of
European Decorative Arts Purchase
funds, 1989.154

The Belgian architect and designer Henry van de Velde was one of the primary figures of Art Nouveau, an international design style informed by the British Arts and Crafts movement (see p. 115) that was born in the 1880s and flourished at the turn of the century. This samovar, or Russian tea kettle, beautifully illustrates the adroit mixture of taut lines and curvilinear motifs that characterizes van de Velde's mature Art Nouveau style. The sinuous organic lines of its base twist and snake around upright brackets that seem almost architectural in their strength and pick up again in the braided band motif of the teak handle. The kettle itself is simple in form, unornamented, and, with a prominent hinge on the spout cover, appears to be more engineered than crafted. This example is made of silvered brass and teak, in accord with van de Velde's philosophy that art should be accessible and affordable to a broad public (though other examples were made of silver). The kettle was designed at the Weimar School of Applied Arts, where van de Velde became director in 1904 (he had left Brussels in 1900). Later, this school became the Bauhaus, the bastion of Modernist design.

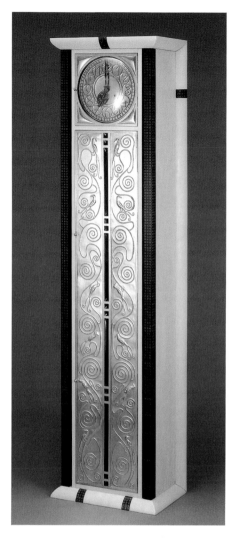

TALL-CASE CLOCK

Austrian, c. 1906
Designed by Josef Hoffmann (1870–
1956) and Carl Otto Czeschka (1878–1960)
Painted maple, ebony, mahogany, gilt
brass, glass, silver-plated copper,
clockworks; 70⁵/₈ × 18¹/₄ × 12 in.
(179.4 × 46.4 × 30.5 cm)
Laura Matthews, Mary Waller
Langhorne funds, 1983.37

This tall-case clock represents a masterful
collaboration between two major figures
in the Vienna Secession movement: the
architect Josef Hoffmann and the designer
Carl Otto Czeschka. Like their British
counterparts of the Arts and Crafts move-
ment, the Secession initially supported the
credo that art is for everyone, and worked
to create good and simple objects for
everyday use. A manifestation of this phil-
osophy was the Wiener Werkstätte, or
Vienna Workshop, of which Hoffmann
was a founder and Czeschka a member.
Produced by the Werkstätte's specialist
craftsmen, the clock embodies the unex-
pected dichotomy that arose within the
workshop: its early reformist ideals
resulted in progressive, even avant-garde,
products that appealed primarily to a priv-
ileged, sophisticated clientele. Hoffmann's
design consists of simple, architectonic
forms emphasized through the bold use of
stark, white-painted maple, and an inlaid
checkered pattern (a motif he favored). In
striking contrast to the case's austere recti-
linearity, Czeschka designed a luxurious,
hand-wrought scheme for its dial and
door. The door is fashioned from hand-
embossed gilt brass, inset with cut-glass
prisms. Its richly patterned surface deco-
ration depicts a stylized Tree-of-Life motif.
The hands gracing the dial are of silver-
plated copper.

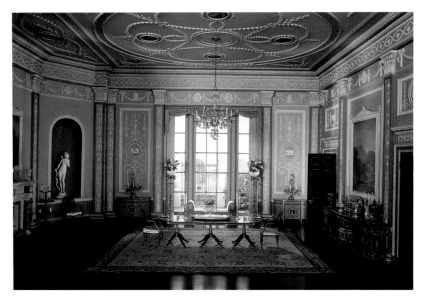

ENGLISH DINING ROOM OF THE GEORGIAN PERIOD

(1770/90), 1937/40
Miniature room; 11¼ × 19 × 16½ in. (28.6 × 48.3 × 41.9 cm)

The fascinating Thorne Miniature Rooms, sixty-eight in all, feature highlights from the history of interior design and the decorative arts from the thirteenth century to 1940. These enchanting miniature stage sets were conceived by Mrs. James Ward Thorne of Chicago and constructed between 1937 and 1940 by master craftsmen according to her exacting specifications, on a scale of one inch to one foot. The harmonious elegance seen here is derived from two dining rooms designed by Scottish-born Robert Adam, the successful eighteenth-century London architect whose precise and delicate interpretation of the antique (stimulated by the recent excavations at Herculaneum and Pompeii) dictated English taste for a quarter of a century. To insure perfect conformity, Robert (with his brother James) undertook the entire design of a house and every detail of its interior, hiring cabinetmakers like Thomas Chippendale, Jr., to execute furniture whose designs blended Neoclassical elements with current English forms. Instead of wood and wallpaper, Adam carved low-relief ornament in plaster in the style of Roman stuccos against painted panels, as seen in this dining room. Adam's furniture was often gilded in the continental fashion, as in the side table here. The landscape over the side table, painted by one of the many artists Mrs. Thorne commissioned, is in the style of Claude Lorrain (see p. 203).

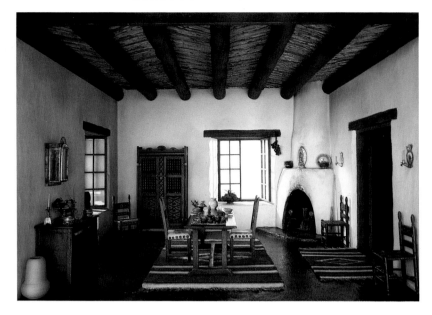

NEW MEXICO DINING ROOM

(c. 1940)
Miniature room; 12 × 17 × 16¾ in. (30.5 × 43.2 × 42.6 cm)

This model New Mexican interior illustrates the unique blend of Spanish and Native American cultures that distinguishes the Southwest. Inspired by modern New Mexican versions of ancient missions and haciendas, the dining room is essentially Spanish in feeling, but expressed with materials and methods native to the Pueblo Indians. Its walls are modeled after the thick walls of mud-plastered, white-washed adobe brick that protected the inhabitants from the extreme heat and cold of the desert. The mud-covered roof was supported by *vigas*, the ceiling beams of native pine. The herring-bone pattern of small saplings, called *latillas*, insulated the room and prevented dirt from sifting down from the mud roof. The floor was also made of earth, painted and polished. The traditional semicircular corner fireplace recalls the great Pueblo hivelike dwellings, some of which can be spotted through the open window. The solid, rectangular furniture with carved and painted decoration reflects its Spanish and Mexican heritage. The tin shrine, votive figure, and sconces are Mexican designs. Much of the miniature silver, pottery, and rugs was found by Mrs. James Ward Thorne, who shopped all over the world for miniature furniture, in Mexico City.

CORNER CABINET (ÉTAT D'ANGLE ENCOIGNUÉ)

French, c. 1916
Designed by Jacques Émile Ruhlmann
(French, 1879–1933)
Amboyna, ebony, and ivory veneer on
oak and mahogany carcass; replace-
ment silvered escutcheon plate; 50⅛ ×
32⅜ × 20½ in. (127.3 × 82.9 × 52 cm)
Restricted gift of Mrs. James W. Alsdorf,
Mrs. T. Stanton Armour, Mrs. DeWitt
W. Buchanan, Jr., Mrs. Henry M.
Buchbinder, Mrs. Robert O. Delaney,
Mrs. Harold T. Martin, Manfred
Steinfeld, and Mrs. Edgar J. Uihlein;
Mrs. T. Stanton Armour, Mr. and Mrs.
Robert O. Delaney, Mr. and Mrs. Fred
Krehbiel, and Mr. and Mrs. Eric
Oldberg funds; Mrs. Pauline S. Arm-
strong, Harry and Maribel G. Blum,
Richard T. Crane, Jr. Memorial, Mr. and
Mrs. Fred Krehbiel, Mary Waller Lang-
horne, and European Decorative Arts
endowments; through prior acquisitions
of the Antiquarian Society, European
Decorative Arts Purchase Fund, Howard
Van Doren Shaw, and Mr. and Mrs.
Martin A. Ryerson, 1997.694

This sumptuously veneered corner cabinet by the French designer Jacques Émile Ruhlmann is arguably a signature piece of the Art Deco era. This design term, used since the 1960s to refer to the high-style interiors of the interwar years — that is the late 1910s, 1920s, and early 1930s — is derived from the title of the 1925 Paris "Exposition internationale des arts déco-ratifs et industriels modernes." In this piece, the monumental triangular form with its serpentine door is supported on short, fluted legs that are shod with ivory on the two front feet, and that terminate at the knees with a scroll flourish of ivory sandwiched between amboyna veneers. Ruhlmann employed ebony and ivory to depict a large, fluted urn from which cascade an abundance of stylized flowers and leaves, overflowing the limits of their container to form a black-and-white oval against the amber tones of the burl amboyna background. Ruhlmann's success was based on his skillful use of exotic and costly materials; his emphasis on exquisite craftsmanship; and his mastery of inven-tive design in the traditions of eighteenth-century French cabinetmaking.

European
Painting

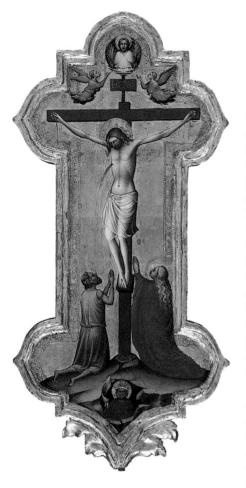

LORENZO MONACO
(Italian c. 1370–c. 1423)

The Crucifixion, c. 1400
Tempera on panel; 20 × 9¼ in.
(50.9 × 23.5 cm)
Mr. and Mrs. Martin A. Ryerson
Collection, 1933.1032

The delicate colors and simplified forms
of this intimate devotional panel indicate
that it was painted by Lorenzo Monaco, a
Camaldolese monk and leading Florentine
practitioner of the International Gothic
style, or by an assistant in his workshop.
In excellent condition, this panel offers
unusual iconographic features. The medal-
lion above the crucified Christ contains an
image of Christ in Glory holding a palm in
each hand to symbolize his victory over
death. Below, the crowned figure of King
David holds an inscribed scroll. (More typ-
ically in Crucifixion scenes of this period, a
pelican is shown at the top of the cross,
and the skull of Adam lies at the foot.)
Cloaked in a glowing red robe, a haloed
Mary Magdalen kneels to the right of the
cross. To the left, in a torn brown cloak, is
an unidentified *beatus* ("blessed one") with
incised rays issuing from his head. The
angle of the footrest gives the impression
that it is toward this unidentified man that
Christ turns. The function of the panel is
unclear. It may simply have ornamented a
cell in the monastic community in which
it was almost certainly painted.

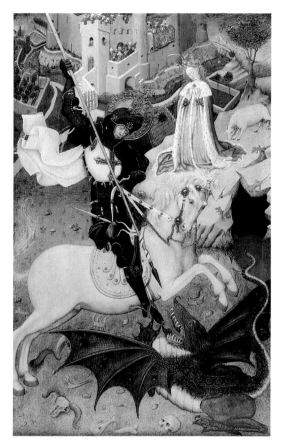

BERNARDO MARTORELL
(Spanish, c. 1400–1452)
Saint George Killing the Dragon, 1430/35
Tempera on panel; 61⅛ × 38⅝ in. (155.3 × 98 cm)
Gift of Mrs. Richard E. Danielson and Mrs. Chauncey McCormick, 1933.786

Bernardo Martorell was the greatest paint-er of the first half of the fifteenth century in Catalonia, the northeastern region of Spain. Depicted here is the most fre-quently represented episode from the pop-ular medieval legend of Saint George, in which the model Christian knight saves a town and rescues a beautiful princess. Conceived in the elegant and decorative International Gothic style, the panel scales its figures by their relative importance in the story. Saint George on his pure white steed is large as life as he triumphs over the evil dragon. The princess is smaller than the dominant figures, yet still quite big compared to her father the king and his threatened subjects, who watch from the distant, tiny castle. A wealth of pre-cisely observed details intensifies the drama. George's halo and armor and the scaly body of the dragon are richly mod-eled with raised stucco decoration. Draped in ermine, the princess wears a sumptuous gilded crown atop her wavy red hair. Even the sand seems gritty and alive, littered with bones and crawling with lizards. Originally, the painting was the large central panel of an altarpiece honoring the saint; it was surrounded by four smaller narrative panels, now in the Musée du Louvre, Paris.

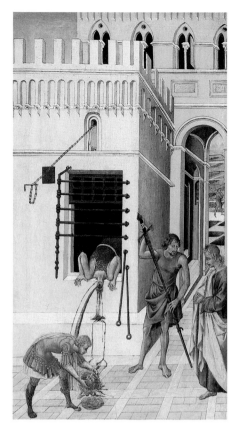

GIOVANNI DI PAOLO
(Italian, c. 1402–c. 1482)
The Beheading of Saint John the Baptist,
1450/60
Tempera on panel; 27 × 14¼ in.
(68.6 × 36.3 cm)
Mr. and Mrs. Martin A. Ryerson
Collection, 1933.1014

Among the most impressive achievements of the Sienese master Giovanni di Paolo is his narrative series illustrating the life of Saint John the Baptist, which once comprised a major altarpiece. With a wonderful feeling for detail and eccentricity of silhouette, the artist depicted events from John's life, from his birth, prophecy, and baptism of Christ, through his gruesome beheading at the request of Salome. These scenes are enacted in complex settings that exploit the tall, slender proportions of the panels and set off the expressive poses of the figures. *The Beheading of Saint John the Baptist* depicts the henchmen of Queen Herodias placing the head of John on a golden platter. The execution has occurred only moments before; blood spews profusely from the elongated neck of the saint. The rich patterning of the architecture, painted in soft colors, is complemented by the elegant, if gruesome, trails of blood falling to the ground and collecting beneath the decapitated corpse. Through the arch can be discerned the plowed fields and roads and tiny, jagged mountains inspired by the Tuscan landscape, painted in cool, delicate tones. Throughout the series, Giovanni skillfully repeated these colors, settings, and patterns to unite the narrative. Eleven of the original twelve panels survive: the Art Institute owns six and the remaining five are scattered in various European and American collections. Although the altarpiece's original setting is unknown, it is clear that the panels were arranged in two large, movable wings, like a double door, which may have enclosed a sculpture or reliquary shrine.

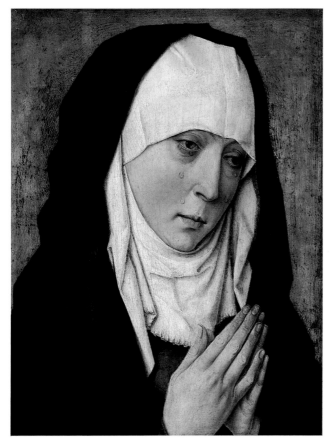

DIERIC BOUTS
(Netherlandish, c. 1420–1475)

Mater Dolorosa (Sorrowing Madonna), 1470/75
Oil on panel; 15¼ × 12 in. (38.8 × 30.4 cm)
Chester D. Tripp Fund; Chester D. Tripp Endowment;
through prior acquisition of Max and Leola Epstein, 1986.998

This intimate devotional painting by Dieric Bouts at one time formed the left side of a private diptych (a folding altarpiece). The gently grieving Madonna directs her gaze toward a now-lost representation of her suffering son in the right panel. The diptych marked that stage in the Passion narrative when Christ, crowned with thorns, was taunted as "king of the Jews"; the Crucifixion was yet to come. Bouts's capacity to project the emotional state of the Madonna, coupled with his exquisite attention to detail and texture, transformed his *Mater Dolorosa* into a movingly human devotional image. By focusing on the head and hands of the Madonna against a simple gold background, Bouts gave the painting the detached and timeless quality of an icon. Her elegantly elongated hands are joined in quiet supplication; her reddened eyes brim over with tears. The artist's sensitive treatment of light renders her skin almost luminous, her veil shimmering. The existence of numerous replicas of the Art Institute's painting indicates the degree to which Bouts's diptych captured the essence of late-fifteenth-century spirituality.

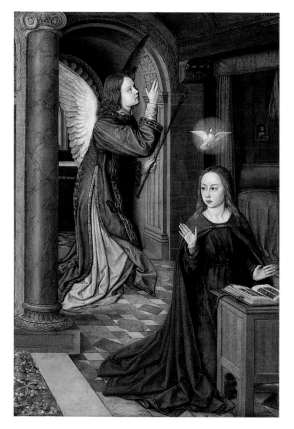

JEAN HEY
(THE MASTER OF MOULINS, French, active 1490/1510)
The Annunciation, c. 1500
Oil on panel; 28⅜ × 19¾ in. (72 × 50.2 cm)
Mr. and Mrs. Martin A. Ryerson Collection, 1933.1062

God seems omnipresent in this image of archangel Gabriel's announcement to Mary that she will give birth to Jesus Christ. The radiant colors and subtle modeling of such elements as the white dove, the holy book Mary is reading, even the delicate vegetation growing to the left of the elaborate marble floor appear to suffuse them with a holy presence. Jean Hey imbued with crystalline purity not only the cool, refined figures but every detail in this painting; his elegant observation, complex lighting, and glowing color made him the finest painter at the end of the fifteenth century in France. Employed by the regents Pierre de Bourbon and Anne de Beaujeu at their court in Moulins, Hey fused the intense naturalism and preciousness of Flemish and French manuscript painting with the emerging Renaissance interest in antiquity, which appears in the painting's Italianate architecture. *The Annunciation* probably formed the right side of an altarpiece honoring the Virgin Mary. The left panel included scenes of her parents, Joachim and Anne (National Gallery, London), and a central section, now lost, featured the Virgin and Child. This arrangement explains why Mary gestures and looks modestly to the left. Her attention is drawn toward what would have been the altarpiece's focus: the image of the Virgin enthroned.

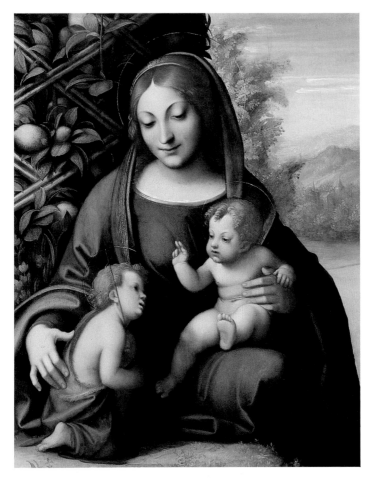

CORREGGIO
(ANTONIO ALLEGRI, Italian, c. 1494–1534)
Virgin and Child with the Young Saint John the Baptist, c. 1515
Oil on panel; 25¼ x 20⅛ in. (64.2 x 51 cm)
Clyde M. Carr Fund, 1965.688

Correggio spent most of his brief career in the northern Italian city of Parma. Despite his distance from the great centers of Renaissance art, he created a remarkably innovative body of work. This intimate devotional panel is a product of the artist's youth. In it, Correggio revealed his own evolving style while assimilating lessons from other masters. The panel's pyramidal grouping of soft, full figures reflects the High Renaissance manner of such artists as Leonardo da Vinci and Raphael. The bright contrasting colors recall the work of older northern Italian painters such as Andrea Mantegna, whereas the evocative use of the distant landscape demonstrates the young artist's awareness of Northern European examples. The gentle sensuousness of the figures and the tenderness they show one another through glance and gesture bear Correggio's unique signature. The young artist's mastery of light, shadow, and color seems to bathe the canvas in a soft, gentle glow; skin and fabrics appear almost velvet. The expressive, idyllic quality of this painting presages the radiant ceiling frescoes of Correggio's maturity.

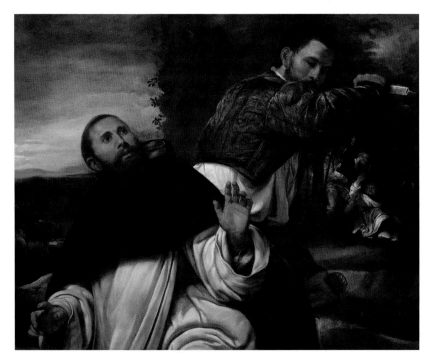

GIOVANNI GIROLAMO SAVOLDO
(Italian, c. 1480–1548)
The Death of Saint Peter Martyr, 1530/35
Oil on canvas; 45⁵⁄₁₆ × 55½ in. (115.3 × 141 cm)
Lacy Armour Endowment, 2001.330

With its high drama and bold composition, this painting is one of Giovanni
Girolamo Savoldo's most ambitious works. Dating to Savoldo's mature period in
Venice (c. 1524–48), it depicts the murder of Saint Peter Martyr, a thirteenth-
century Dominican friar who devoted himself to reconverting to Catholicism
the Cathar heretics in northern Italy. Enraged by Saint Peter's activities, several
Cathars ambushed him on a road near Milan. The artist represented the assas-
sin as he is about to stab the friar with a small dagger, while the killer's left
hand grasps the sword with which he will deliver the final, fatal blows. The
Cathar's vibrant, red jacket conveys the passion and anger of his act, otherwise
veiled by his curiously introspective countenance. The saint's situation—his vul-
nerability and resignation—is eloquently communicated by his open left hand,
isolated in the very center of the composition. The ominous, twilit sky behind
Peter's head fittingly complements the narrative. Savoldo's darkly poetic work
pays homage to a once-renowned (now destroyed) altarpiece by the Venetian
Renaissance master Titian. At the same time, the painting displays a realism
(note the saint's undershirt, visible up his sleeve) that was typical of art in
Savoldo's native town of Brescia. Such natural details and direct presentation
would later influence the great Baroque master Caravaggio (1571–1610).

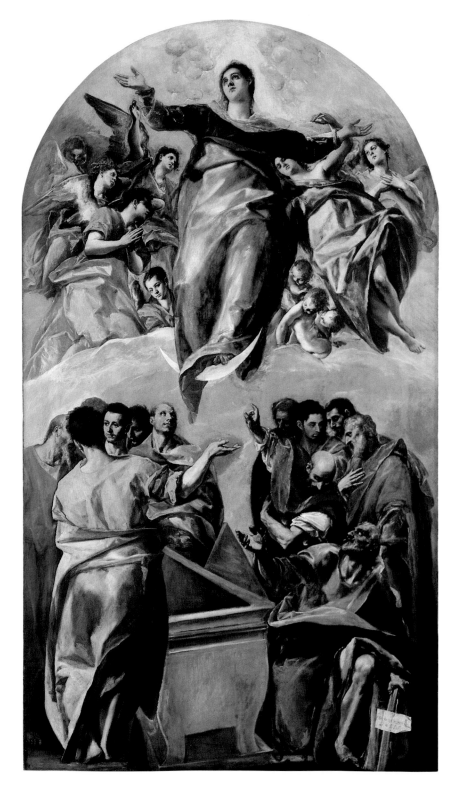

EL GRECO
(Domenico Theotokópoulos,
Spanish, 1541–1614)

The Assumption of the Virgin, 1577
Oil on canvas; 158 × 90 in. (401.4 ×
228.7 cm)
Gift of Nancy Atwood Sprague in
memory of Albert Arnold Sprague,
1906.99

This monumental composition was the central narrative of El Greco's first major Spanish commission that was also his first large public work. After living in Venice and Rome, where he absorbed the late Mannerist style, the Greek-born artist settled in Toledo, Spain, in 1577 in order to work on the high altar of the convent church of Santo Domingo el Antiguo. The church of this ancient convent of the Cistercian order was being rebuilt as the funerary chapel of Doña Maria de Silva, a pious widow who lived there in the last decades of her life, and of Don Diego de Castilla, the dean of Toledo cathedral and executor of Doña Maria's will. *The Assumption of the Virgin* and the other painted portions of the altarpiece were set in an austerely harmonious architectural framework that filled the end wall of the church's sanctuary. The *Assumption* was surmounted by a grand image of the Trinity surrounded by angels and was flanked by two side altars decorated with El Greco's highly charged images of the Adoration of the Shepherds and the Resurrection. The imagery of the altarpiece emphasizes the saving power of Christ's Incarnation and Resurrection, and of the masses said for the patrons buried in the sanctuary. El Greco divided the *Assumption*'s tall, narrow composition into two zones that intensify its impassioned drama and spirituality: the earthly sphere of the apostles and the celestial sphere of the angels. The Virgin rises majestically above her empty tomb, purposely given a rather blank form since this spot above the altar table would have been covered by the tabernacle that housed the Eucharist. She is carried on a crescent moon, a symbol of her purity. Draped in brilliantly colored garments, the powerful figures of the apostles crowd together in wonder around the Virgin's tomb; their faces and gestures express emotions ranging from confusion and disbelief to excitement and awe as they gaze into the heavens. The swinging, upward movement of the Virgin, and the flickering, almost supernatural colors aptly represent the hope of salvation that motivated the foundation and decoration of Doña Maria's funerary chapel. With its bold, agitated figural arrangement and broad, free brushwork, this early painting seems to burst from its frame with the expressive energy that would characterize El Greco's mature works.

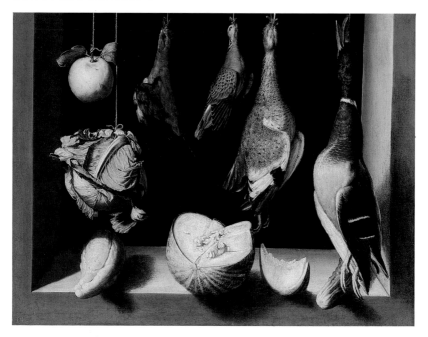

JUAN SÁNCHEZ COTÁN
(Spanish, 1561–1627)

Still Life, c. 1602
Oil on canvas; 26¾ × 35 in. (67.8 × 88.7 cm)
Gift of Mr. and Mrs. Leigh B. Block, 1955.1203

This work, the Art Institute's earliest European still life, was painted by a
leading Spanish practitioner of this new genre. The composition exhibits Juan
Sánchez Cotán's signature format: commonplace edibles placed in a shallow,
windowlike setting against an impenetrable dark background. Some of his still
lifes contain few objects, while others, such as this one, fill the space in front
of the window. The objects are painstakingly rendered, and their placement
seems mathematically exact. The hanging apple and birds are arranged not
perpendicular to the bottom edge of the painting, but on a barely perceptible
diagonal. Further enlivening the composition is the strong, implacable light
that sweeps over the still life and creates a dramatic juxtaposition of light and
shade, of precise realism and abstract form. After 1603, the artist stopped
creating these austere and powerful images. In a shift that was not uncommon
in seventeenth-century Spain, Cotán left his successful artistic career in Toledo
to join the Carthusian order as a lay brother at the charterhouse of Granada.
Thereafter, his work consisted solely of idealized religious images.

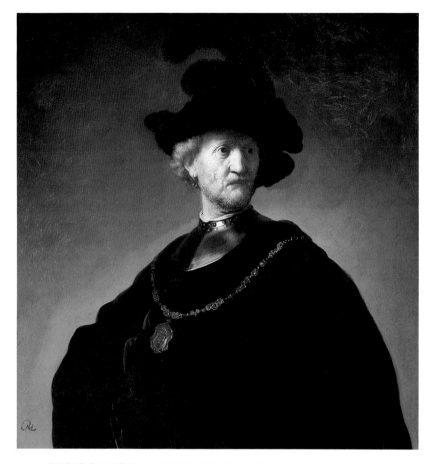

REMBRANDT HARMENSZ. VAN RIJN
(Dutch, 1606–1669)
Old Man with a Gold Chain, c. 1631
Oil on panel; 32¾ × 29¾ in. (83.1 × 75.7 cm)
Mr. and Mrs. W. W. Kimball Collection, 1922.4467

This evocative character study is an early example of a subject that preoccupied the great Dutch master Rembrandt van Rijn throughout his long career. Although Rembrandt's prolific output ranged from landscape and genre paintings to biblical scenes and still lifes, he was fascinated by the portrayal of single figures, penetratingly observed through the use of dramatic costume and rich and subtle lighting. Here is the face of a real person, weathered and watchful, glowing with pride and humanity. The simplicity of the broad, black mass of the old man's torso against a neutral background contrasts vividly with the worldly trappings of his gold chain, steel gorget, and plumed beret (one of many such costumes Rembrandt collected for his models). The unidentified sitter, once thought to be Rembrandt's father, was a favorite model who appeared in many of the artist's early works. The confident execution suggests that the young Rembrandt completed this picture about the time he left his native Leiden to pursue a career as a fashionable portrait and history painter in Amsterdam, and that perhaps he wished to use this work to demonstrate his skills in a genre that combined both these branches of the art.

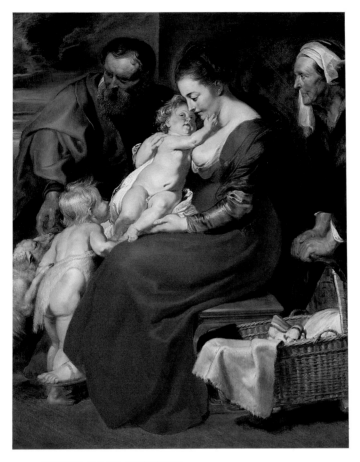

PETER PAUL RUBENS
(Flemish, 1577–1640)
The Holy Family with Saints Elizabeth and John the Baptist, c. 1615
Oil on panel; 45⅛ × 36 in. (114.5 × 91.5 cm)
Major Acquisitions Endowment, 1967.229

This painting of the Holy Family is one of several completed in the decade after
Peter Paul Rubens returned to his native Antwerp, following an eight-year stay
in Italy. Fully immersed in Italian art, the prodigiously productive artist had
acquired such facility in handling brush and color, figures and drapery, and in
arranging large-scale compositions, that he had no rival north of the Alps.
Here, he displayed these skills by not only bringing a sacred subject to life, but
by bringing it down to earth as well. Vital and believable Flemish figures fill the
composition, which is dominated by the brilliantly clad Madonna. The bold,
diagonal movement of the playful and charming infants — John and Jesus — is
an effective counterbalance to the full, rounded figure of Mary. Saints Joseph
(Mary's husband) and Elizabeth (her cousin, and John's mother) frame the
dynamic pyramidal group, as aged and more passive protectors. This atmo-
sphere of joyful solemnity — of light, color, and life — presages Rubens's later
work, which included huge decorative schemes for churches and palaces
throughout Europe.

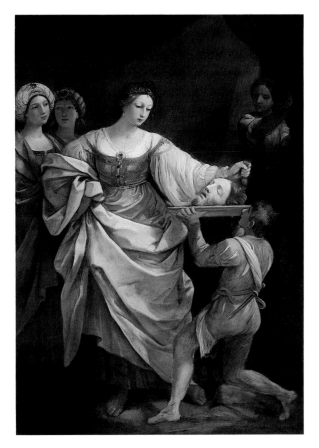

GUIDO RENI
(Italian, 1575–1642)
Salome with the Head of Saint John the Baptist, 1639/40
Oil on canvas; 97¾ × 88½ in. (248.5 × 224.8 cm)
Louise B. and Frank H. Woods Fund, 1960.3

In this large canvas, Guido Reni, a leading seventeenth-century Bolognese painter, depicted one of the New Testament's more macabre stories. Salome, the daughter of Herodias, so pleased her stepfather Herod Antipas by dancing at his birthday feast that he promised to grant her any wish. Prompted by her vengeful mother, Salome asked for the head of the prophet John the Baptist, whom Herod had imprisoned for denouncing his marriage. The painting illustrates the moment when the head of the saint is presented to the beautiful young woman. Highly selective in his palette and choice of detail, Reni presented this gory event with rhythmic grace, soft modeling, and elegant remove; no blood drips from John's head. Color and illumination are cool; there is no specific setting, nor are there any strong emotions. The only indulgences are Salome's exquisite garment and headdress, and the mint-green costume worn by the young servant. In this late work, the handling of the figures is broad. The legs of the young page and the feet of Salome seem almost unfinished. The rapid brushstrokes and sketchy execution in this area, as well as the canvas's luminous transparency, have raised the central, unresolved question of much of Reni's late work: whether or not it was completed.

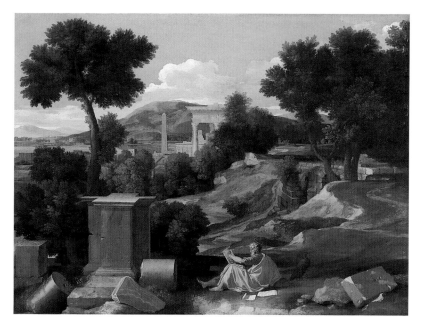

NICOLAS POUSSIN
(French, 1594–1665)

Landscape with Saint John on Patmos, 1640
Oil on canvas; 40 × 53½ in. (101.7 × 136 cm)
A. A. Munger Collection, 1930.500

Although French by birth and training, Nicolas Poussin spent most of his
career in Rome, immersed in ancient art and history and painting classically
inspired works for an educated elite. His noble and austere art has long been
considered the embodiment of the ideals of seventeenth-century classicism.
In this early painting, Saint John, one of the four evangelists who wrote the
Gospels of the Bible's New Testament, reclines beside an eagle (which symbol-
izes him) composing the Book of Revelation. To suggest the vanished glory
of antiquity, Poussin carefully constructed an idealized setting for the saint,
whom he has dressed like a Roman orator — the Greek island of Patmos, com-
plete with an obelisk, temple, and column fragments. In Poussin's Patmos,
man-made and natural forms are adjusted according to principles of geometry
and logic to reinforce the measured order of the scene. Even the profile view of
Saint John is in total harmony with the classical landscape surrounding him.
This painting was probably part of a projected series on the four evangelists.
Only this work and its companion, *Landscape with Saint Matthew* (Gemälde-
galerie, Berlin), are known to have been completed.

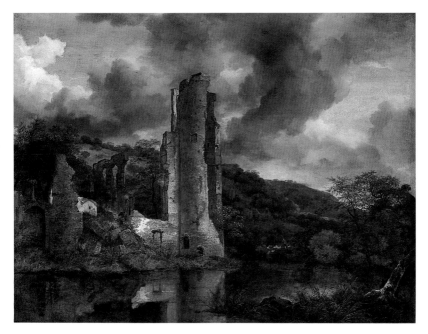

JACOB VAN RUISDAEL
(Dutch, 1628/29–1682)

Landscape with the Ruins of the Castle of Egmond, 1650/55
Oil on canvas; 38¾ × 51¼ in. (98.5 × 130 cm)
Potter Palmer Collection, 1947.475

The heroic but ephemeral constructions of humankind and the enduring power and grandeur of nature are evocatively expressed in this brooding canvas by the landscapist Jacob van Ruisdael. A shepherd and his flock are dwarfed by the towering ruins of Egmond, the long, massive hill behind it, and the dark, swollen clouds gathering above. Ruisdael's skillful use of color also enhances the painting's poetic effect. Other than the glowing terracotta of the ruins and the restrained use of white and near-white, his palette consists mostly of the dark greens and browns of nature. There is only one small point of bright color in the entire painting: the shepherd's red jacket. Although Ruisdael's choice of ruins as his subject followed an established pictorial tradition in the Netherlands, he was not concerned with overall topographical accuracy, for the prominent hill behind the structure was a product of his imagination. The castle, once the seat of the counts of Egmond, had powerful associations. It was destroyed at the command of the prince of Orange to prevent the Spanish army from occupying it during the Dutch struggle for independence from Spanish rule in the late sixteenth century.

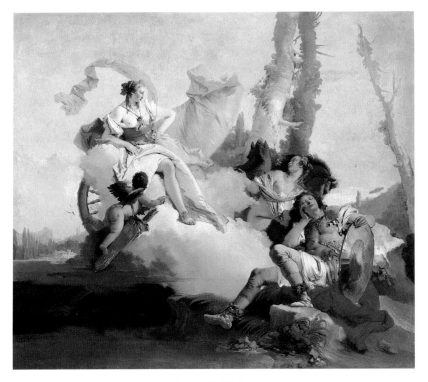

GIOVANNI BATTISTA TIEPOLO
(Italian, 1696–1770)

Rinaldo Enchanted by Armida, 1742
Oil on canvas; 73⅞ × 85⅜ in. (187.5 × 216.8 cm)
Bequest of James Deering, 1925.700

Giovanni Battista Tiepolo's gigantic ceiling and wall decorations epitomize the lighthearted exuberance of the Rococo style. His mastery of light, color, and illusion transformed castles and monasteries not only in his native Venice and Italy but throughout Germany and Spain, as well. This painting is the first in a series of four, now all in the Art Institute, from a room in a Venetian residence. The suite illustrates Torquato Tasso's popular sixteenth-century epic romance, *Gerusalemme liberata*, about the First Crusade, in the eleventh century, to take Jerusalem from the Muslims. The canvas captures the very moment of seduction: the beautiful sorceress Armida has just arrived to divert the sleeping hero Rinaldo from his crusade. Accompanied by her attendant nymph and a cupid figure, she appears like a beautiful mirage, seated on a billowing cloud, her drapery and shawl wafting gently behind her. Tiepolo's effervescent colors, luminous airy atmosphere, and creamy density of paint enhance the work's extraordinary pictorial beauty. Although Tasso's story symbolizes the conflict between love and duty, Tiepolo's rendering of a magical pastoral world seems to evoke only love's enchantment.

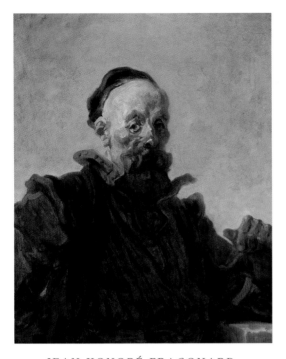

JEAN HONORÉ FRAGONARD
(French, 1732–1806)
Portrait of a Man, 1768/70
Oil on canvas; 31⅝ × 25½ in. (80.3 × 64.7 cm)
Gift of Mary and Leigh Block in honor of John Maxon, 1977.123

Jean Honoré Fragonard is perhaps best known for his light-hearted, amorous subjects, which seem to embody the spirit of eighteenth-century France. This portrait, painted in lively brushstrokes, represents another important aspect of Fragonard's genius, in which he used the work of earlier artists to inspire vivid characterizations of his patrons and artistic friends. Here, the identity of the sitter is unknown; however, the composition, the rapid, virtuoso handling of the paint, and use of seventeenth-century costume link this work to a group of fantasy portraits that are among the artist's most striking and original achievements. In this instance, Fragonard took as his starting point a depiction of an actor by the Italian Baroque painter Domenico Fetti, then in a leading Parisian collection; in other related portraits, the French painter was inspired by the bravura style of Flemish artists Peter Paul Rubens and Anthony van Dyck. Two paintings from this series bear inscriptions stating that they were painted in one hour. Whether or not this is literally true, the direct, personal quality that results from Fragonard's command of the medium makes these fantasy portraits particularly appealing to a modern sensibility.

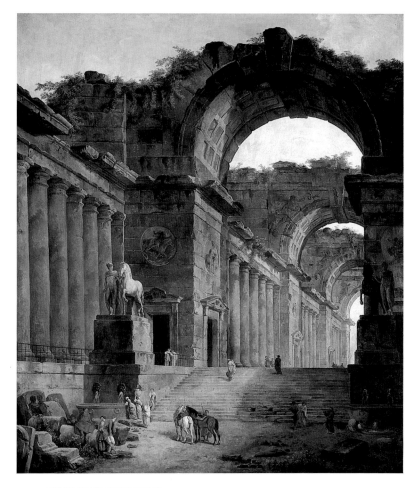

HUBERT ROBERT
(French, 1733–1808)
The Fountains, 1787/88
Oil on canvas; 100¼ × 88 in. (254.5 × 223.5 cm)
Gift of William C. Hibbard, 1900.385

Neoclassical ruin painting had reached its zenith of popularity when Hubert Robert, its foremost French practitioner, was commissioned in 1787 to paint a suite of four canvases for a wealthy financier's chateau at Méréville. Robert had gleaned his artistic vocabulary from more than a decade's study (1754–65) in Rome. Like the other three massive compositions, all in the Art Institute, *The Fountains* contains Robert's stock-in-trade: fictive niches, arches, coffered vaults, majestic stairwells, decaying colonnades, and Roman statuary. These are staffed with tiny figures in the foreground who serve only to set the scale and animate the scene, for the ruins themselves are the true subject of the picture. Just as the exaggerated architectural scale dwarfs the figures, so were *The Fountains* and its companion pieces meant to dominate the chateau's salon. Thus Robert expressed the Romantic concept then current of the relationship of man and his works to nature, as expressed by the French philosopher and encyclopedist Denis Diderot: "Everything vanishes, everything dies, only time endures."

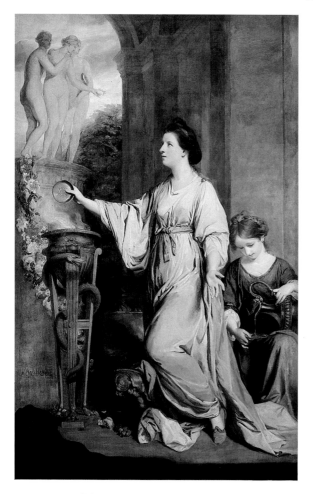

SIR JOSHUA REYNOLDS
(English, 1723–1792)

Lady Sarah Bunbury Sacrificing to the Graces, 1763–65
Oil on canvas; 95¼ × 59⅝ in. (242 × 151.5 cm)
Mr. and Mrs. W. W. Kimball Collection, 1922.4468

Lady Sarah Bunbury, a renowned beauty of the eighteenth century, began sitting for Sir Joshua Reynolds when she was eighteen, three years after attracting the attention of young King George III and one year after her marriage to Sir Charles Bunbury, a baronet. The artist—the first president of the Royal Academy, and author of fourteen classic discourses on painting that promulgated Neoclassicism—conferred upon her a flattering honorary citizenship in the ancient world. Dressed in a loose, vaguely Roman costume and surrounded by the art and artifacts of antiquity, Lady Sarah is cast as a devotee of the Three Graces, symbols of generosity and the mythical companions of Venus, the goddess of love and beauty of ancient Rome. She pours a libation into a smoking tripod; the statue seems to offer her a wreath, as if the Graces themselves are inviting the aristocratic beauty to join their number. To heighten this illusion the color seems to drain from the upper part of Lady Sarah's robe, as if she were meeting them halfway.

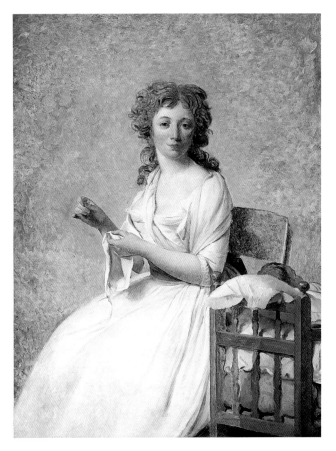

JACQUES LOUIS DAVID
(French, 1748–1825)
Madame de Pastoret and Her Son, 1791/92
Oil on canvas; 52⅜ × 39⅜ in. (133.1 × 100 cm)
Clyde M. Carr Fund; Major Acquisitions Endowment, 1967.228

The volatile events leading to the French Revolution make the date of Jacques Louis David's warm and fresh portrait of Adélaïde de Pastoret impossible to determine with certainty. They also probably account for the portrait's unfinished state. David, a renowned Neoclassical painter, was at the time an ardent revolutionary; the marquise was the wife of a staunch royalist. The sittings must have occurred after the birth, early in 1791, of her son, who is portrayed here asleep by her side, and before her brief imprisonment during the Reign of Terror in 1792. David completed the stippled, almost monochromatic underpainting, but did not work up the stark, enamel-smooth surface characteristic of his finished paintings. He did not even have time to place the needle and thread in Madame de Pastoret's hand. Nevertheless, this large portrait of unaffected domesticity captures the youthful mother with charm as well as dignity and displays David's skill as a portraitist. Objecting to David's revolutionary ideals, the marquise refused the painting during the artist's lifetime. After David's death, she had her son, by then grown up (see p. 143), purchase the portrait.

JEAN AUGUSTE DOMINIQUE INGRES
(French, 1780–1867)
Amédée-David, Marquis de Pastoret, 1823–26
Oil on canvas; 40½ × 32¾ in. (103 × 83.5 cm)
Bequest of Dorothy Eckhart Williams; Robert Allerton, Bertha E. Brown,
Major Acquisitions endowments, 1971.452

Jean Auguste Dominique Ingres, who championed classical ideals throughout his long and productive career, began this portrait in 1823, the same year that the thirty-two-year-old marquis helped his portraitist become a full member of the French Academy. Ingres astutely captured the character of this suave young nobleman, from the refined line of his silhouette to his elegant costume, long fingers, and slightly swaggering pose. The artist's fastidious and impeccable technique is particularly evident in the precisely rendered details of the sword hilt and the Order of the Legion of Honor, which the marquis had received in 1824. Ingres had studied in the famous atelier of Jacques Louis David; although he considered himself a history painter, portraits such as this paid his bills for many years and earned him much praise. This work was in progress, in fact, at about the same time that the marquis acquired David's painting of his mother (see p. 142). In 1897, *Amédée-David, Marquis de Pastoret* was purchased by the painter Edgar Degas, an avid art collector and admirer of Ingres who succeeded the older artist as the greatest French portrait painter of his generation.

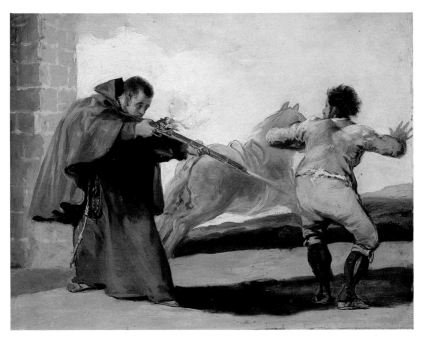

FRANCISCO GOYA Y LUCIENTES
(Spanish, 1746–1828)

Monk Pedro de Zaldivia Shoots the Bandit Maragato, 1806/07
Oil on panel; 12 × 15¾ in. (30.3 × 39.9 cm)
Mr. and Mrs. Martin A. Ryerson Collection, 1933.1075

When the dreaded bandit Maragato was seized in 1806 by the humble monk Pedro de Zaldivia, a lay brother of a Franciscan barefoot order, the story swept through Spain. Not only did daily newspapers and pamphlets publicize it, but songs, ballads, and popular prints praised the heroic deed. At that time, Francisco Goya was chief painter to the Spanish king. Profoundly intelligent, the great artist was interested in the whole range of human experience, including contemporary Spanish events, and the tale evidently captured his imagination. This small, lively painting belongs to a series of six in the Art Institute which, like a modern-day comic strip, dramatically illustrates the event. This climactic scene presents the bandit's degrading and not unhumorous downfall at the hands of brave monk Pedro. Here, as in all the panels, Goya's broad and quick brushwork dispenses with unnecessary detail to pinpoint the essential drama of the event. Goya seems to have made these paintings for his own interest rather than for a commission, because they were still listed among his possessions in an 1812 inventory.

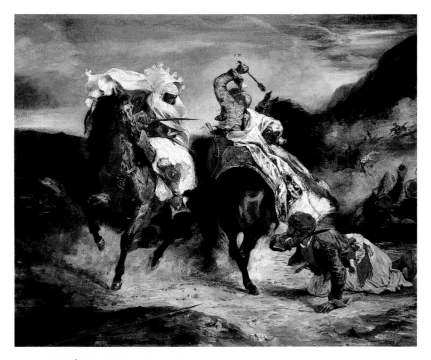

EUGÈNE DELACROIX
(French, 1798–1863)

The Combat of the Giaour and Hassan, 1826
Oil on canvas; 23½ × 28⅞ in. (59.6 × 73.4 cm)
Gift of Bertha Palmer Thorne, Rose Movius Palmer, Mr. and Mrs. Arthur M.
Wood, and Mr. and Mrs. Gordon Palmer, 1962.966

The Combat of the Giaour and Hassan is considered one of the finest early representations of battle by one of the leaders of the French Romantic movement, Eugène Delacroix. The painting was inspired by "The Giaour," a lengthy poem by England's most famous Romantic poet, Lord Byron. Written in 1813 and translated into French in 1824, the poem presents a subject, passion avenged, and a setting, an exotic battlefield in Greece, that perfectly suit the Romantic imagination. The painting depicts the poem's dramatic climax, when the Venetian giaour (a Christian infidel), his eyes bloodshot, avenges his lover's death at the hands of a Turk called Hassan. Weapons poised, the two enemies face off in mirroring poses: the Giaour in swirling white, and Hassan with his face not visible. This painting, with its exotic costumes, intense drama, and high-keyed colors and forms, is considered the finest of six known versions Delacroix based on Byron's poem. Begun in 1824, the year Byron died in the struggle for Greek independence from the Turks, the painting was finished two years later, just in time to be included in a Parisian exhibition benefiting the popular Greek cause.

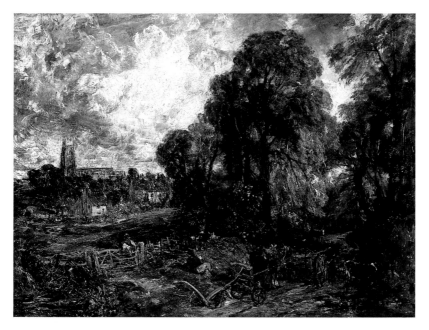

JOHN CONSTABLE
(English, 1776–1837)
Stoke-by-Nayland, 1836
Oil on canvas; 49⅝ × 66½ in. (126 × 169 cm)
Mr. and Mrs. W. W. Kimball Collection, 1922.4453

Stoke-by-Nayland depicts the lifelong subject matter of the landscape painter
John Constable: the Suffolk countryside of his youth. Constable based his
landscapes on countless studies and sketches that he would often take back to
his London studio to expand and then finish. Of *Stoke-by-Nayland*, he wrote to a
friend: "What say you to a summer morning? July or August, at eight or nine
o'clock, after a slight shower during the night." To achieve the effect of spark-
ling wetness and a freshness of earth and air, Constable painted as much with a
palette knife as with a brush, flecking the surface with white highlights, sketch-
ing and scraping the picture into existence. The deliberate ruggedness of his
style echoes nature's rough spontaneity. The unpolished execution is remi-
niscent of the full-scale sketches in oil Constable made for earlier exhibition
paintings, but no more fully treated version is known, and the rich color sug-
gests that it is a finished work, done in his late style. Constable's emphasis
on surface brushwork and texture in his effort to record the constantly shift-
ing effects of natural light on land and sky exerted enormous influence on
French artists like Delacroix and a younger generation of French painters, the
Impressionists.

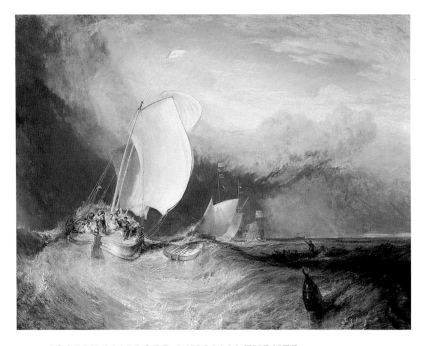

JOSEPH MALLORD WILLIAM TURNER
(English, 1775–1851)

Fishing Boats with Hucksters Bargaining for Fish, 1837/38
Oil on canvas; 68¾ × 88½ in. (174.5 × 224.9 cm)
Mr. and Mrs. W. W. Kimball Collection, 1922.4472

In *Fishing Boats with Hucksters Bargaining for Fish*, Joseph Mallord William
Turner translated his enduring preoccupation with the sea into a dramatic
vision. The subject itself and the painting's low horizon line derive directly
from seventeenth-century Dutch sea painting. But where the boats in seascapes
of that period are almost reconstructible in their exactness, Turner's minimal
and more impressionistic depiction of vessels is secondary to the drama of the
roiling seas, billowing sails, and threatening sky. With just a few figurative
details, Turner roughly sketched in tiny figures in the foreground who are
presumably to negotiate with the standing figure to the right. Between them
is a mythical golden boat that seems to spring from the artist's imagination
and, on the distant horizon, the suggestion of progress, a steam-driven vessel.
With his manipulation of translucent and opaque pigments to create a sense
of atmosphere and light, Turner alluded to the insignificance of man in the
face of nature's mysterious and sublime power.

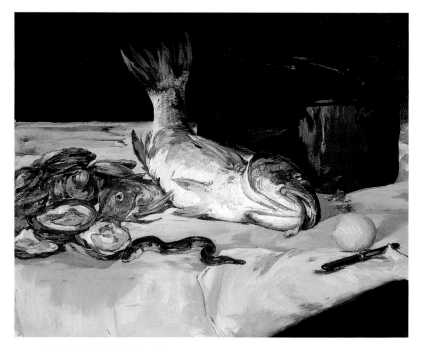

EDOUARD MANET
(French, 1832–1883)

Fish (Still Life), 1864
Oil on canvas; 28⅞ × 36¼ in. (73.4 × 92.1 cm)
Mr. and Mrs. Lewis Larned Coburn Memorial Collection, 1942.311

Although still-life ensembles were an important element in many of the major
paintings of the avant-garde artist Edouard Manet, his most sustained interest
in the genre itself was from 1864 to 1865, when *Fish* was painted. Manet's
focus on still lifes coincided with the gradual reacceptance of the genre during
the nineteenth century, due in part to the growing middle class whose tastes
ran to intimate, moderately priced works. This painting, like many of Manet's
still-life compositions, recalls seventeenth-century Dutch models. The direct-
ness of execution, bold brushwork, and immediacy of vision displayed in this
canvas suggest why the public found Manet's work so unorthodox and con-
frontational. While *Fish* is indeed about "dead nature." (*nature morte* is the
French term for the genre), there is nothing still here: the produce seems fresh
and the handling of paint vigorous. Further enlivening the composition is the
placement of the carp, which offsets the strong diagonal of the other elements.
Manet never submitted his still lifes to the official exhibition called the Salon,
but sold them through the burgeoning network of art galleries and also gave
them to friends.

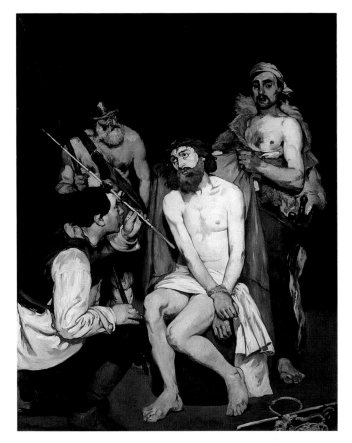

EDOUARD MANET
(French, 1832–1883)
The Mocking of Christ, 1865
Oil on canvas; 74⁷/₈ × 58³/₈ in. (190.3 × 148.3 cm)
Gift of James Deering, 1925.703

Although the art of Edouard Manet was often rooted in references to the history of art, his subjects — parks, cafés, racetracks — were usually quite modern. *The Mocking of Christ* represents a foray into religious imagery that was rare for Manet (and for his peers in the French avant-garde). Its theme, heroic scale, and dark colors relate it to Old Master paintings. Its treatment, however, reflects Manet's usual daring, his flouting of convention. Here, the viewer is confronted with a very human, vulnerable Jesus whose fate is no longer his to determine. Manet depicted the moment when Jesus' captors have mocked the "king of the Jews" by crowning him with thorns and covering him with a purple robe. Although this taunting is followed by beatings, according to Gospel narrative, Manet's three earthy and contemporary-looking soldiers appear ambivalent as they surround the pale, stark figure of Jesus. One gazes at him, one kneels in apparent homage, and one holds the purple cloak in such a way as to suggest that he wishes to cover Christ's nakedness, rather than strip him. Manet's use of stark contrasts, flat forms, and a dark palette of thickly applied pigment enhances this raw and powerful impression.

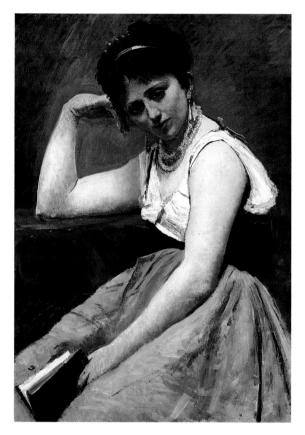

JEAN BAPTISTE CAMILLE COROT
(French, 1796–1875)

Interrupted Reading, c. 1870
Oil on canvas mounted on board; 36⅜ × 25⅝ in. (92.5 × 65.1 cm)
Potter Palmer Collection, bequest of Bertha Honoré Palmer, 1922.410

Interrupted Reading is among the greatest of Camille Corot's late figure paintings. Corot almost never exhibited these studies of the human form, preferring instead to publicize the idyllic landscapes that were his specialty. To emphasize the private nature of *Interrupted Reading*, Corot enclosed the model within the protective environment of a neutral studio. The mood is introspective, somewhat melancholic, the very essence of the Romantic sensibility. This muselike image of a woman holding a book was a popular one in nineteenth-century art, despite the rarity of females with enough leisure or learning to read. A lover of everything Italian (Corot spent a number of years there), the artist often furnished his models with Italianate costumes such as the one worn here. Whereas Corot's subject matter is traditional, his technique is not. With direct and bold brushwork, he explored the human form as a construction of masses that support and balance one another. This broad handling is complemented by the artist's obvious delight in detail—the ribbon in the model's hair, the delicate earrings, the deep folds in the skirt. Corot combined here a profound sense of formal structure with the dreamy softness and intimacy that characterize his most famous landscapes.

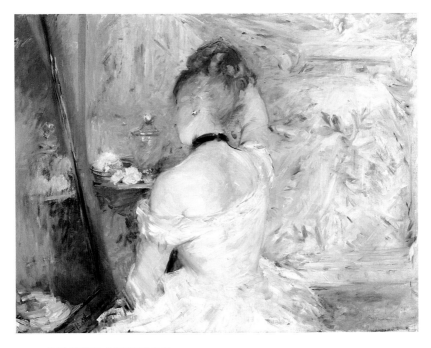

BERTHE MORISOT
(French, 1841–1895)

Woman at Her Toilette, c. 1875
Oil on canvas; 23¾ × 31⅝ in. (60.3 × 80.4 cm)
Stickney Fund, 1924.127

Consistent with the Impressionist aesthetic that Berthe Morisot fervently
espoused, *Woman at Her Toilette* attempts to capture the essence of modern life
in summary, understated terms. The painting also moves discreetly into the
realm of female eroticism explored by Edgar Degas, Pierre Auguste Renoir, and
Edouard Manet but seldom broached at this time by women artists. Rendered
with soft, feathery brushstrokes in nuanced shades of pink, blue, white, and
gray, the painting resembles a visual tone poem, orchestrated with such per-
fumed and rarified motifs as brushed blonde hair, satins, powder puffs, and
flower petals. Morisot even signed her name along the bottom of the mirror, as
if to suggest that the image in her painting is as ephemeral as a silvery reflec-
tion. Morisot exhibited in seven of the eight Impressionist group shows; this
painting was shown at the fifth exhibition, in 1880, where her work received
high acclaim. She was in particular a close friend of and frequent model for
Manet; she married his younger brother Eugène the year before she completed
this painting. In addition to domestic interiors such as this one, Morisot's
pictorial realm included studies of women and children, and of gardens,
villages, and fields.

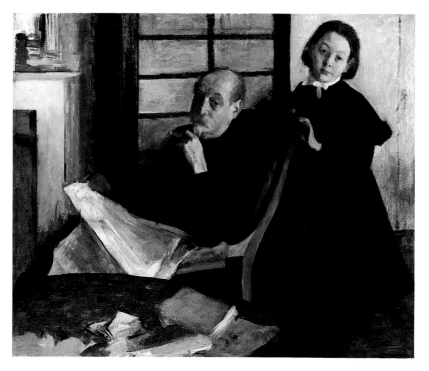

HILAIRE GERMAINE EDGAR DEGAS
(French, 1834–1917)

Uncle and Niece (Henri de Gas and His Niece Lucie de Gas), 1875/78
Oil on canvas; 39¼ × 47¼ in. (99.8 × 119.9 cm)
Mr. and Mrs. Lewis Larned Coburn Memorial Collection, 1933.429

Edgar Degas's masterful and subtle portraits mainly depict close relatives and friends. His approach was rigorous and probing, but the end result was calculated to look like a spontaneous rendering of a private and unguarded moment. Degas painted this double portrait of his uncle Henri and first cousin Lucie in the Degas family residence in Naples, shortly after the orphaned Lucie had been placed in her bachelor uncle's care. The double portrait is innovative for its bold horizontal composition and sensitive expression of complex feelings and relationships. Both Degas and his uncle were also in mourning for the artist's father, who had died recently. Degas captured his relatives with almost photographic immediacy; his uncle seems to have just put down the newspaper and paused between puffs on his cigar. The bond of bereavement between man and child is suggested by the similar tilt of their heads and their black mourning clothes. But the contrasting backgrounds behind the figures and the placement of the old man's chair, on which the child tentatively rests her hands, imply a distance. Isolated, yet connected, in the aftermath of death, three relatives— two who pose and a third who paints them from across the paper-strewn table—poignantly convey the fragility and strength of family ties. Unresolved details and thinly painted areas suggest that the painting may not have been completed.

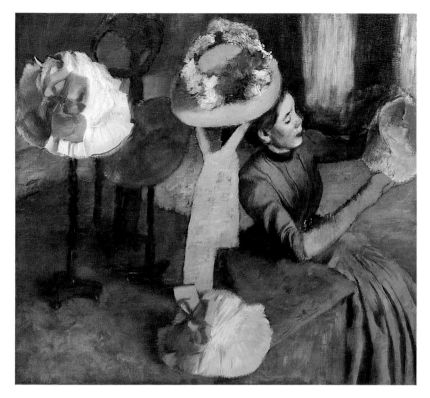

HILAIRE GERMAINE EDGAR DEGAS
(French, 1834–1917)
The Millinery Shop, 1884/90
Oil on canvas; 39⅜ × 43⅝ in. (100 × 110.7 cm)
Mr. and Mrs. Lewis Larned Coburn Memorial Collection, 1933.428

As if the viewer were a modish stroller out window shopping, this painting—with its unusual cropping and tilted perspective—seems to capture an unedited glimpse of the interior of a small, nineteenth-century millinery shop. With her mouth pursed around a pin and her hands gloved to protect the delicate fabric, a young shop girl leans back to examine her creation. She is totally absorbed and, like most of the women in Edgar Degas's paintings, seems unaware of being watched. Degas has scraped and repainted the milliner's hands and her hat-in-progress so that both appear to be in movement, drawing an analogy between her creative efforts and those of the artist. This analogy extends to the bonnets, which are displayed on the table like a still life: where they are unfinished, so too is the painting. X-rays and preparatory drawings show that Degas originally intended the figure to be a customer. Thus, what had begun as a painting about vanity and fashion became instead a metaphor on artistic creation and consumption. The hat, for Degas, was a prime symbol of the modern bourgeois woman. Of at least fifteen pastels, drawings, and paintings Degas created on this subject during the 1880s, *The Millinery Shop* is the largest and perhaps the most ambitious.

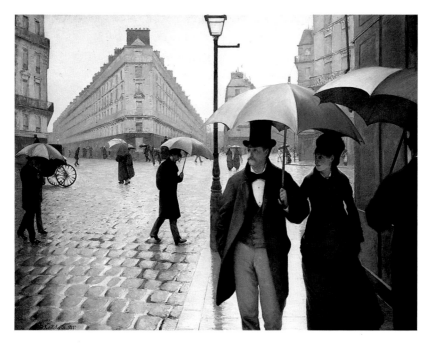

GUSTAVE CAILLEBOTTE
(French, 1848–1894)
Paris Street; Rainy Day, 1877
Oil on canvas; 83½ × 108¾ in. (212.2 × 276.2 cm)
Charles H. and Mary F. S. Worcester Collection, 1964.336

This complex intersection, just minutes away from Saint-Lazare train station
(see p. 155), represented in microcosm the changing urban milieu of late-
nineteenth-century Paris. Gustave Caillebotte grew up near the district when
it was a relatively unsettled hill with narrow crooked streets. As part of a new
city plan designed by Baron Georges Eugène Haussmann, every street was laid,
every building raised during the artist's lifetime. In this monumental urban
view, which measures almost seven by ten feet and is considered the artist's
masterpiece, Caillebotte strikingly captured this vast, stark modernity, complete
with life-sized figures strolling in the foreground and wearing the latest styles.
Paris Street's highly crafted surface, rigorous perspective, and grand scale pleased
Parisian audiences accustomed to the academic aesthetic of the official Salon.
On the other hand, the painting's asymmetrical composition, unusually
cropped forms, rain-washed mood, and candidly contemporary subject stimu-
lated a more radical sensibility. For these reasons, the painting dominated the
celebrated Impressionist exhibition of 1877, largely organized by the artist
himself. Caillebotte's frozen poetry of the Parisian bourgeoisie strangely
prefigures Georges Seurat's luminous *Sunday on La Grande Jatte — 1884*
(pp. 158–59), painted less than a decade later.

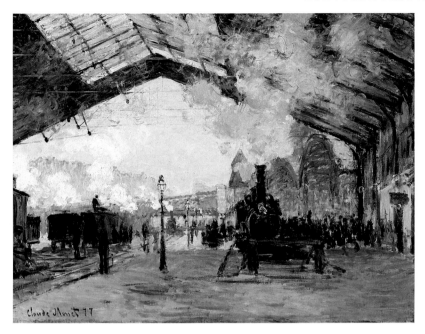

CLAUDE MONET
(French, 1840–1926)

Arrival of the Normandy Train, Saint-Lazare Station, 1877
Oil on canvas; 23½ × 31½ in. (59.6 × 80.2 cm)
Mr. and Mrs. Martin A. Ryerson Collection, 1933.1158

The modern urban landscape of Paris was the quintessential subject for many Impressionist painters. Their interest lay not in depicting new buildings or bridges literally, but rather in capturing fleeting and dynamic impressions of the city in motion. For Claude Monet, Saint-Lazare station was an especially appropriate choice. Its enormous vault of glass and iron, filled with steam and bustling with movement, epitomized the excitement of the new industrial age, and the station was a locus that linked Paris to many of the suburban and rural sites Monet and other Impressionists liked to paint. Legend has it that he convinced the stationmaster to halt the trains and cram the engines with coal to make smoke billow. Using head-on perspective and rapid, often sketchlike, brushwork to imply rather than describe shapes, the artist captured the intensity and flux of the celebrated depot. Of the twelve known versions of this subject by Monet, seven were exhibited in one room at the third Impressionist exhibition, in 1877, thus inaugurating his famous method of working in series, repeatedly examining a particular motif at different times and under different atmospheric conditions (see pp. 164–65).

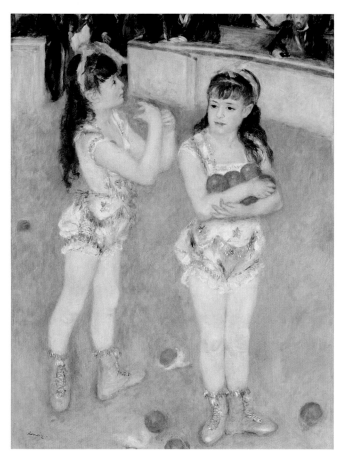

PIERRE AUGUSTE RENOIR
(French, 1841–1919)

Jugglers at the Circus Fernando, 1878–79
Oil on canvas; 51¾ × 39⅛ in. (131.5 × 99.5 cm)
Potter Palmer Collection, 1922.440

The two little circus girls in Pierre Auguste Renoir's painting are Francesca and Angelica Wartenberg, who probably performed as acrobats in their father's famed Circus Fernando in Paris. Although they are depicted in the center of a circus ring, the sisters actually posed in costume in Renoir's studio, enabling him to paint them in daylight. He portrayed them just as they have finished their act and are taking their bows. One sister turns to the crowd, acknowledging its approval, while the other faces the viewer with an armful of oranges, a rare treat that the audience has tossed in tribute. Although *Jugglers at* *the Circus Fernando* reflects the artist's enchantment with the innocence of childhood — he has enveloped the children in a virtual halo of pinks, oranges, yellows, and whites — the partially seen, darkly clothed (mainly male) spectators allude to the less wholesome, nocturnal demimonde of the nineteenth-century circus in which these two were growing up. The famed Chicago collector Mrs. Potter Palmer purchased *Jugglers at the Circus Fernando* in 1892 and was so enamored of the picture that she kept it with her at all times, even on her travels abroad.

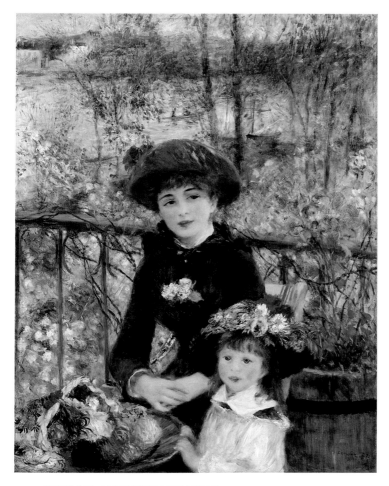

PIERRE AUGUSTE RENOIR
(French, 1841–1919)
Two Sisters (On the Terrace), 1881
Oil on canvas; 39½ × 31⅞ in. (100.3 × 81 cm)
Mr. and Mrs. Lewis Larned Coburn Memorial Collection, 1933.455

"He loves everything that is joyous, brilliant, and consoling in life," an anonymous interviewer once wrote about Pierre Auguste Renoir. This may explain why *Two Sisters (On the Terrace)* is one of the most popular paintings in the Art Institute. Here, Renoir depicted the radiance of lovely young women on a warm and beautiful day. The older sister, formally dressed, is posed in the center of the evocative landscape backdrop of Chatou, a suburban town where the artist spent much of the spring of 1881. She gazes absently beyond her younger sister, who

seems, in a charming visual conceit, to have just dashed into the picture. Technically, the painting is a tour de force: Renoir juxtaposed solid, almost life-sized, figures against a landscape that — like a stage set — seems a realm of pure vision and fantasy. Like a palette, the sewing basket in the left foreground holds the bright, pure pigments the artist mixed, diluted, and altered to create the rest of the painting. Renoir sent this work, along with *Jugglers at the Circus Fernando* (p. 156) and at least twenty-six others, to the seventh Impressionist exhibition in 1882.

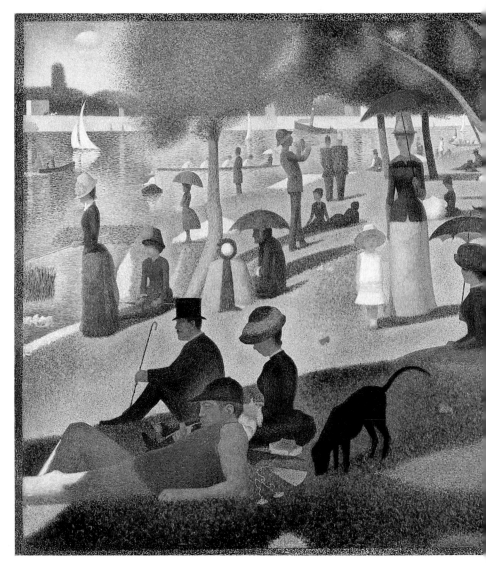

GEORGES SEURAT
(French, 1859–1891)

A Sunday on La Grande Jatte — 1884, 1884–86
Oil on canvas; 81¾ × 121¼ in. (207.5 × 308 cm)
Helen Birch Bartlett Memorial Collection, 1926.224

"Bedlam," "scandal," and "hilarity" were among the epithets used to describe
what is now considered Georges Seurat's greatest work, and one of the most
remarkable paintings of the nineteenth century, when it was first exhibited in
Paris. Seurat labored extensively over *A Sunday on La Grande Jatte — 1884*,
reworking the original as well as completing numerous preliminary drawings
and oil sketches (the Art Institute has one such sketch and two drawings). With
what resembles scientific precision, he tackled the issues of color, light, and

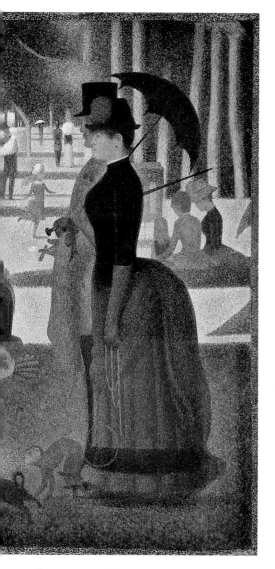

form. Inspired by research in optical and color theory, he juxtaposed tiny dots of colors that, through optical blending, form a single and, Seurat believed, more brilliantly luminous hue in the viewer's eye. To make the experience of the painting even more intense, he surrounded it with a frame of painted dots, which in turn he enclosed with a pure white, wooden frame, which is how the painting is exhibited today. As to the meaning of these Parisians enjoying a day off on an island in the Seine — who they are, where they come from, what they are doing — their very immobility and that of the shadows they cast makes them forever silent and enigmatic. Like all great masterpieces, *La Grande Jatte* continues to fascinate and elude, with our explanations of it revealing perhaps more about us than about the painting itself.

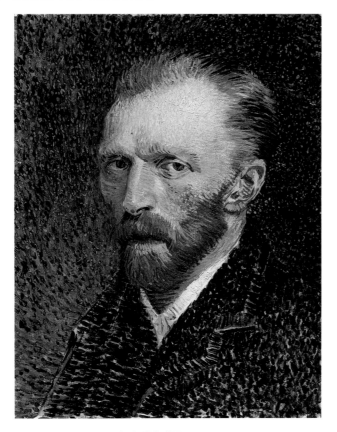

VINCENT VAN GOGH
(Dutch, 1853–1890)

Self-Portrait, 1886/87
Oil on cardboard mounted on cradled panel; 16⅛ × 13¼ in. (41 × 32.5 cm)
Joseph Winterbotham Collection, 1954.326

In 1886, Vincent van Gogh left his native Holland and settled in Paris, where his beloved brother, Theo, was a dealer in paintings. Van Gogh created at least twenty-four self-portraits during his two-year stay in the energetic and innovative French capital. This early example is modest in size and painted on artist's board rather than canvas. Its dense brush-work, which became a hallmark of van Gogh's style, reflects his response to Georges Seurat's revolutionary Pointillist technique in *A Sunday on La Grande Jatte — 1884* (pp. 158–59). But what for Seurat was a method based on the cool objectivity of science became in van Gogh's hands an intense emotional language. The surface of the painting dances with molecular particles of color — intense greens, blues, reds, and oranges. Dominating this dazzling array of staccato dots and dashes are the artist's deep green eyes, and the intensity of their gaze. "I prefer painting people's eyes to cathedrals," van Gogh once wrote to Theo. "…However solemn and imposing the latter may be — a human soul, be it that of a poor streetwalker, is more interesting to me." From Paris, van Gogh traveled to the southern town of Arles for fifteen months (see p. 161). At the time of his death, in 1890, he had actively pursued his art for a period of only five years.

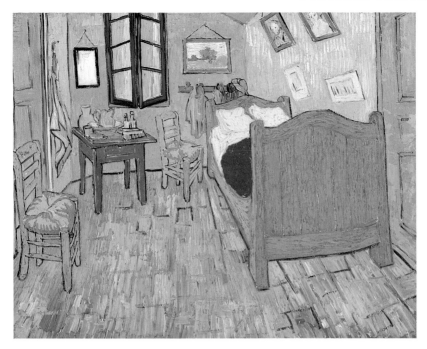

VINCENT VAN GOGH
(Dutch, 1853–1890)
Bedroom at Arles, 1889
Oil on canvas; 29 × 36⅝ in. (73.6 × 92.3 cm)
Helen Birch Bartlett Memorial Collection, 1926.417

"Looking at the picture ought to rest the brain, or rather the imagination," Vincent van Gogh wrote to his brother Theo before painting this bedroom scene. The painting was part of a decorating scheme for his new house in Arles, which van Gogh dubbed "The Studio of the South" with the hope that friends and artists would join him there in the south of France. He created a prodigal outpouring during his fifteen months (from February 1888 to May 1989) there, including this bedroom scene. But, with the exception of Paul Gauguin's two-month visit, the artists' colony never materialized. The vivid palette, dramatic perspective, and dynamic brushwork of *Bedroom at Arles* hardly express the "absolute restfulness" of which van Gogh spoke. Pictures tilt off the wall; a blood-red quilt covers the looming bed. Each object seems palpable, as solid as sculpture, though modeled in paint. The hermetic, sun-drenched space seems ready to burst with an overwhelming sense of presence and an intense and nervous vitality. Van Gogh liked this image so well that he painted three versions. He executed the first in October 1888, right before Gauguin's visit (Rijksmuseum Vincent van Gogh, Amsterdam). He painted the second, the Art Institute's work, in September 1889, during a year of voluntary confinement at the asylum of Saint Paul in Saint-Rémy. At the same time, van Gogh also painted a smaller copy for his mother and two sisters (Musée d'Orsay, Paris).

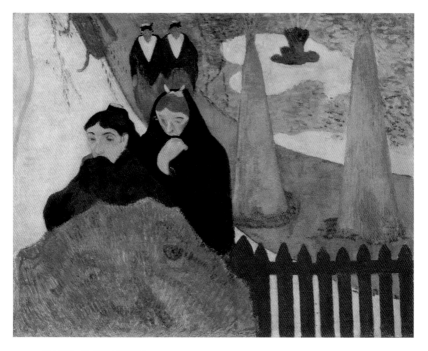

PAUL GAUGUIN
(French, 1848–1903)
Old Women of Arles, 1888
Oil on canvas; 28¾ × 36¼ in. (73 × 92 cm)
Mr. and Mrs. Lewis Larned Coburn Memorial Collection, 1934.391

One of seventeen canvases Paul Gauguin completed during a brief and tumultuous visit with Vincent van Gogh in Arles (see p. 161), this powerful and enigmatic painting depicts the public garden directly across from van Gogh's residence, the Yellow House. Not only is the carefully planned composition in marked contrast to the spontaneity seen in van Gogh's depiction of the same scene (Hermitage Museum, Leningrad), but everything about the painting—its large, flat areas of color, its arbitrary handling of space, its enigmatic silhouettes—exemplifies the deliberateness with which Gauguin sought pictorial harmony and symbolic content in his work. Here, four women wrapped in shawls slowly stroll through the garden.

The two closest to the viewer (the foreground figure may be a café owner called Madame Ginoux, whom both Gauguin and van Gogh depicted in their work) avert their gazes and curiously cover their mouths. Their somber outlines echo the two strange orange cones, which probably represent shrubs wrapped against the frost. The bench along the upper left path rises steeply, defying logical perspective. Equally puzzling is the mysterious, perhaps unintentional apparition resembling a face in the large green bush. With its aura of repressed emotion and elusive meaning, *Old Women of Arles* explores the mysteries, superstitions, and emotions that Gauguin believed underlie appearances.

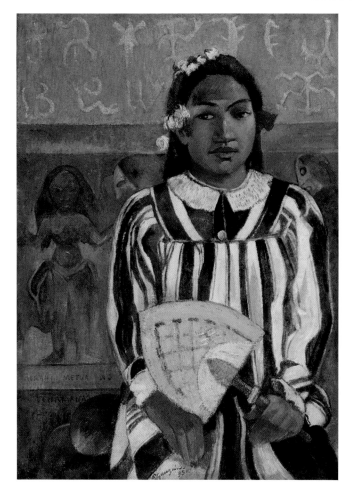

PAUL GAUGUIN
(French, 1848–1903)

Ancestors of Tehamana, 1893
Oil on canvas; 30⅛ × 21⅜ in. (76.3 × 54.3 cm)
Gift of Mr. and Mrs. Charles Deering McCormick, 1980.613

The nomadic Paul Gauguin yearned for the exotic, the primitive, for cultures more spiritually pure than he believed his native France to be. This search took the former stockbroker to the French regions of Brittany and Provence, to South and Central America, and finally to Tahiti in 1891, where he was to spend all but two of the remaining years of his life. This stately portrait of Gauguin's young Tahitian wife, Tehamana, is perhaps a farewell, since it was painted shortly before a two-year trip back to France. Elaborately dressed, her hair decorated with flowers, Tehamana is seated in front of a mysterious painted background similar to a frieze on the wall of an ancient palace or temple. Two ripe mangoes — perhaps an offering, or symbols of fertility — rest beside her hip. She points a fan, a symbol of beauty, toward the similarly frontal figure of a goddess, who also wears a red flower in her hair. The fan, flowers, fruit, and even the way Tehamana glances to her right suggest not only the strong, enigmatic bond between these two figures, but also the connections between the present and past, the corporeal and the spiritual, the living and the dead.

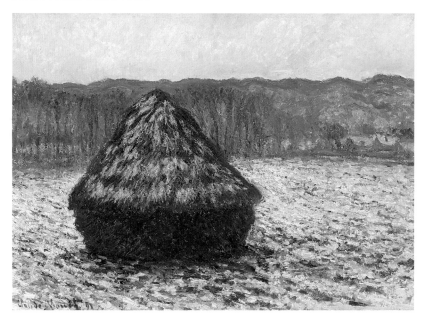

CLAUDE MONET
(French, 1840–1926)

Grainstack, 1890/91
Oil on canvas; 25⅞ × 36¼ in. (65.6 × 92 cm)
Restricted gift of the Searle Family Trust; Major Acquisitions Centennial
Endowment; through prior acquisitions of the Mr. and Mrs. Martin A. Ryerson
and Potter Palmer Collections; through prior bequest of Jerome Friedman,
1983.29
Grainstacks (End of Summer), 1890/91
Oil on canvas; 23⅝ × 39⅜ in. (60 × 100 cm)
Gift of Arthur M. Wood in memory of Pauline Palmer Wood, 1985.1103

In October 1890, already occupied with the *Grainstacks* series, Claude Monet
wrote: "I see that it takes a lot of work to succeed in rendering what I am look-
ing for: 'instantaneity,' especially the envelope, the same light spread every-
where." The monumental stacks, which rose fifteen to twenty feet tall, stood
just outside Monet's farmhouse door at Giverny. Through 1890–91, the artist
painted both in the field, where he worked simultaneously at several easels,
and in the studio, where he refined pictorial harmonies. In May 1891, Monet
hung fifteen of these canvases next to each other in one small room in the
Galerie Durand-Ruel in Paris (thus marking the first time that pictures of the

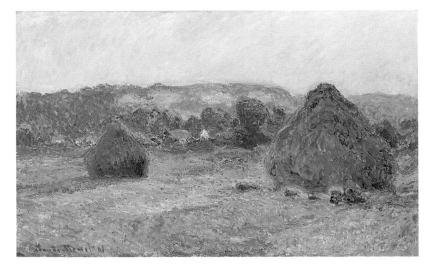

same subject were considered by an artist as part of a collective ensemble).
An unprecedented critical and financial success — the paintings were sold both
multiply and singly — the exhibition marked a breakthrough in Monet's ca-
reer, as well as in the history of French art. It allowed him to combine the basic
doctrine of Impressionism — capturing instantaneous moments in nature's
temporal cycle — with the notion that an artist can reconstruct nature according
to the formal and expressive potential of the image itself. These two canvases,
which were among the original fifteen on view in 1891, share a simple basic
composition: one or two stacks surrounded by parallel bands of field, hills, and
sky. In the late summer view, and in nearly all of the autumn views as well, the
conical tops of the stacks often break the horizon and push into the sky. But
in most of the winter views, which constitute the core of the series, the long-
lasting grainstack seems wrapped by bands of hill and field, as if bedded down
for the season. For Monet, the grainstack was a resonant symbol for suste-
nance and survival. He followed this group with further series: of poplars,
of the facade of Rouen Cathedral, and later, of his own garden at Giverny
(see p. 246). The Art Institute has the largest group of Monet's *Grainstacks*
in the world.

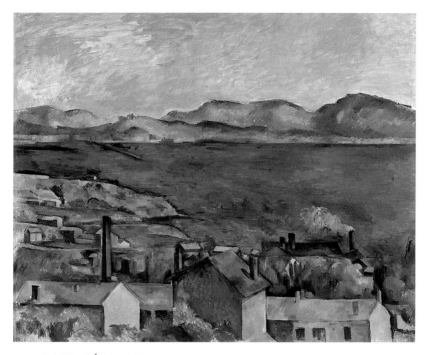

PAUL CÉZANNE
(French, 1839–1906)

The Bay of Marseilles, Seen from L'Estaque, 1886/90
Oil on canvas; 31⅝ × 39⅝ in. (80.2 × 100.6 cm)
Mr. and Mrs. Martin A. Ryerson Collection, 1933.1116

In a letter to his friend and teacher Camille Pissarro, Paul Cézanne compared
the view of the sea from L'Estaque to a playing card. Its configuration and color
fascinated him. The Art Institute's painting is one of more than a dozen such
vistas created by the artist during the 1880s. Cézanne divided the canvas into
four zones—architecture, water, mountain, and sky. Although these four
elements are seen again and again in Impressionist paintings, Cézanne's work
is worlds away from that of his fellow artists. Whereas their primary purpose
was to record the transient effects of light Cézanne was interested in under-
lying structure and composition. Filling the canvas with shapes defined by
strong, contrasting colors and a complex grid of horizontal, vertical, and
diagonal lines, Cézanne created a highly compact, dynamic pattern of water,
sky, land, and village that at once refers back to traditionally structured land-
scape paintings and looks forward to the innovations of Cubism. Using block-
like brushstrokes to build the space, Cézanne created a composition that seems
both two- and three-dimensional. Not locked tightly in place, his forms seem
continually to touch and shift, creating a sense of volume and space that
strengthens the composition and brings it to life.

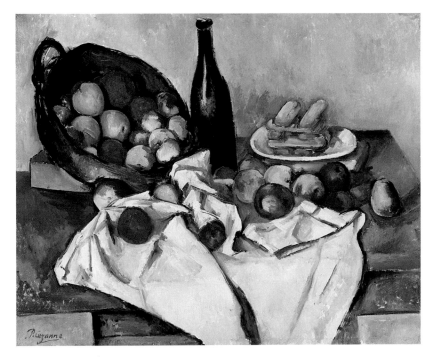

PAUL CÉZANNE
(French, 1839–1906)

The Basket of Apples, c. 1895
Oil on canvas; 25½ × 31½ in. (65 × 80 cm)
Helen Birch Bartlett Memorial Collection, 1926.252

Art, Paul Cézanne once claimed, is "a harmony running parallel to nature,"
not an imitation of nature. In his quest for underlying structure and composi-
tion, he recognized that the artist is not bound to represent real objects in real
space. Thus *The Basket of Apples* contains one of his signature tilted tables, an
impossible rectangle with no right angles. On it, a basket of apples improbably
pitches forward from a slablike base, seemingly balanced by the bottle and
the tablecloth's thick, sculptural folds. The heavy modeling, solid brushstrokes,
and glowing colors give the composition a density and dynamism that a more
realistic still life could never possess. This painting, one of his rare signed
works, was part of an important exhibition urged on Cézanne by the Parisian
art dealer Ambroise Vollard in 1895. Since Cézanne had spent the majority
of his career painting in isolation in his native Provence, this was the first
opportunity in nearly twenty years for the public to see the work of the artist
who is now hailed as the father of modern painting.

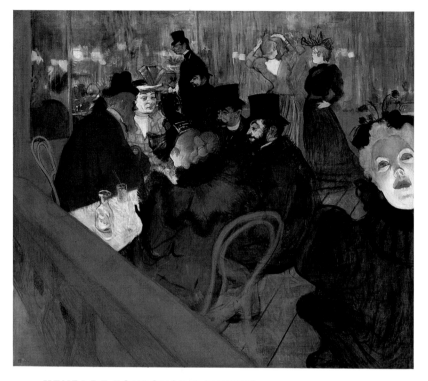

HENRI DE TOULOUSE-LAUTREC
(French, 1864–1901)

At the Moulin Rouge, 1893/95
Oil on canvas; 48½ × 55½ in. (123 × 141 cm)
Helen Birch Bartlett Memorial Collection, 1928.610

Henri de Toulouse-Lautrec memorialized Parisian night life at the end of the
nineteenth century in his masterpiece *At the Moulin Rouge*. The painting is noted
for its daring composition, dramatic cropping, and flat planes of strident color.
A regular patron of the Moulin Rouge, one of the most famous cabarets of the
Montmartre district, Toulouse-Lautrec here turned his acute powers of observa-
tion on the club's other habitués. The flaming red-orange hair of the enter-
tainer Jane Avril is the focal point of the central seated group. Preening in the
greenish mirror in the back is the dancer La Goulue. The stunted figure of the
aristocratic artist appears, as it often did in life, side-by-side with his devoted,
much taller cousin, Dr. Tapié de Céleyran. But it is the frozen, acid-green face
of the dancer May Milton that dominates the canvas and haunts the action.
In the painting, she seems to have just left the table; she was apparently ostra-
cized from the group in 1895. There is continued debate as to why the canvas
comprises two joined parts. According to some scholars, the artist added an
L-shaped panel to the lower and right edges of a smaller canvas either before
he began his composition or during its execution. Others have posited that the
canvas was severed after the artist's death, presumably by the dealer (to make
the composition less radical and more saleable), and restored sometime before
1924 for a special exhibition of Toulouse-Lautrec's work at the Art Institute.

Photography

WILLIAM HENRY FOX TALBOT
(English, 1800–1877)

Flowers, Leaves, and Stem, c. 1838
Photogenic drawing stabilized in potassium bromide; 8⅞ × 7³/₁₆ in.
(225 × 183 mm)
Edward E. Ayer Endowment in memory of Charles L. Hutchinson, 1972.325.2

Contained within this haunting and poetic image is the seed of photography: the possibility of creating a negative from which an unlimited number of positives can be made. William Henry Fox Talbot created this image by placing the botanical specimen on sensitized paper and exposing it to light. This groundbreaking discovery was made by Talbot after a honeymoon in 1833 on the shores of Lake Como, in Lombardy, Italy. Frustrated by his inability to accurately draw his Italian surroundings, Talbot recalled the fleeting images of external objects appearing within a camera obscura (literally, a "dark box" with a lens) and wondered how to make them "imprint

themselves durably, and remain fixed upon the paper." What resulted, two years later, were the first camera negatives. Unveiled in 1839 and called photogenic drawing, Talbot's process was perfected two years later into the calotype (from the Greek *kalos*, meaning beautiful). By the end of his life, Talbot—whose far-ranging interests included mathematics, botany, etymology, and ancient Assyria—had also discovered the basis of halftone printing, held twelve patents, and had authored seven books, including the first book illustrated with photographs (*The Pencil of Nature*, 1844).

GUSTAVE LE GRAY
(French, 1820–1882)

Tree, South of France, 1856/60
Gold chloride-toned albumen silver print; 12⅜ × 16⅜ in. (314 × 416 mm)
Samuel P. Avery, Edward E. Ayer in memory of Charles L. Hutchinson,
Wentworth Greene Field Memorial, Maurice D. Galleher, Laura T. Magnuson,
and General Acquisitions endowments, 1987.54

Gustave Le Gray was involved with photography less than thirteen years, but
he was remarkably prolific. He documented historic French monuments and
the military maneuvers of Emperor Napoleon III, helped found the world's first
photographic association, published a noted photographic treatise, ran his own
atelier, and exhibited internationally. This luminous and evocative view of an
olive tree in the south of France is similar to images in the photographer's well-
known series of the Fountainebleau forest, in which he catalogued the myriad
idyllic and intimate settings as if to guide his viewers through the woods. The
diffusion of light created by the canopy of foliage animates a single grand and
gnarled old tree, demonstrating the photographer's consummate skill in captur-
ing the rich tonal drama of light and shade. In 1860, Le Gray abruptly aban-
doned his family, an overextended photography practice, and Paris to travel in
the Middle East. He eventually settled in Egypt, where he became an instructor
of painting and drawing.

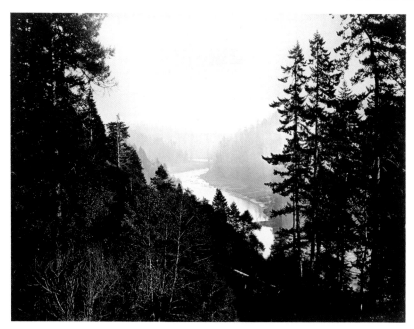

CARLETON WATKINS
(American, 1829–1916)

Mendocino River, from the Rancherie, Mendocino County, California, 1863/68
Albumen print from collodion negative; $15^{11}/_{16} \times 20^{11}/_{16}$ in. (399×525 mm)
Gift of the Auxiliary Board, 1981.649

Like the vast and untapped landscape of the American West he photographed, Carleton Watkins's photographic images are grand, both in spirit and in size. Using a giant wet-plate camera whose thick glass negatives — coated with a sensitized emulsion called collodion and exposed while still wet — were often as large as the average easel painting of the time, Watkins here fused a sense of the picturesque with a Romantic expression of nature's timelessness, immensity, and silence. The trees are sharply defined, still, and majestic. Depicted with equal clarity is the river as it winds into the receding hills. This technical and aesthetic perfection was all the more remarkable considering the difficulty of the wet-plate process for the frontier photographer. On a photographing trip, Watkins had to transport (with the aid of several pack mules) mammoth cameras, dark tents, chemicals, and as many as four hundred glass plates. He also had to contend with constant packing and unpacking, the lack of pure water, and the tendency of dust to adhere to the sticky collodion. Photographs such as *Mendocino River* and Watkins's famous views of Yosemite (which helped persuade the United States Congress to pass legislation protecting the valley's wilderness) provided the world with some of the first glimpses of this unknown territory.

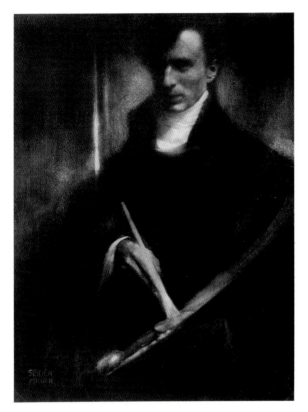

EDWARD STEICHEN
(American, 1879–1973)
Self-Portrait with Brush and Palette, 1902
Gum-bichromate print; $10^{1}/_{2} \times 7^{7}/_{8}$ in. (267 × 200 mm)
Alfred Stieglitz Collection, 1949.823

"What is true of the oil or watercolor is equally true of the photograph," said Edward Steichen, aptly expressing the overt pictorial intent of this Romantic self-portrait. As a founding member of Alfred Stieglitz's Photo-Secession (see p. 176), Steichen made his photographs of this period artistic equivalents of his paintings (he was then as much a painter as a photographer), in accordance with the Photo-Secessionists' campaign to win artistic credibility for the much newer art form. To achieve these painterly ends, Steichen here expertly manipulated the elastic and expressive gum-bichromate method, in which the application of water and brushwork in the printing process can soften or omit details, reduce dark parts, even change light into dark and vice versa. The result is an image whose dramatically posed and lit subject foreshadows Steichen's later success as a leading portrait and fashion photographer for Condé Nast publications (1923–37). His career as one of the primary shapers of twentieth-century photography culminated with his directorship of the Department of Photography at the Museum of Modern Art, New York, a position he held from 1947 until his retirement in 1962; it was there that he organized his famous synthesis of worldwide photography, "The Family of Man."

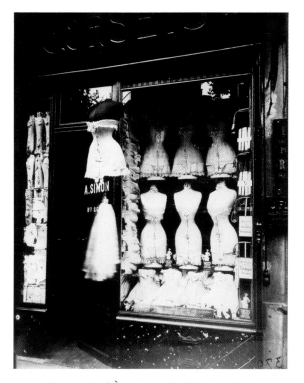

JEAN EUGÈNE AUGUSTE ATGET
(French, 1856–1927)
Corsets/379, c. 1912
Gelatin printing-out-paper print from dry-plate negative; $9 \times 7^{1}/_{16}$ in.
(229 × 180 mm)
Julien Levy Collection, gift of Jean and Julien Levy, 1975.1130

For almost three decades, the former actor Eugène Atget systematically, often serially, documented everything about the Paris he saw vanishing with the encroachments of modernization. Usually early in the morning, so no one would bother him, he hauled around on his back a large view camera, wooden tripod, and heavy glass plates. Impeccably composed, with poetically rich and varied textures and forms, his images range from unpeopled streets, parks, and monuments to cafés, street vendors, and shop windows, this one displaying haunting human surrogates. In *Corsets*, rows of hourglass-shaped busts emerge out of darkness, while a dangling corset swings in the cracked doorway, animating the entire scene (Atget's old-fashioned camera often recorded moving objects as blurred). Atget sold these cultural documents for modest sums to artists, craftspeople, and institutions interested in preserving the past. It was not until after 1925, when he was discovered by the expatriate American artist/photographer Man Ray, that his work began to be published and recognized. Upon Atget's death, Man Ray's assistant, the photographer Berenice Abbott, acquired the more than eight thousand prints found in his studio and devoted decades to promoting his vast and remarkable oeuvre. The funds for Abbott's purchase were supplied by Julien Levy, the prominent dealer of Surrealist art, whose personal collection of photography the Art Institute is fortunate to house.

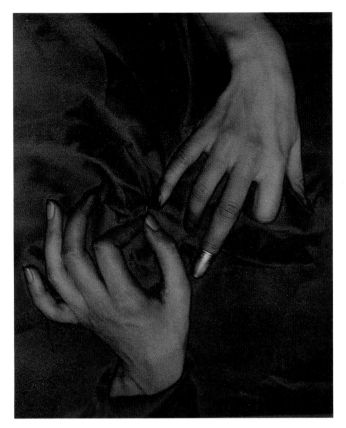

ALFRED STIEGLITZ
(American, 1864–1946)
Georgia O'Keeffe, 1920
Solarized palladiotype; 9⅞ × 7¹⁵/₁₆ in. (251 × 202 mm)
Alfred Stieglitz Collection, 1949.745

Alfred Stieglitz was perhaps the foremost crusader in the United States during the early twentieth century for modern art and photography. He campaigned to legitimize photography as a valid art form through his organization, the Photo-Secession, and its handsome quarterly, *Camera Work*; in a series of exhibitions at the New York gallery 291, Stieglitz — with the assistance of Edward Steichen, then living in Paris — introduced the work of such leaders of the European avant-garde as Paul Cézanne, Henri Matisse, and Pablo Picasso to the American public. Georgia O'Keeffe, who became Stieglitz's wife in 1924, was among the progressive American artists whose work he also exhibited at 291. In a search for objective truth and pure form, the innovative photographer took some five hundred photographs of O'Keeffe between 1917 and 1937. The essence of O'Keeffe, he felt, was not confined to her head and face alone; equally expressive were her torso, feet, and especially her hands, as seen here. What resulted is a "composite portrait" of the painter in which each photograph, revealing her intrinsic nature at a particular moment, can stand alone as an independently expressive form. When these serial images are viewed as a whole, they portray the essence of O'Keeffe's many different "selves."

TINA MODOTTI
(American, b. Italy, 1896–1942)
Interior of Church Tower, Tepotzotlán, Mexico, 1924
Platinum print; 9⅝ × 7³/₁₆ in. (244 × 183 mm)
Laura T. Magnuson Fund, 1991.62

The bulk of Italian-born Tina Modotti's small but accomplished oeuvre was created in Mexico during a six-year stay from 1923 through 1929. She began photographing under the tutelage of her companion Edward Weston (see p. 178), and was deeply influenced by his aesthetic sense of form and purity of vision. Weston accompanied Modotti to Tepotzotlán and reported in his *Daybooks* that she was particularly pleased with this interior view of a church tower. The stucco ceiling seems almost Cubist in its abstraction. Modotti accentuated the ambiguity of the space by using the platinum printing process, which registers an exceptionally broad range of gray tones. The subtle gradations of light and hue that result enhance the transcendental quality of the image. Modotti also made a negative print of this exposure to register forms and shapes in greater clarity, suggesting her interest in the abstract composition of the tower interior. Deeply immersed in Mexico's cultural and political life from the beginning of her stay, Modotti became even more involved in revolutionary activities after Weston's departure in 1926, and was, in fact deported from Mexico in 1930 for Communist activity. She returned in 1938, and resumed photographic work, only to die four years later.

EDWARD WESTON
(American, 1886–1958)
Washbasin, 1925
Platinum print; 9⁹/₁₆ × 7⁷/₁₆ in. (244 × 189 mm)
Harold L. Stuart Endowment, 1987.377

In 1923, Edward Weston embarked upon a new life in Mexico, leaving California behind him. He set up a portrait studio with his muse and apprentice, Tina Modotti (see p. 177), who introduced him to such artists as Diego Rivera and José Clemente Orozco. Stimulated by the vital Mexican culture, as well as by his previous contacts with three other great photographers—Sheeler, Stieglitz, and Strand—Weston's soft-focus, painterly style underwent a radical change. "The camera must be used for a recording of *life*," he wrote in his *Daybooks* during this period, "for rendering the very substance and quintessence of *the thing* itself." This simple metal washbasin, which he stored under his sink, is an example of the new and unconventional subjects Weston began to photograph during this Mexican sojourn. In his obsession for clarity of form and precision of image, he visualized the final print on the ground glass of his 8 × 10-inch view camera while focusing; any cropping, trimming, or enlarging of the print was rejected as a betrayal of vision. Here he captured the worn metal and porcelain surfaces with sensuous, almost preternatural clarity. An important transitional piece, *Washbasin* prefigures Weston's exquisite and erotic studies of nudes, shells, and plant forms.

ANDRÉ KERTÉSZ
(American, b. Hungary, 1894–1985)
Mondrian's Eyeglasses and Pipe, 1926
Silver-gelatin print; 6³/₁₆ × 7³/₁₆ in. (157 × 182 mm)
Julien Levy Collection, gift of Jean and Julien Levy, 1975.1137

Hungarian-born André Kertész had been living in Paris less than a year when he visited the studio of the Dutch painter Piet Mondrian (see p. 255). *Mondrian's Eyeglasses and Pipe* is among a group of beautiful still lifes that the photographer took that day. Within the austere clarity of these simple geometric forms — common manufactured items that Mondrian used daily — Kertész captured the essence of this master of abstraction, both his aspiration to order and his slight and human divergences from it. The insistent angularity of the stark white table is offset by the sculptural curves of the glasses, bowl, and pipe, curves that were rigorously excluded from Mondrian's art. Ever since Kertész began photographing, in 1912, and throughout his long career, he sought the revelation of the found still life, of an abstract or resonating image discovered in the elliptical view. His signature practice of snaring and fixing these lyrical perceptions was facilitated by his later use of light, portable, hand cameras that enabled him to remain mobile and agile even when making still lifes. Kertész's work significantly influenced that of his contemporaries Henri Cartier-Bresson and Brassaï (see pp. 180 and 181).

HENRI CARTIER-BRESSON
(French, b. 1908)

Hyères, France, 1930
Silver-gelatin print; 7¹³⁄₁₆ × 11⅝ in. (198 × 295 mm)
Julien Levy Collection, gift of Jean and Julien Levy, 1975.1134

In *Hyères, France*, Henri Cartier-Bresson captured that peak instant when life's
ever-moving image — in this case, a bicyclist streaking by an iron railing —
achieves a timeless harmony of form, expression, and content. An early work,
taken before Cartier-Bresson was a professional photographer, this image of the
world in flux shows spontaneity, intuition, and a Surrealist whimsy. Cartier-
Bresson's keen sense of composition derived, in part, from his training as a
painter, as well as an acknowledged indebtedness to André Kertész (see p. 179).
Both photographers used the miniature Leica camera, which allowed thirty-six
exposures in quick succession, and, because of its compact serviceability, acted
as a true extension of the eye. So definite was Cartier-Bresson's rapid-fire
release of the shutter that he used the entire negative for the final print, unre-
touched and unmanipulated. This remarkable capacity to seize life's calculated
and coincidental ambiguities explains why his is one of the most influential
visions of the twentieth century. In addition to his later celebrated photojour-
nalistic works, Cartier-Bresson also produced two films, published more than
a dozen books, and, in 1947, helped establish the collaborative photography
agency Magnum.

BRASSAÏ
(GYULA HALÁSZ, French, b. Romania, 1899–1984)
Untitled (Streetwalker), 1932
Silver-gelatin print; 9³⁄₁₆ × 6¹³⁄₁₆ in. (233 × 173 mm)
Restricted gift of Leigh B. Block, 1983.55

From the moment of his arrival in Paris in 1924, Brassaï (who took his name from Brasov, his Transylvanian birthplace) was fascinated by the city "under cover of darkness." Around 1930, when the former art student learned from his friend André Kertész that photography at night was indeed possible, he began documenting this extraordinary underworld. The result was his remarkable publication *Paris at Night* (first published in France in 1933), which led the reader not only to such well-known spots as the Arc de Triomphe, but also through dark streets and alleys that had just enough light to reveal a florist shop window, a pissoir, a show at the Folies-Bergères, or the details of wet paving bricks. This image is from a 1932 series taken around Les Halles when Brassaï recorded those he called the "Venuses of the Crossroads," prostitutes standing at their posts—a section of the sidewalk, a corner—which they had struggled so hard to get. With an aura of mystery, Brassaï captured one of these ladies of the evening as she stands at the puddled street corner, smiling into the shadows during her centuries-long wait.

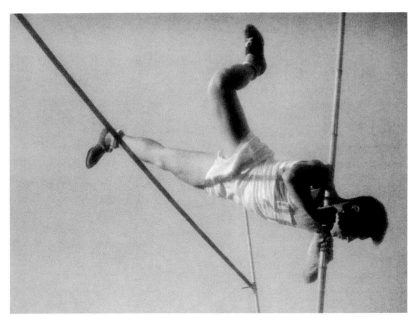

ALEXANDER RODCHENKO
(Russian, 1891–1956)
Untitled (Pole Vaulter), c. 1936
Silver-gelatin print; 11³⁄₈ × 15⁹⁄₁₆ in. (289 × 395 mm)
Wirt D. Walker Endowment, 1989.486

Suspended in midair, legs splayed, this pole vaulter must have been photo-
graphed in the split-second that he catapulted over the Constructivist Alexan-
der Rodchenko's head. The radical point of view with which Rodchenko seized
his subject to create this dramatic, yet gracefully graphic, composition typifies
what had come to be known as "Rodchenko perspectives." These disorienting
vantage points — extreme up and down angles, tilted horizons, steeply receding
perspectives — were attempts to dislocate and defamiliarize the viewer. "We
have to revolutionize our visual thinking," stated the photographer, who was
also a talented designer, painter, and sculptor; "we must draw back the curtain
from our eyes." Only when society had reeducated itself by shedding old,
stifling habits of vision could a new and better reality exist. Condoned and
supported in the mid-1920s, Rodchenko's ideas began to draw fire in 1928 from
a government moving strongly toward a conservative aesthetic of social real-
ism. Nevertheless, Rodchenko continued to work, producing, for instance, the
series of athletes in the mid-1930s of which this image is part, so that by the
end of the decade, despite heavy criticism, he was generally recognized as one
of Russia's greatest photographers.

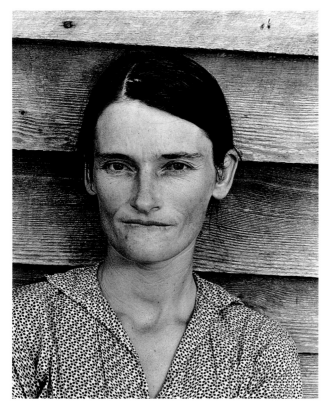

WALKER EVANS
(American, 1903–1975)

Alabama Cotton Tenant Farmer's Wife, 1936
Silver-gelatin print; 8³/₁₆ × 6⅝ in. (208 × 168 mm)
Gift of Mrs. James Ward Thorne, 1962.158

"Unrelieved, bare-faced, revelatory fact," read the monograph that accompanied Walker Evans's photographs when many of them were displayed at New York's Museum of Modern Art in 1938. Taken during the preceding two years, when he traveled throughout the South for the Farm Security Administration under the direction of Roy Stryker, these images document the plight of the rural poor during the Depression. With clinical precision and a fastidious reserve, Evans photographed Main Streets, storefronts, hand-painted signs, gas stations, abandoned buildings, automobiles. He took pictures of tenant farmers' homes — their kitchens, beds, bureau drawers, fireplaces — with and without their occupants. Taken for *Fortune* magazine when Evans, on leave from the FSA, was traveling with the writer James Agee, this famous photograph shows a tenant farmer's wife standing outside her house. With patient dignity she looks straight at the viewer, a shy half-smile on her lips. This work is part of a remarkable collaboration with Agee published in the book *Let Us Now Praise Famous Men* (1941). As one of the nation's finest documentary photographers, Evans continued this exacting and lucid description of American culture throughout his career. Later work includes a series of anonymous subway riders, followed by Chicago street portraits and, in the 1950s, snapshots of industrial landscapes taken from a moving train.

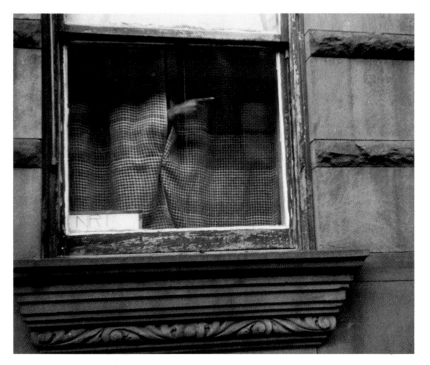

HELEN LEVITT
(American, b. 1918)

New York City, 1940
Silver-gelatin print; 6³/₁₆ × 7³/₈ in. (157 × 188 mm)
Restricted gift of Lucia Woods Lindley and Daniel A. Lindley, Jr., 1991.63

For more than half a century, Helen Levitt focused her camera unobtrusively and intuitively on the streets of New York. To seize anonymously the unguarded, split-second response for which she became noted, she occasionally even attached a right-angle viewfinder to her hand-held camera. Whether her serendipitous images were children at play, people gossiping on stoops, or an enigmatic hand in a window, there is always a wit, verve, and lyricism about them. Levitt framed forever this disembodied hand, which itself is framed within the peeling window. As in all of her photographs, she avoided reference to a specific season or time, using an indeterminate, general illumination. Just as this cloaked hand points toward an undisclosed location, so too is place unspecified. Levitt, whose early influences included the intuitive work of Henri Cartier-Bresson and Walker Evans's documentary photographs (see pp. 180 and 183), turned briefly to filmmaking during the 1950s, but returned to photography, both black-and-white and color, of the theater of daily life on city streets.

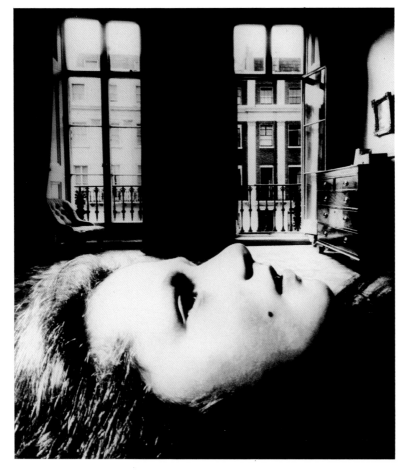

BILL BRANDT
(English, 1904–1983)
Portrait of a Young Girl, Eaton Place, London, 1955
Silver-gelatin print; 13 × 11⁵⁄₁₆ in. (330 × 287 mm)
Gift of Helen Harvey Mills, 1981.724

This provocative and mysterious image is from a late and influential series of
distorted female figures, mostly nudes, by one of Britain's foremost twentieth-
century photographers. Shot sometimes on the rough English seacoast, some-
times, as seen here, in a spare parlor, Bill Brandt's nudes represent a turning
away from his earlier documentary work toward, as he put it, "something
beyond the real." Brandt's use of the fixed-focus, wide-angle lens of a police
evidentiary camera, with its radical distortion and warped perspective, instills
an aura of hallucination throughout the series. With the camera, Brandt was
able, as in this image, to isolate and inflate parts of his subjects' anatomy. In
other images, he stretched nudes to fill empty interiors, or elongated them
along rocky shores, their scale curiously and poetically merging with the room
or with nature. This surreal and romantically mordant quality permeates the
artist's oeuvre, from his frank photos of British life to his moody landscapes
and his portraits of artistic and literary luminaries.

ROBERT FRANK
(American, b. Switzerland, 1924)
Fourth of July, Jay, New York, from *The Americans*, 1958
Silver-gelatin print; 13¼ × 8¾ in. (339 × 225 mm)
Photography Purchase Fund, 1961.942

In 1955, Swiss-born Robert Frank rented a second-hand car and, for the next two years, traveled with his 35 mm Leica camera throughout the United States, capturing his impressions with the ironic distance of an outsider. Made possible by a Guggenheim Foundation grant (the first awarded to a foreigner), this photographic odyssey resulted in a landmark book, *Les Américains*, published in France in 1958. The brilliant technical "wrongness" of Frank's gritty, rough, and graceless images, his "artless" imagery, represents a new and highly influential expressionistic approach to photographic observation. Meant to be seen as a series, Frank's photographs are filled with such Americana

as luncheonettes and jukeboxes, tailfins and motels — and, as shown here, the American flag. Dominating this depiction of the nation's annual birthday party, the star-spangled banner hardly waves bravely, freely. Instead it hangs down over a Fourth of July picnic, sheer and patched, like the bars of a prison. As the beat poet Jack Kerouac wrote in his introduction to the controversial 1959 American edition of Frank's book: "With that little camera that he raises and snaps with one hand he sucked a sad poem right out of America onto film." Frank subsequently turned to filmmaking, and returned to still photography upon his move to Nova Scotia in 1969.

RAY METZKER
(American, b. 1931)
Composites: Philadelphia, 1964
Silver-gelatin print; 34 × 33¼ in. (862 × 845 mm)
Gift of Dirk Lohan, 1988.542

Educated at Chicago's famed Institute of Design, where formal experimentation
and personal expression were encouraged equally, Ray Metzker was a pivotal
figure among photographers of the 1960s whose concerns shifted from repre-
senting places to exploring their medium. "Discontented with the single, fixed
frame image, the isolated moment," Metzker explained, "my work…moved
into something of the composite, of collected and related moments, employing
methods of composition, repetition and superimposition." As Metzker inves-
tigated "the possibilities of synthesis," the scale of some resulting pieces
increased to wall size, with perhaps hundreds of individual exposures within
each piece. In *Composites: Philadelphia*, Metzker overlapped successive expo-
sures on roll film so that the entire strip is seen as one print. Read at a distance,
this large photographic mosaic presents abstract, yet active, patterns of light
and shadow, almost machinelike in its precision; close up, the panel reveals the
presence of the "real world," often in urban areas — in this case, the facade of
a modern factory. Metzker's formal investigations have continued, resulting in
a multifaceted vision of single prints, couplets, collages, and composite images
whose size, shape, scale, and format range widely.

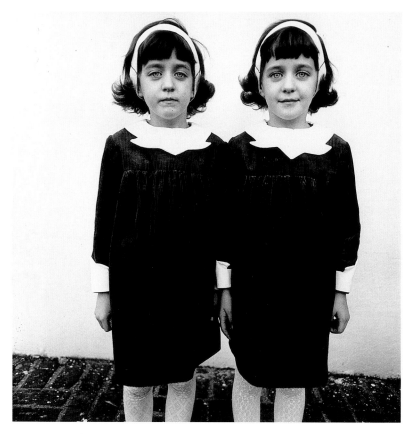

DIANE ARBUS
(American, 1923–1971)

Identical Twins, Roselle, N.J., 1967
Silver-gelatin print; 14⅞ × 14⁷/₁₆ in. (378 × 367 mm)
Gift of Richard Avedon, 1986.2976

Diane Arbus once said: "It's what I've never seen before that I recognize," which perhaps explains her focus on the irregular, the eccentric, the extreme. Dwarfs, transvestites, giants, nudists, and, as seen here, identical twins were among her subjects; paradoxically, she posed them in the most prosaic terms. Here these eerily matched elfin girls face the camera head-on, posed in front of a naked wall, staring directly at the viewer. The lighting is bright, the camera sharply focused. The radical candor with which Arbus presented these twins and most of her subjects disallows the viewer to stand at a distance. This forced familiarity is coupled with a dialogue between photographer and subject, an intimacy and understanding that extends to the viewer as well. Such pioneering, powerful first-person directness can be seen throughout Arbus's work. A fashion and general-assignment photographer for much of her career, Arbus created most of her serious prints in a relatively brief period of ten years.

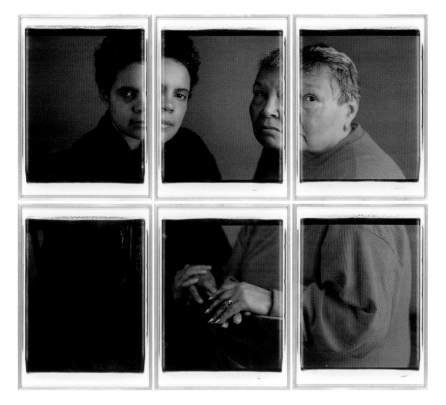

DAWOUD BEY
(American, b. 1953)
Candida and Her Mother, Celia, II, 1994
Six internal dye diffusion transfers; each 30⅛ × 22⅟₁₆ in. (765 × 560 mm)
Gladys N. Anderson Endowment, 2002.554.1–6

In the dispiriting times just after World War I, the Irish poet William Butler
Yeats wrote the famous line: "Things fall apart; the centre cannot hold." We
have since gotten used to living with pieces — pieces of time, heritage, even
morality. Although Dawoud Bey sometimes seeks a solitary moment or a single
point of view in a photograph, he knows that the essence of what lives before
the camera often eludes that approach. For example, in his photograph *Candida
and Her Mother, Celia, II,* the photographer emphasizes through its parts the com-
plexity of a mother-daughter and husband-wife relationship. The grid format of
his composition allows the two women separate frames for their faces and
hands to be together. It also includes frames for their different and deep gazes
back to him, a presence outside the picture. Even though our time has its own
horrors and ambiguities that need to be addressed, Bey knows that all
people and peoples can build a cohesive sanctuary within what is theirs alone.
The photographer has found it here among pieces and shares it with us as the
wholesome beauty of a loving family bond.

VIK MUNIZ
(Brazilian, b. 1961)
11 Eggs, 1997
Gelatin silver print; 22¹⁵⁄₁₆ × 19³⁄₁₆ in. (582 × 487 mm)
Barbara and Lawrence Spitz Fund, 1998.572

This photograph, entitled *11 Eggs*, shows only eight. It therefore seems that the
photographer, Vik Muniz, has conjured up a fantastical reality, even if it is
grounded in real material. He has used photography, the most accurate of all
visual mediums, to gain our trust. Thus, if we convince ourselves that the hid-
den eggs are somewhere beneath the ones we see so clearly, a trick of appear-
ances has already been played. There are no eggs at all, just an illusion deftly
sketched in what we can make out as lighter earth — the clutch is nothing but a
different patch of dirt. Muniz is fond of saying that his goal is to be like a
clumsy magician who likes to leave traces of his tricks for us to discover.
Although the appearance-versus-reality theme is older than Harry Houdini and
more ancient than Plato, philosophers, scholars, and artists continue to grapple
with it. Historian Daniel Boorstein anticipated Muniz's contemporary attitude in
1961 when he wrote: "The everyday images which flood our experience have
this advantage over the tricks of magic: even after we have been taken behind
the scenes, we can still enjoy the pleasures of deception."

Prints and
Drawings

MASTER OF THE AMSTERDAM CABINET
(German or Dutch, active c. 1465–1500)

The Road to Calvary, 1475/80
Drypoint on ivory laid paper;
5⅛ × 7⅝ in. (130 × 194 mm)
Clarence Buckingham Collection, 1958.299

This dramatic depiction of Christ's suffering on his way to his crucifixion is one of the first examples of drypoint by the anonymous master who invented this method of engraving. In drypoint, one draws directly on a metal plate with a sharp instrument, a process that preserves the artist's personal "handwriting" and imparts to the print a characteristically velvety line. Here, the artist skillfully exploited the soft, atmospheric effects, silvery shadows, and sense of delicate, luminous distances that are attainable in drypoint. The forest of lances that juts up behind the background hills also creates the illusion of depth. The central motif is Christ's suffering at the hands of three soldiers who force him and Simon of Cyrene, an innocent bystander, onward in their ordeal. On the left, the grieving figure of Mary, supported by the apostle John, is strikingly juxtaposed with the utterly indifferent, elegant soldier on the right, who has turned his back on the whole scene. This impression of *The Road to Calvary* is one of three known by this artist, who is called the Master of the Amsterdam Cabinet (or sometimes the Housebook Master) because the Rijksprentenkabinet in Amsterdam owns eighty of the approximately ninety surviving prints by his hand.

GIOVANNI BENEDETTO CASTIGLIONE
(Italian, 1616–1670)
The Creation of Adam, c. 1642
Monotype on ivory laid paper;
11⁷/₈ × 8¹/₁₆ in. (302 × 204 mm)
Restricted gift of Dr. William D. and Sara R. Shorey
and an anonymous donor, 1985.1113

Considered one of the most original and innovative Italian artists of the Baroque period, Giovanni Benedetto Castiglione literally separated light from darkness, creating form out of chaos, in this earliest known monotype. In a perfect match of medium and message, Castiglione, the native Genoese artist credited with inventing the technique, used this new method to portray the central act of Genesis: the creation of man. He produced this electrifying image by scraping the design into the inked surface of a copper plate with a blunt instrument, such as a stick or paintbrush handle, and then printing directly on a sheet of paper. Broad, angular strokes of white depict God emerging from a cloud, while thin, fluid lines extract the languid body of Adam from velvety blackness. Castiglione's monotypes employ both this dark-ground technique, which naturally lends itself to dramatic and mysterious imagery, and the light-ground manner, in which the design is drawn in ink directly on a clean copper plate. Both processes yield only one, fine impression. It was not until the nineteenth century that such versatile artists as Edgar Degas (see p. 197) explored the monotype's full potential.

REMBRANDT HARMENSZ. VAN RIJN
(Dutch, 1606–1669)

Adam and Eve, 1638
Etching on ivory laid paper;
6⅜ × 4⁹⁄₁₆ in. (162 × 116 mm)
Gift of the Harry and Maribel G. Blum Foundation, 1987.247

Rembrandt van Rijn was as great a graphic artist as he was a painter (see p. 133). In the etching *Adam and Eve*, he combined his technical finesse with his genius for biblical storytelling to present a powerful, psychologically nuanced portrayal of the very moment of temptation, when the first man and woman consider eating the forbidden apple of knowledge. Descriptive, wiry lines portray real human beings with knotty flesh and protruding bellies, caught in a minutely rendered bower of leaves, lichen, and moss. Behind them, in an open and evocative landscape, trumpets a tiny elephant, an exotic motif representing a virtuous counterpart to the evil serpent hovering above the primordial couple. Rembrandt's naturalistic rendering of Adam and Eve imparted deep humanity to these individuals, struggling with the unidealized emotions of temptation and guilt. At the same time, using the etcher's needle to exploit the medium's wide tonal range, Rembrandt suggested the divine importance of the moment by infusing the entire scene with light and shadow.

RODOLPHE BRESDIN
(French, 1822–1885)

The Good Samaritan, 1861
Lithograph on ivory wove paper;
22³/₁₆ × 17⁷/₁₆ in. (564 × 443 mm)
Through prior bequests of Charles Deering, Maxine Kunstadter, and Carl O.
Schniewind; through prior acquisitions of the Joseph Brooks Fair Endowment
and the Carter H. Harrison, Print and Drawing Club, and Print Department
Purchase funds; through prior gift of an anonymous donor, 1989.478

Considered one of the outstanding prints of the nineteenth century, *The Good Samaritan* is regarded as the masterpiece of Rodolphe Bresdin's lithographic career. This rare, first-edition impression is a highlight of the Art Institute's extensive collection of Bresdin's work. The fantastically intricate lithograph reveals the artist's fertile imagination and technical powers, which intensify every inch of the large image. It relates the Christian parable of the Samaritan, a foreigner, who mercifully aids a wounded traveler whom a priest and Levite had passed with eyes averted. Bresdin first exhibited the print in Paris at the state-sponsored Salon of 1861 under the title *Abd el-Kader Aiding a Christian*, referring to the contemporary Muslim hero who had personally saved thousands of Christians from Syrian aggression in 1860. This allusion to the celebrated Algerian proved so popular that *The Good Samaritan*'s printing history spanned nearly thirty-eight years, resulting in approximately one thousand impressions. Bresdin thus nicknamed the print his own "good Samaritan," but its success could not sustain his career. Despite his creation of some fine late works, Bresdin died alone and impoverished.

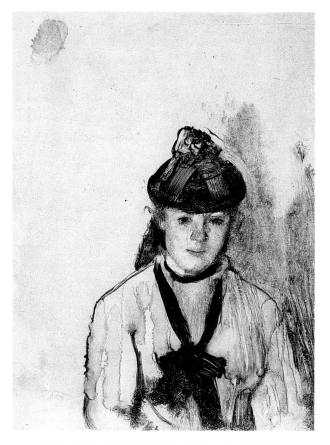

HILAIRE GERMAINE EDGAR DEGAS
(French, 1834–1917)
The Actress Ellen Andrée, c. 1876
Monotype printed in brownish-black ink on cream laid paper;
9⁵/₁₆ × 7³/₁₆ in. (237 × 183 mm)
Potter Palmer Collection, 1956.1216

Edgar Degas's portrait of the actress Ellen Andrée is one of the most unusual and haunting images in the monotype medium by the artist considered to be its greatest practitioner in the nineteenth century. An early work, it was executed in the light-field manner, but in a highly unorthodox way: while Degas drew directly on the copper plate, in some places he thinned the ink with turpentine to such an extent that it is barely visible. What emerged was a unique, painterly image, at once watery in consistency and warm in tone. Andrée's limpid eyes and sensuous lips may have been touched up with a brush after the plate was printed. Ellen Andrée was a lively, witty woman whose circle also included the artists Auguste Renoir and Edouard Manet, in whose work she also appeared. She was the model as well for Degas's masterpiece *The Absinthe Drinker* (Musée d'Orsay, Paris). Her own artistic preferences, however, were unequivocally on the side of the more traditional Salon painters, as indicated by her retort when she refused a pastel of one of Degas's dancers: "Degas, my sweet, thank you very much, but she is too vile-looking."

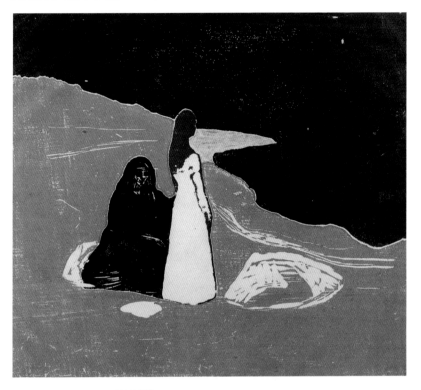

EDVARD MUNCH
(Norwegian, 1863–1944)
Women by the Shore, 1898
Woodcut printed in four colors on cream Japanese paper;
21 × 23⁷⁄₁₆ in. (533 × 595 mm)
Clarence Buckingham Collection, 1963.293

"I painted the lines and colors that impinged on my inner eye. I painted from
memory, adding nothing and omitting the details that I no longer had before
my eyes. Hence the simplicity of these paintings, their apparent emptiness. I
painted the impressions of my childhood. The troubled colors of a bygone era,"
Edvard Munch wrote in 1889. The woodcut, with its rough texture and primi-
tive quality, was a particularly effective medium to express these interiorized,
distant experiences. In this large and starkly compelling woodcut, the master
printmaker explored the themes of loneliness, sex, and death. A young girl,
clad in white, gazes outward across an open, dark sea, seemingly oblivious to
her fate, the spectral figure squatting beside her. As he frequently did toward
the late 1890s, Munch sawed the woodcut into three sections — separating the
figures from the land and the land from the sea — which he then inked in
different colors, reassembled, and printed. The flat, simplified planes of color
that resulted, with their clear, undulating contours, enhance the woodcut's
expressiveness. The division and unification of the woodblock may have
had emotional significance for an artist who saw the world as alienating
and fragmented.

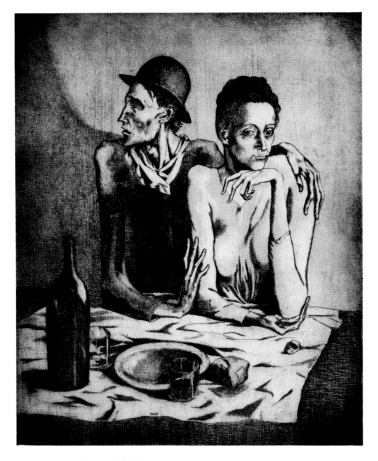

PABLO PICASSO
(Spanish, 1881–1973)
The Frugal Repast, 1904
Etching printed in blue-green on ivory laid paper; 18½ × 15 in. (480 × 380 mm)
Clarence Buckingham Collection, 1963.825

The remarkable artistic career of Pablo Picasso spanned more than seven decades and influenced nearly every major trend in the first half of the twentieth century. One of the last works of Picasso's "blue period" (1901–04) is this large, hauntingly expressive etching, completed just after the artist settled permanently in France and moved into a dilapidated Montmartre tenement nicknamed the *bateau-lavoir* (washerwoman's boat). During this time, the struggling artist's palette and the mood of his particular cast of characters — the poor, the ill, the outcast — were dominated by a chilling and timeless blue. In this austere etching, two subjects that fascinated Picasso — couples in cafés and the solitude of the blind — are brought to refinement. The man's emaciated face is in profile, while the woman stares directly at the viewer, emphasizing the blindness of her companion. Their angular bodies and elongated fingers and the chalky, cold light recall works by El Greco. *The Frugal Repast*, which was only Picasso's second attempt at printmaking, reveals the artist's extraordinary gift for draftsmanship and his remarkable facility with new mediums and techniques.

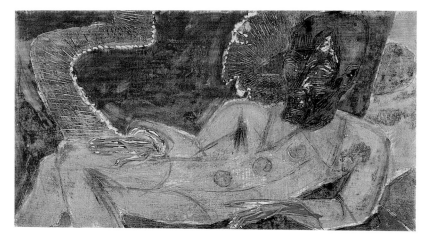

ERNST LUDWIG KIRCHNER
(German, 1880–1938)

Portrait of Otto Müller, 1915
Woodcut printed as a monoprint on cream wove paper;
10¾ × 21½ in. (273 × 546 mm)
Gift of Dr. Eugene Solow in honor of Paulette Solow, Judy Solow Kleckner,
Bryan Kleckner, and Gabrielle Kleckner, 1988.433

Among the greatest achievements in Ernst Ludwig Kirchner's career are his
innovative techniques and potent color woodcuts. A pivotal figure of the
German Expressionist movement, Kirchner first met Otto Müller, also a
painter-printmaker, in 1910. Müller joined Die Brücke (The Bridge), a group
Kirchner had helped found in 1905 that was instrumental in promoting
Expressionism. The emphasis of Die Brücke artists on process and technical
originality informs this portrait, which is from a small group of prints Kirchner
created between 1915 and 1917. In these works, Kirchner invented an unpre-
cedented method of color printing by inking a single block with a brush in
varying colors. Traditionally, prints are produced as exactly repeatable images;
each proof in this group was a unique work. Here Kirchner's rugged woodcut
vocabulary and striking color combinations convey not only the sitter's intense
intelligence but also the anxiety of the times, early in World War I. Müller's
passion for Egyptian art is also hinted at in the figure's frontal, reclining pose.
Kirchner made only a handful of impressions of this incisive and powerful
portrait.

ANSELM KIEFER
(German, b. 1945)

The Paths of the Wisdom of the World: Hermann's Battle, 1980
Woodcut with additions of acrylic and shellac on forty-five sheets of ivory wove paper; 135¾ × 208 in. (3450 × 5280 mm)
Wirt D. Walker Fund; restricted gift of Mr. and Mrs. Noel Rothman, Mr. and Mrs. Douglas Cohen, Mr. and Mrs. Thomas Dittmer, Mr. and Mrs. Lewis Manilow, Mr. and Mrs. Joseph Shapiro, Mr. and Mrs. Ralph Goldenberg, 1986.112

Born the year World War II ended, Anselm Kiefer confronts "the terror of history" in his provocative, intensely German art. Begun in 1978, the woodcut series *The Paths of the Wisdom of the World* (the title of an apology for Catholicism written in 1924) culminated in this 1980 work. Monumental in concept as well as size (it measures more than eleven by seventeen feet), this work is Kiefer's expansive study of German culture. The central image, a dark, primordial forest, represents the scene of the Teutonic tribal chieftain Hermann's legendary first-century victory over the Romans. A mysterious fire — perhaps of purification, perhaps of destruction — burns at the base of the trees. Around this mythic birthplace of German nationalism are clustered some thirty woodcut portraits of German poets, writers, philosophers, and military leaders — a kind of spiritual family tree of, in Kiefer's words, "personages [whom] history has abused." Kiefer unified this ambitious yet ambiguous work with a network of crude black lines not unlike the rings of a tree, a metaphor for the growth and cyclical evolution of the complicated web of German history. As in his other woodcuts, Kiefer used a traditional medium in an untraditional way. Instead of multiple images, he produced a unique work by grafting together the various woodcut portraits and embellishing them with acrylic and a wash of diluted shellac.

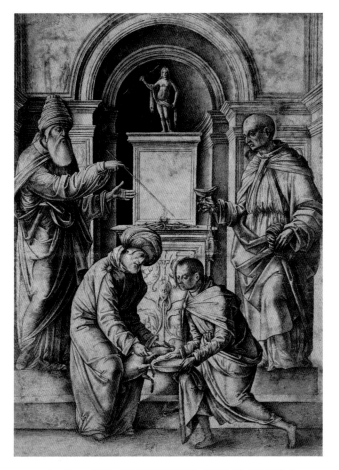

GIOVANNI FRANCESCO DE' MAINERI
(Italian, c. 1460–after 1506)

A Pagan Sacrifice, 1485/89
Pen and black ink, with brush and gray and brown wash, heightened with lead
white (partially discolored) on cream laid paper, edge mounted to cream wove
card; 16⁷/₁₆ × 11¹³/₁₆ in. (418 × 300 mm)
Restricted gift of the Regenstein Foundation, 1989.686

A masterpiece of fifteenth-century Italian
drawing, *A Pagan Sacrifice* may be the first
known work of Giovanni Francesco de'
Maineri. Maineri worked for the d'Este
family, whose court at Ferrara was one of
the most spectacular in Europe. Impres-
sive for its size and high quality, this draw-
ing imaginatively depicts an ancient ritual
through a classicizing Renaissance sensi-
bility. Despite its grisly subject matter,
animal sacrifice, the work is serene and
elegant, with refined, classically inspired
architecture and a sweetness of style often
seen in late fifteenth-century Italian art.
The drawing's rigidly geometric composi-
tion and sharp, concise draftsmanship
are characteristic of the style of Maineri,
who was a miniaturist as well as a painter
of court portraits and religious scenes.
The drawing's conscientious realization
suggests that it was a *modello* for an
unknown painting or part of a painting, a
sort of trial run Maineri used to prove to
himself or to a patron that he was capable
of completing the task at hand.

CLAUDE LORRAIN
(CLAUDE GELLÉE, French, 1600–1682)

Panorama from the Sasso, 1649/55
Pen and brown ink, and brush and brown wash, heightened with white gouache and traces of white chalk, over black chalk and traces of graphite, on cream laid paper; 6⁷⁄₁₆ × 15¹⁵⁄₁₆ in. (162 × 402 mm)
Helen Regenstein Collection, 1980.190

For the Frenchman from Lorraine, one of the most important aspects of his adopted city of Rome was its surrounding countryside, the Campagna, which the artist studied, sketched, and painted all his life. His evocative classical landscapes were sought after by papal patrons as well as aristocrats and royalty throughout Europe. For nearly a century after his death, travelers on the Grand Tour of European capitals judged real scenery according to his standards. In Claude's landscapes, as in this superb drawing, order and tranquility prevail; men perform no labor but rather exist peacefully in beautiful pastoral settings blessed by the warm Roman light. Depicted here is the region around the Sasso, a large rock ten miles south of Civitavecchia, which was then Rome's modern seaport. Evidently made at the site of the rock itself, the drawing is remarkable in its mastery of subtle ink washes that evocatively suggest, rather than describe, the landscape and sea. Individual trees stand out as nearly geometrical forms against the unifying light. The drawing's very long format enhances the idyllic landscape's panoramic sweep, which the viewer savors along with the solitary shepherd.

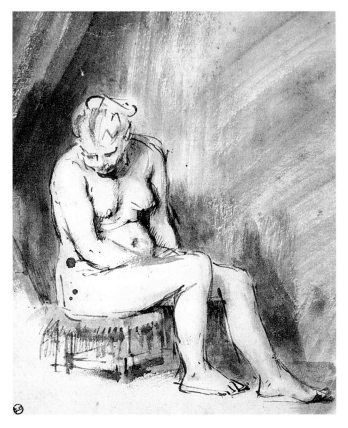

REMBRANDT HARMENSZ. VAN RIJN
(Dutch, 1606–1669)
Nude Woman Seated on a Stool, 1654/56
Pen and brown ink, and brush and brown wash, on ivory laid paper, laid down
on cream laid card; 8¼ × 6⅞ in. (212 × 174 mm)
Clarence Buckingham Collection, 1953.38

For Rembrandt van Rijn, simple honesty of vision and sureness of line were far more important than the classical glorification of the nude. He focused on this subject only during certain phases of his career; very few of these studies, which he used to prepare biblical or mythological representations, survive today. This heroic form is a late work, and one of only four extant drawings of the female nude attributed to Rembrandt with certainty. Unlike the almost scientific realism of his earlier nudes (see p. 195), his late studies are less detailed and more painterly. He attained a maximum of expression with a minimum of means. Rendered with a swift treatment by brush and the blunt reed pen favored by the artist in his late years, this ample figure projects a forceful presence. Her face is generalized; instead, feelings are conveyed through her contemplative pose. Her simple shape and external immobility seem to increase the viewer's sense of her inner vitality. In *Nude Woman Seated on a Stool*, Rembrandt's pen stroke and brushwork are integrated with the utmost lightness and perfection, the pen stressing structural features while the brush provides a transparent, atmospheric tone linking figure and space.

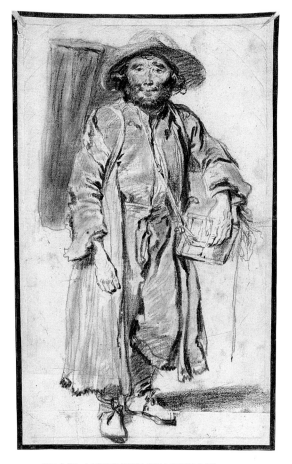

JEAN ANTOINE WATTEAU
(French, 1684–1721)

The Old Savoyard, c. 1715
Red and black chalk, with stumping, on buff laid paper, laid down on cream
wove card, laid down on cream board; 14¼ × 8⅞ in. (360 × 224 mm)
Helen Regenstein Collection, 1964.74

The Flemish-born artist Jean Antoine Watteau deviated from his acclaimed scenes of courtly figures in parklike settings (called *fêtes galantes*) with this arresting and naturalistic chalk drawing of a humble Savoyard. This elderly vagabond from the Savoy region of France was one of many peasants who flocked, around the turn of the eighteenth century, to Paris, where they tried to eke out livings as chimney sweeps, scavengers, or, like this old man, as street entertainers. His props accompany him: a large box of curiosities on his back, and under his arm a smaller case probably containing his constant companion and coperformer, a furry, small-eared marmot. Using only two colors of chalk, Watteau depicted the Savoyard's shrewd, humorous face, his tattered clothing, and his bulky paraphernalia with remarkable precision, sensitivity, and humanity. Of the ten extant studies of Savoyards by Watteau, four appear to portray the same salty character seen here. The drawing's broad, free execution points to the accomplished late works of this short-lived, gifted artist.

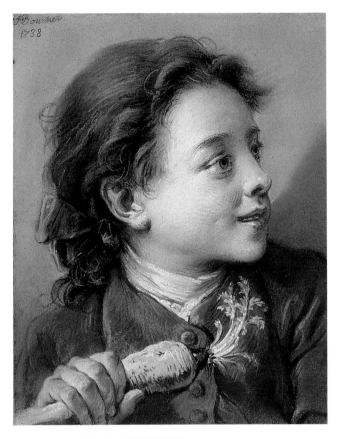

FRANÇOIS BOUCHER
(French, 1703–1770)

Boy Holding a Carrot, 1738
Pastel on buff laid paper;
12⅛ × 9⁹/₁₆ in. (306 × 241 mm)
Helen Regenstein Collection, 1971.231

François Boucher, whose art epitomized the light-hearted sensuality of the
Rococo style, was the most famous painter and decorator during the reign of
Louis XV (r. 1715–74), and was championed by Madame de Pompadour, the
king's powerful mistress. Boucher seldom ventured from major paintings and
decorative ensembles to do finished, independent works on paper. Nor did
he pursue portraiture, apart from his depictions of royal patrons and members
of his family. This engaging and fresh portrait of a boy, perhaps a studio
apprentice, may well be one of Boucher's first, and finest, forays into pastel
drawing. With this adaptable and newly fashionable medium, Rococo artists
were able to imbue their images with a spirited directness and sense of life.
Here Boucher captured the dimple-cheeked lad just as he seems to turn, lips
parted as if to speak. The youth's attentive gaze, tousled hair, and delicately
rendered rosy skin convey an extraordinary immediacy and warmth. His
elegant city clothes herald the artist's suave later manner as court painter.
This same young model, again holding a carrot, appears in at least two paint-
ings of pastoral subjects by Boucher.

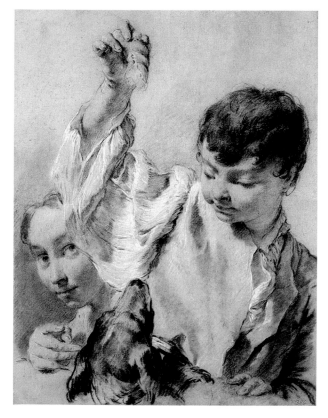

GIOVANNI BATTISTA PIAZZETTA
(Italian, 1682–1754)

Boy Feeding a Dog, 1738/39
Black chalk, with stumping, and traces of charcoal, heightened with touches of
white chalk, on blue-gray laid paper (discolored to cream) laid down on cream
wood pulp buff; 21 1/8 × 16 5/8 in. (535 × 422 mm)
Helen Regenstein Collection, 1971.326

This charming and energetic chalk study is a product of the fruitful alliance of the gifted Venetian artist Giovanni Battista Piazzetta and his German patron, Count von der Schulenburg. An avid art collector and field marshal who successfully defended the Venetian republic against Turkish invasion, Schulenburg owned over 957 works of art upon his death, at least thirty of which were by Piazzetta. *Boy Feeding a Dog* reflects the count's fondness for genre subjects and Piazzetta's vivacious and full-bodied studies of the Venetian populace, on which his fame as a draftsman rests today. This drawing was particularly valued by the artist, perhaps because the youths portrayed may well be his thirteen-year-old son, Giacomo, and his ten-year-old daughter, Barbara Angiola. Piazzetta captured the boy teasing the dog with a twisted roll, or *cornuto*. The enigmatic presence of the girl and the spectacular quality of the white-chalk highlights illuminating the boy's pleated sleeve both serve to heighten the drama of this otherwise playful scene. Other works by Piazzetta formerly in the Schulenburg family collection and now in the Art Institute include eight additional chalk drawings as well as two paintings, including *The Beggar Boy*, one of the many other works for which Giacomo also modeled.

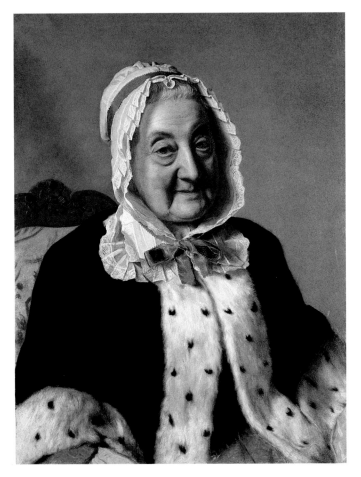

JEAN ETIENNE LIOTARD
(Swiss, 1702–1789)
Marthe Marie Tronchin, 1758/61
Pastel on vellum; 24⁹/₁₆ × 18⁵/₈ in. (624 × 473 mm)
Clarence Buckingham Collection, 1985.252

Jean Etienne Liotard executed this portrait of a shrewd but sympathetic elderly woman at the height of his career as a celebrated pastel portraitist. Son of a Geneva jeweler, Liotard was trained in miniature painting, a Genevese specialty closely linked with the country's watch industry. His Swiss heritage, with its native reserve and deeply rooted Calvinism, informed his highly realistic and straightforward portrait style, which he used to depict aristocrats such as the empress Maria Theresa and the nobility of the Viennese imperial court no differently than burghers. With characteristic direct-ness, Liotard here depicted the matriarch of one of the most influential families of the Swiss Confederation. The rosy flesh of her wise, wry face almost glows. The unerring precision with which Liotard rendered such details as the lace bonnet and ermine-trimmed velvet jacket reflects his early training in miniatures. Throughout his career, a peripatetic one that included travel and work through much of Europe as well as a four-year stay in Constantinople, Liotard painted no fewer than eight members of the powerful Tronchin family.

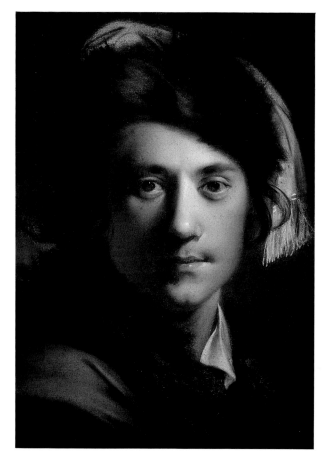

JOSEPH WRIGHT OF DERBY
(English, 1734–1797)
Self-Portrait in a Fur Cap, c. 1765/68
Black chalk heightened with white on blue-gray paper;
16¾ × 11⅝ in. (425 × 295 mm)
Clarence Buckingham Collection, 1990.141

Joseph Wright, a leading artist of the eighteenth century, spent most of his life in the central Midlands town of Derby, where he ran a successful portrait-painting practice. His best work in this vein portrays solid middle-class citizens, much like himself, with a keen perceptiveness of both character and physical appearance. Throughout his career, Wright was preoccupied with the evocative effects of light, specifically that of a single light source such as a candle, and the resulting play of shadows. Influenced by the powerful chiaroscuro of the superb mezzotints of Thomas Frye, a contemporary printmaker, he produced a number of dramatically lit self-portraits during the mid-1760s in oil, charcoal, and, as seen here, in black chalk heightened with white. Depicting himself in nocturnal lighting and wearing an exotic black hat, the artist evoked a time-honored tradition in portraiture, the deeply pensive artist who confronts himself and the viewer with quiet challenge. Wright later ventured into landscape and genre subjects, the most original of which are concerned with the exploration of light phenomena. Portrait commissions continued throughout his career to be a reliable source of income.

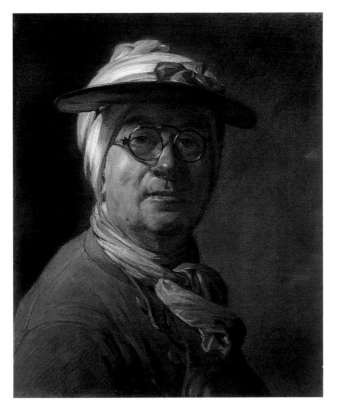

JEAN SIMÉON CHARDIN
(French, 1699–1779)

Self-Portrait with a Visor, c. 1776
Pastel on blue laid paper mounted on canvas;
18 × 14¹³/₁₆ in. (459 × 374 mm)
Clarence Buckingham Collection; Harold Joachim Memorial Fund, 1984.61

"This old oddity," said the French novelist Marcel Proust about Jean Siméon Chardin's audacious self-appraisal over a century after its creation, is "...so intelligent, so crazy... above all, so much of an artist." In a fitting finale to a long, successful career as a painter of still lifes and genre scenes, Chardin turned in his last decade to a new medium, pastel, and to new subject matter — portraits, primarily self-portraits. Eye problems due to poisoning from lead-based oil paints were the partial cause of this dramatic change. Of the thirteen pastel self-portraits by Chardin known today, most famous are versions of the example seen here, with the casually dressed, aging artist in his studio.

In this case, a blue visor (protecting his failing eyesight) adds the finishing touch to his eccentric attire. A virtuoso colorist, the septuagenarian revealed here a joyously free stroke and palette. Nonetheless, the construction of the figure is solid and rigorous, adding to his powerful presence. This composition was created at the same time as a portrait of the artist's wife for the 1775 Salon (both now in the Musée du Louvre, Paris). A year later, Chardin — with greater daring — replicated the pair. These later portraits were separated for almost two hundred years until they were reunited in the collection of the Art Institute.

JEAN HONORÉ FRAGONARD
(French, 1732–1806)

The Letter or *The Spanish Conversation*, c. 1778
Brush and brown ink with brush and brown wash, over graphite,
on ivory laid paper; 15¹¹/₁₆ × 11⁷/₁₆ in. (399 × 290 mm)
Margaret Day Blake Collection, 1945.32

Jean Honoré Fragonard's highly personal, powerful style emerged after periods of study with both François Boucher and Jean Siméon Chardin (see pp. 206 and 210) and over five years at the Académie de France in Rome. Entitled *The Letter* or *The Spanish Conversation* (because of the man's elegant attire — with a doublet of full sleeves and a wide, stiff neck ruff — a costume that was "in the Spanish mode"), this lively brown wash depicts with wit and teasing ambiguity an intimate incident in an upper-class drawing room. The artist's rapid, virtuoso draftsmanship evokes form with what seems like a minimum of effort, and his powerful handling of brush and wash reflects his ability to capture the effects of light. The interplay between the drawing's broad, free underdrawing and its shimmering veils of wash lend this work its charm and vivacity. The model in this drawing is said to be Fragonard's sister-in-law, the artist Marguerite Gérard, who appears in another Fragonard drawing in the Art Institute, *Marguerite Gérard Reading to Her Mother and Rosalie Fragonard*.

CASPAR DAVID FRIEDRICH
(German, 1774–1840)

Mountain Sanctuary, 1804
Brush and black ink and gray wash, with graphite, on cream wove paper;
9⅝ × 15⅛ in. (244 × 382 mm)
Margaret Day Blake Collection, 1976.22

This vast, distant landscape by one of the central figures of German Roman-
ticism dates from Caspar David Friedrich's early years in Dresden, where he
settled after studying in Copenhagen (then considered the artistic metropolis
of northern Europe). Subtly graded shades of gray wash evoke the gloomy,
overcast days so common in Germany in November, when this image was
created. The drawing also conveys, in the artist's words, "…not only what he
sees before him, but also what he sees within him." In the center of the land-
scape, atop the highest peak, a tiny pilgrim kneels in prayer at the base of a
statue of the Madonna. Nature, with its sheer blank of sky, stark hills, and mute
firs, is depicted almost religiously. In this deeply spiritual image, humankind's
experience of nature seems as overwhelming as the unfathomable mystery of
our existence. Just as the infinitesimal pilgrim wanders in this faraway, infinite
landscape, so did the artist embark upon his own Romantic quest, a search for
meaning in a natural world that reveals the sacred.

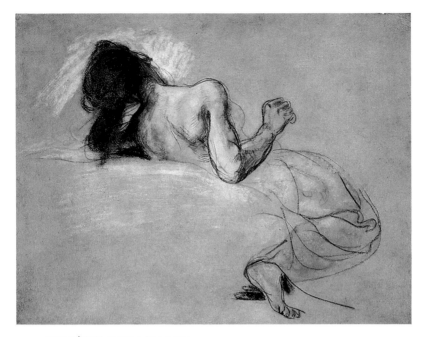

EUGÈNE DELACROIX
(French, 1798–1863)

Crouching Woman, study for *The Death of Sardanapalus*, 1827
Black and red chalk, with pastel, heightened with white chalk, over wash,
on tan wove paper; 9¹¹/₁₆ × 12⅜ in. (246 × 314 mm)
Through prior bequest of the Mr. and Mrs. Martin A. Ryerson Collection,
1990.226

Crouching Woman is one of five pastel studies for Eugène Delacroix's monu-
mental painting *The Death of Sardanapalus* (Musée du Louvre, Paris), which
helped establish the artist's reputation as the leader of the French Romantic
movement. Of the few pastels that Delacroix produced, this is the only group
that can be related to a single painting. Inspired by an 1821 play by the English
Romantic poet Lord Byron, the canvas dramatically depicts the last king of the
Assyrians who, reclining on his bed moments before his own suicide, watches
as his wives, concubines, and livestock are slain, by his order, to prevent their
slaughter by the enemy army that has just defeated them. In this expressive
image of one of the concubines, Delacroix convincingly captured the horror of
the fatal moment. With a sure, sweeping line, he described the rhythmic, taut
posture of a figure recoiling from a blow or the stab of a knife. Although this
powerful figure is significantly truncated in the final painting, the pastel pro-
vides insight into Delacroix's creative process, and its sensual drama is resonant
of the Romantic period. The Louvre also houses three of the five pastel studies
for the composition; the whereabouts of the fifth is unknown.

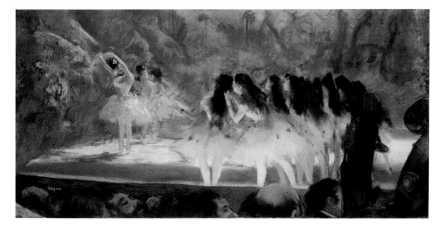

HILAIRE GERMAINE EDGAR DEGAS
(French, 1834–1917)
Ballet at the Paris Opéra, 1876/77
Pastel over monotype on cream laid paper;
13⅞ × 27¹³/₁₆ in. (352 × 706 mm)
Gift of Mary and Leigh Block, 1981.12

One of the nineteenth century's most innovative artists, Edgar Degas often combined traditional techniques in unorthodox ways. In *Ballet at the Paris Opéra*, the artist creatively combined the monotype technique, rarely used in his time, with the fragile medium of pastel. Described as "the powder of butterfly wings," pastel was the perfect medium to illustrate the onstage metamorphosis of spindly young dancers into illusions of beauty as perfect and short-lived as butterflies. This work, executed in the dark-field manner with one of the widest monotype plates ever used by the artist (see p. 197), bears Degas's characteristically cropped forms and odd vantage points, which so effectively convey the immediacy of the scene. Here the view is from the orchestra pit, with the necks of the bass viols intruding into the dancers' zone. The central dancer is in fifth position, *en pointe*, but the random positioning of the corps de ballet, with the dancers' free-flowing hair, suggests that they are rehearsing rather than performing. The Paris Opéra was the official school of the first state-supported ballet, the Académie Royale de Danse, created in 1661.

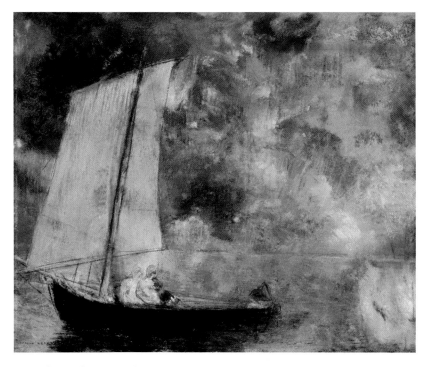

ODILON REDON
(French, 1840–1916)

Flower Clouds, c. 1904
Pastel, with scraping, on tan wove paper with black fibers, wrapped around gray board; 17⁹/₁₆ × 21⁵/₁₆ in. (447 × 542 mm)
Through prior bequest of the Mr. and Mrs. Martin A. Ryerson Collection, 1990.165

The evocative, symbolic art of Odilon Redon drew its inspiration from the internal world of his imagination. For years, this student of Rodolphe Bresdin (see p. 196) worked only in black and white, producing powerful and haunting charcoal drawings, lithographs, and etchings. Just as these black works, or *Noirs*, began to receive critical and public acclaim in the 1890s, Redon began to discover the marvels of color through the use of pastel. His immersion in color and a new technique brought about a change in the artist's approach to subject matter as well. *Flower Clouds* is one of a number of pastels executed around 1905 that are dominated by spiritual overtones. Here, a sailboat bears two figures, perhaps two saintly women, on a timeless journey through a fantastic, phosphorescent sea and sky. The dreamlike skiff may reflect Redon's internal voyage, replacing the nocturnal turmoil of the earlier *Noirs* with a more hopeful vision. The luminous intensity of the pastels echoes the ardent spirituality of the theme.

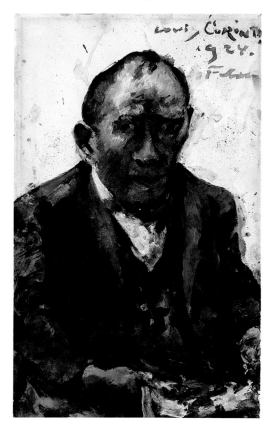

LOVIS CORINTH
(German, 1858–1925)
Self-Portrait, 1924
Gouache with possible additions in oil paint on ivory wove paper;
19⅛ × 12 in. (486 × 305 mm)
Clarence Buckingham Collection, 1987.280

"The times are not the same for us old folk anymore," read a 1923 diary entry by Lovis Corinth, who had suffered a stroke in 1911 and never quite recovered. "We have lost our way…so sad, so very sad." The following year, he created this tortured self-image; he was sixty-five, with one year left to live. An inveterate self-portraitist, Lovis Corinth produced more images of himself than almost any other artist except Rembrandt. In this haunting gouache, the artist gazes at the viewer in anguish. The brooding palette portrays the deeply shadowed face, contorted and haggard and sunk into hunched shoulders. The pain that both the diary entry and this portrait convey was curiously at odds with Corinth's professional life, which had, in fact, been successful. Challenging traditional approaches to art, his early figure compositions, with their overt sexuality and violent movement, made his reputation. Later, he executed intensely colored, windswept landscapes that became his most popular works. But Corinth was a deeply patriotic man, and his personal accomplishments failed to assuage the torment he experienced from Germany's humiliation in World War I and his despair over the values of the ensuing Weimar Republic.

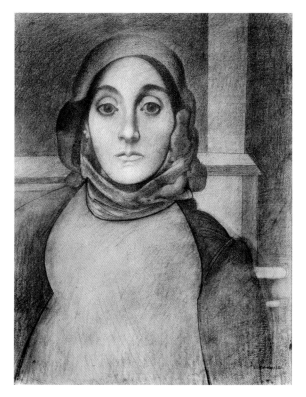

ARSHILE GORKY
(American, b. Armenia, 1904–1948)
The Artist's Mother, 1938
Charcoal on ivory laid paper; 24⅞ × 19³⁄₁₆ in. (630 × 485 mm)
Worcester Sketch Collection Fund, 1965.510

"The eyes of the Armenian speak before the lips move and long after they cease to," Arshile Gorky once wrote. These words well describe this heroic portrait of the artist's mother, Lady Shushanik. Although of noble lineage, Shushanik and her family were peasants exposed to severe hardship, including poverty and Turkish persecution and massacre. In 1919, Lady Shushanik died from starvation; the following year, Gorky and a sister emigrated to the United States. This tender, haunting image is based on a photograph of the artist with his mother taken in 1912. Clad in simple country clothes, Lady Shushanik is a gaunt and distant figure, with remarkable and piercing eyes; in them seem to be reflected all of Armenia's woes. Gorky depicted her with careful, classical simplicity, transforming the woman's dark beauty into the perfect features of an Eastern church icon. The same photograph served as inspiration for two canvases entitled *The Artist and His Mother* (Whitney Museum of American Art, New York; National Gallery of Art, Washington, D.C.), as well as numerous notebook sketches and other drawings. The Art Institute's drawing is the most finished of these sheets. From this early representational mode, Gorky's art underwent a complex evolution that led, in the 1940s, to his dynamic, biomorphic abstractions. Tragically, the artist himself did not escape hardship. After a series of personal disasters in the 1940s, Gorky took his own life.

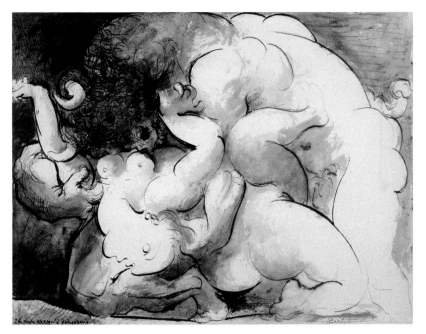

PABLO PICASSO
(Spanish, 1881–1973)

Embrace of the Minotaur, 1933
Brush and pen and black ink, and gray wash, on blue wove paper;
18⅜ x 24¼ in. (480 x 630 mm)
Gift of Tiffany and Margaret Day Blake, 1967.516

The consummate draftsmanship, fertile imagination, and boundless energy of
Pablo Picasso combined to produce a tremendous outpouring of graphic work
throughout his career. In the late 1920s and early 1930s, one of the artist's
favorite subjects made its debut: the Minotaur, the monstrous creature from
Greek mythology, half-man and half-bull, who lived in the labyrinth of King
Minos on Crete. Here, in a swirl of intertwined limbs, a struggling nude woman
is enveloped in the powerful embrace of the beast. Picasso's masterful tech-
nique echoes the Minotaur's attack: the brushstrokes are full of barely con-
trolled excitement; thin layers of wash heighten the drawing's mystery and
sexuality. This tragic hybrid, torn between human and animal needs, was a
powerful symbol for Picasso. A group of etchings made the same year and
later published as the *Vollard Suite* portray the Minotaur as a winsome beast,
sometimes carousing, often rapacious, who was both feared and loved by the
women he victimized. Also in 1933, the lusty beast launched the first issue of
Minotaure, a Surrealist journal published in Paris whose cover Picasso designed.

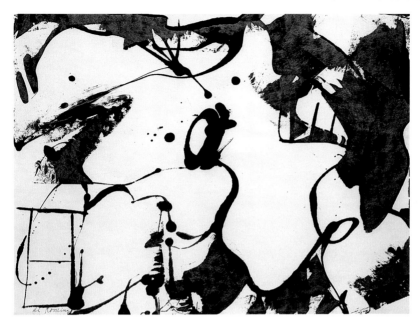

WILLEM DE KOONING
(American, b. Netherlands, 1904–1997)

Untitled, 1950
Black enamel on off-white wove paper; 20 × 26 in. (485 × 651 mm)
Gift of Katharine Kuh, 1986.138

This expressive black-enamel drawing illustrates the radically new visual language espoused by the Abstract Expressionist artists in New York during the late 1940s and 1950s. It culminates a series of complex black-and-white abstractions begun by the Dutch-born Willem de Kooning in 1946. His almost exclusive use of such a restricted palette, while aesthetically motivated, was also determined in part by the availability of inexpensive commercial paint. For these explorations, de Kooning used a sign painter's long-bristled brush capable of holding large quantities of paint (one of his first jobs in the United States was house and sign painting). Here the artist made rapid marks and dribbles across the white surface that he then scraped with a palette knife, splaying and breaking the speed of the original line. One can see in this sheet, with its inventive and sweeping strokes and dynamic sense of form and space, the origins of the pictorial vocabulary the artist took up in full color after he completed this series of abstractions.

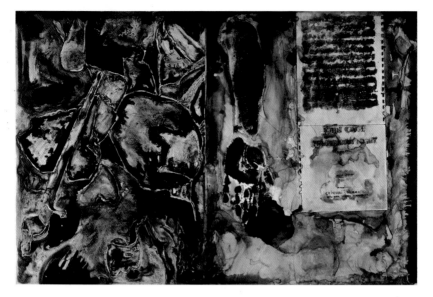

JASPER JOHNS
(American, b. 1930)

Perilous Night, 1982
Ink on frosted mylar; 39⁹/₁₆ × 94⁷/₁₆ in. (1004 × 2400 mm)
Through prior gift of Mary and Leigh Block; Harold L. Stuart Endowment,
1989.82

Jasper Johns, one of the pioneers of Pop art, began his career in the mid-1950s
by re-creating, with great precision, such familiar images as targets, letters,
numbers, and flags. Although Johns's subject matter has become less common-
place, he continues to "borrow" from the public domain. *Perilous Night*, for
instance, owes its title to a pivotal and expressive piece of music written by the
American composer John Cage (1912–1992) in 1945, upon the break-up of his
marriage. Both score and cover sheet are rendered on the right-hand side of the
drawing with Johns's characteristically fluid handling of ink. On the drawing's
left side is a freehand version, abstracted, reversed, and turned ninety degrees,
of a single, terror-stricken soldier from the Resurrection panel of Mathias
Grünewald's sixteenth-century masterwork, the *Isenheim Altarpiece* (Unterlin-
den Museum, Colmar). Between the soldier and the musical score is a black
imprint of Johns's right arm, evidence perhaps of the creative power that can
merge two disparate images into a cogent statement. The overcome soldier
witnessing the Resurrection of Christ and a piece of music marking a key
transition in a composer's career both point to "perilous nights" that can
change the course of human lives. Characteristically, Johns has explored the
same subject in different media. This somberly colored drawing derives
from a painting of the same name (private collection) also executed in 1982.

Textiles

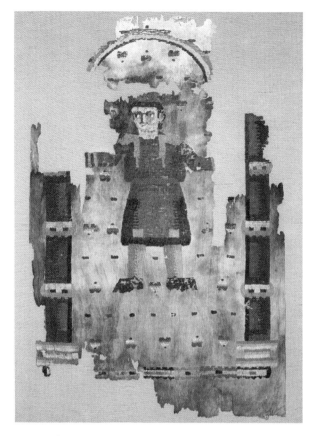

PORTION OF HANGING WITH WARRIOR

Egyptian, Coptic, 5th/6th cen.
Linen and wool, plain weave with weft pile and embroidered linen pile in back
and stem stitches; 53¾ × 34¾ in. (136.5 × 88.3 cm)
Grace R. Smith Textile Endowment, 1982.1578

Because many textiles made by Early Christian Egyptians, called the Copts, were preserved in arid tombs, a substantial number of these fabrics have survived in remarkably good condition. This striking portion of a wall hanging depicts a warrior standing beneath a colonnaded, arched opening. With raised arms, which perhaps once held a weapon, he wears a traditional tunic with clavic bands, the narrow strips extending down from the shoulders, front and back, to the waist or hem. This woven piece is distinguished by its large size, imposing composition, and brilliant, unfaded shades of reds, greens, blues, browns, and yellows. The figure's commanding frontality, solemn expression, and animated side glance, together with the composition's bold lines and vivid colors, relate this fragment to the Copts' hauntingly realistic portrait icons. Also suggestive of icons is the three-dimensional appearance, achieved by using darker colored threads, of the warrior's face, his legs, and the columns — an effect much easier to achieve in painting than in weaving. Woven of indigenous materials, the hanging is composed of linen warps and wool and linen wefts to create an uncut pile against a plain-weave foundation, a fabric surface less common in Coptic textiles than the tapestry weave.

TUNIC DEPICTING FELINES AND BIRDS

Peruvian, Nazca culture, 3rd/4th cen.
Camelid wool, cotton, and feathers;
33½ × 33⅞ in. (85.2 × 86 cm)
Kate S. Buckingham Endowment, 1955.1789

This striking feathered tunic was produced by weavers of the Nazca people,
who lived on the arid coastal plain of southern Peru. Owing to the desert
climate of this area, the poncho — along with many other artifacts of the Nazca
culture — was so well preserved in the sandy grave in which it lay buried that it
appears today much as it did seventeen centuries ago. Made of brightly colored
feathers imported from the Amazon basin, tunics such as this were worn for
special ceremonies, presented to diplomatic missions, and placed in royal tombs
as part of the mummy bundle of the deceased. Technical requirements of
weaving and attaching feathers produced the angular, simplified shapes seen
here, standard subjects of the Nazca visual repertoire. The heraldic motif of
two opposing felines signals the regal status of the wearer, a convention that
reappeared in Peru twelve hundred years later in the royal garments worn by
Inca kings. The series of sea birds may refer to the high value placed on them
by fishermen, who located schools of fish beneath the surface of the sea by
observing the flight patterns of these birds. The water and sea symbolism is
continued in the lower portion of the tunic, which is embellished with a
stepped wave motif.

PANEL (detail)
Italian, early 15th cen.
Silk, plain weave, cut solid velvet;
19¼ x 23⅝ in. (49 x 59.7 cm)
Kate S. Buckingham Endowment, 1954.12

Silk — the filament produced and spun into a cocoon by the larva of the silk moth — has long been considered the finest of all fibers woven into cloth. Of all fabrics woven of silk, lush-textured velvet is the most sumptuous. The manufacture of velvet reached its apogee during the Italian Renaissance. In techniques of cut or uncut pile, a combination of the two *(ciselé)*, or the richest of all, pile-on-pile, velvet was used extensively, appearing in ecclesiastical life and the secular world alike. This fragment, produced in an Italian workshop, was once part of a splendid garment worn only for the most distinguished occasions. Its design of calves' or oxens' heads and eagles linked by floral tendrils was perhaps a family crest. Weaving velvet on hand-operated looms was a particularly complex process. Here, the unusually large size and the ambitious use of three different colors in the pattern make this panel an exceptional example of Italian Renaissance velvets.

RETABLE AND ALTAR FRONTAL

Spanish, c. 1468
Linen, plain weave; appliquéd with linen and silk, plain weaves and cut solid
velvet; embroidered with silk and gilt-and-silvered-metal-strip-wrapped silk;
seed pearls and spangles; retable: 65 × 79 in. (165.2 × 200.8 cm); altar frontal:
35 × 79⅝ in. (88.8 × 202.3 cm)
Gift of Mrs. Chauncey McCormick and Mrs. Richard Ely Danielson, 1927.1779

A masterpiece of textile art from the
Renaissance, this Spanish altarpiece was
originally given around 1468 to the
Cathedral of Burgo de Osma by its gener-
ous benefactor, Pedro de Montoya, bishop
of Osma. A virtual encyclopedia of com-
plex textile techniques using velvet, silk,
gold and silver threads, as well as seed
pearls and spangles, this sumptuous
devotional work shares the iconography,
design, and architecture of paintings and
carvings of the period. The upper portion
(retable) features a triptych of Gothic
arches separated by tall, heavily padded
colonnettes that is remarkable in its illu-
sion of depth. Long, closely laid stitches
(laid work) create subtle shading to simu-
late shadows cast by the architectural
enframements. Enclosed within
the arches are the Madonna and Child,
flanked by the Nativity on the left and the
Adoration of the Magi on the right. Bor-
dering the retable are medallions filled
with angels' heads alternating with the
Montoya coat of arms. The lower portion,
which covered the front of the altar,
depicts the Resurrection in the central
niche, with three apostles on either side.
Flemish art was prevalent in Spain during
the fifteenth century, and influenced the
naturalism of the figurative scenes, the
substitution of landscape backgrounds
for the customary gold, and the detailed
precision of the various textile techniques.

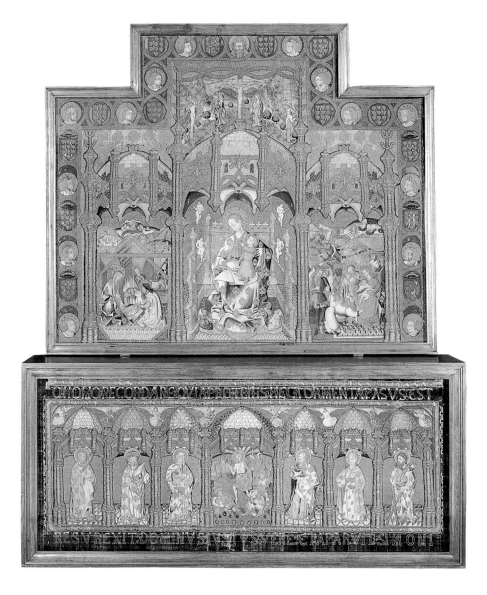

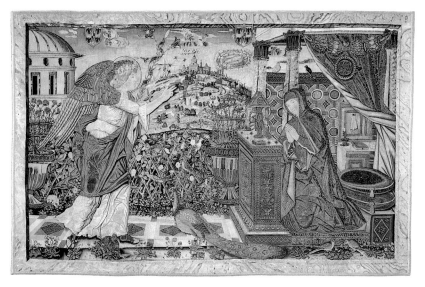

HANGING DEPICTING THE ANNUNCIATION

Italian, 1506/19
Design attributed to Andrea Mantegna (1431–1506) or artists at court
of Mantua
Inscription: *A[ve] G[ratia] P[lena] Ecce Ancilla D[omini] F[iat] M[ihi] S[ecundum] T[uum]* ("Hail full of grace; behold the handmaid of the Lord; Be it unto me according Thy word")
Wool, silk, and gilt-and-silvered-metal-strip-wrapped silk, slit, dovetailed, and interlocking tapestry weave; 45⅛ × 70⅜ in. (114.6 × 178.8 cm)
Bequest of Mr. and Mrs. Martin A. Ryerson, 1937.1099

In Europe, the great era of tapestry weaving stretched from the twelfth to the eighteenth centuries, with centers of production based in Flanders and France. Among the first to bring northern weavers to Italy was the ruling family of Mantua, the Gonzagas, whose court painter was the eminent Andrea Mantegna. Tapestries are based on actual-size cartoons, or drawings. This exquisite New Testament scene, with its vivid depiction of detail, may have been woven by Flemish weavers from a cartoon designed by Mantegna. As was customary in the finest works from the fifteenth century on, silk and threads of precious metal are combined here with wool to enhance detail. A fruit-bearing trellis separates the elegant figures of the angel Gabriel and the Virgin, who kneels in prayer in a sumptuous loggia, or porch. Peafowl roam in front (referring perhaps to the interest in birds of the dukes of Mantua), while in the distance stretches a minutely depicted landscape, filled with more plants and animals as well as a miniature town and people working the land. Symbolic perhaps of the close alliance between tapestry making and painting, the piece is bordered by a woven frame imitating marble. Two Gonzaga coats of arms hang from the top edge of the border.

COPE

English, late 15th/early 16th cen.
Silk, cut voided velvet; appliquéd with plain weave; embroidered with silk and
gilt-metal-strip-wrapped silk; 56¾ × 114⅝ in. (144 × 291.1 cm)
Grace R. Smith Textile Endowment, 1971.312a

The production of splendid textiles for the Church—hangings, altar frontals,
and liturgical vestments—was a thriving industry in Europe from the twelfth
through the eighteenth centuries. Unlike secular fabrics, these glorious works
of art were preserved in church treasuries, and many survive today. Among the
finest ecclesiastical vestments is this resplendent velvet cope, a semicircular
cloak worn as an outer garment in processions or during special ceremonies by
a priest or bishop. The elegant needlework was called *opus anglicanum* (English
work). Surrounding the cope's central image of the Assumption of the Virgin,
rendered in silk and gold threads, are seraphim standing on wheels, thistles,
fleurs-de-lis, and double-headed eagles, all connected by tendrils animated by
spangles. Old Testament prophets and New Testament saints with their attri-
butes alternate on the orphrey band, which runs the full width of the cope.
Saint Paul is depicted on the hood, which rests on the back of the cope, while
God holding an orb decorates the morse, or closure. The brown velvet ground
(which may have faded from purple or crimson), unusual for the color of a
vestment, can be found in other textiles used in the English church.

NŌ DRAMA COSTUME *(NUIHAKU)*

Japanese, Momoyama period, 16th cen.
Silk, plain weave; patterned with resist dyeing, impressed gold leaf, and
embroidered with silk in a variety of stitches; couching; 63¼ × 52⅜ in.
(160.6 × 133.1 cm)
Restricted gift of Mrs. Charles H. Worcester, 1928.814

This exquisitely woven silk robe, or *nui-haku*, from the Momoyama period is the only known theatrical costume of its age and kind in the West. Its extraordinary beauty was the visual focus of the otherwise austere, wooden stage set used in Nō drama. Emerging as part of religious ceremonies in the fourteenth century, Nō evolved into a highly refined, poetic form of court theater centered on music and dance. Nō plays were based on classical Buddhist literature and folktales. Costumes were designed with infinite care, for encoded within their motifs were points of plot, character, and atmosphere, as well as allusions to the spiritual substance beneath a gloriously shimmering surface. Here, in the *katamigawari* style (meaning "one side differs from the other"), plant and floral arrangements are depicted in the interlocking lozenge pattern on the left side, while on the right, tiny narrative scenes suggest vignettes from classical literature. Made with expensive and intricate techniques such as paste-resist dyeing, impressed gold leaf, and silk needlework, this *nuihaku* was used primarily for female roles (which were played by men). In a custom unique to Nō, enthusiastic patrons would donate their own garments for future costumes of the troupe, and it is thought that this robe originally belonged to one such aristocratic aficionado.

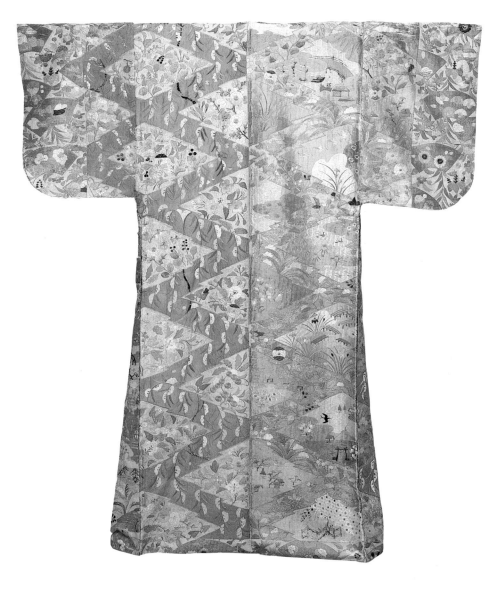

CUSHION COVER

English, 1601
Inscription: *N W / 1601 / C W*
Linen, plain weave; embroidered with
silk, linen, and wool in long-armed
cross stitches; edged with woven fringe;
19½ × 20¾ in. (49.5 × 52.8 cm)
Robert Allerton Endowment, 1989.149

This richly embroidered cushion cover,
one of a pair, reflects the resurgent popu-
larity of the art of needlework during the
reign of Queen Elizabeth I (r. 1558–1603).
The bold design, worked on linen in color-
ful silks, wool yarns, and linen threads,
features Tudor roses in the corners and
center, the latter depicted in the traditional
rose red and pink. The alternate blossoms
represent the beautiful exotic flowers
beloved by the English at the time. The
renowned ecclesiastical needlework of
English embroiderers became personal
and domestic around the turn of the
seventeenth century. Judging from the
inscription, it is likely that this cover and
its companion (currently in The Metro-
politan Museum of Art, New York) were
made to celebrate a wedding. The letters
"N. W." and "C. W." are the initials of the
betrothed, and 1601 marks the date of
their union. Cushions of this type were
also used to hold coronets and special
jewels, as well as to support books with
precious bindings, such as devotional texts.

CRAVAT END WITH MONOGRAM OF LOUIS XIV

Belgian, 1700/15
Linen, bobbin part-lace of a type known
as "Brussels"; 12⅝ × 16⅜ in.
(32.1 × 41.7 cm)
Restricted gift of Mr. and Mrs. John V.
Farwell, 1987.334

When the heavily Baroque fashions
originating at the court of Louis XIV
(r. 1643–1715) were simplified during the
late 1660s, accessories underwent similar
changes. Once belonging to a set of two,
this splendid piece of Brussels lace was
made for the Sun King himself, shortly
before his death. This type of bobbin part-
lace, initially produced in Brussels during
the eighteenth century, consists of indi-
vidual motifs made separately, but joined
together so skillfully that the seams are
almost imperceptible. Worn, with its mate,
slightly gathered at the neck, this rectan-
gular piece is replete with symbols sig-
nifying the elevated status of its wearer.
In its center are a rooster and trophies,
beneath which is the king's monogram of
double L's. Surmounting this image and
supported by two trumpeting angels is a
baldachin, a canopy carried over impor-
tant personages during processions. Armed
female warriors appear to the right and
left, and gracing the upper corners are the
Maltese cross and the emblem of Louis
himself, the sun.

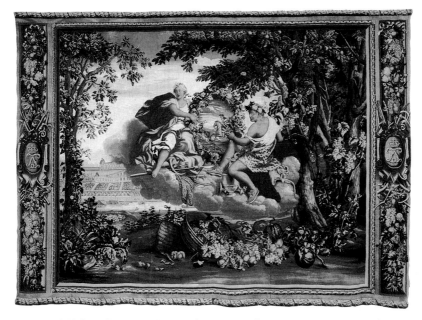

HANGING ENTITLED "AUTUMN"

French, c. 1710
After a cartoon by Charles Le Brun (1619–1690); woven by Étienne Claude
Le Blond (c. 1700–1751) and Jean de La Croix (active 1662–1712),
Gobelins factory
Wool and silk, slit and double interlocking tapestry weave; 149⅛ × 209⅜ in.
(378.8 × 531.8 cm)
Gift of the Hearst Foundation, 1954.260

In 1662, King Louis XIV of France (r. 1643–1715) acquired the former town-
house of the Gobelins family, cloth dyers and merchants, and after five years of
renovation proclaimed it a royal factory. The prominent painter Charles Le
Brun was appointed director; all designs for tapestry, known as cartoons, were
to be supplied by him. (As evidence of the close link between tapestry and
painting, such notable artists as François Boucher, Francisco Goya, and Nicolas
Poussin were also involved in textile manufacture or design.) This large picto-
rial hanging is from a series based on the four seasons, from designs by Le Brun
that were utilized long after his death. (The Art Institute also owns the *Winter*
hanging.) Floating on a cloud, the central allegorical figures hold a floral
wreath enclosing a scene of a stag hunt. At their feet are hunting equipment,
wine goblets, and ewers. An autumnal cornucopia surrounds them: fruit-laden
trees, baskets overflowing with just-harvested fruits and vegetables, and, in
the background, beyond a heavily trafficked river filled with boats ferrying
crops, the bounteous walled gardens of a magnificent palace. Enclosing this
visual feast is a woven depiction of the wooden frame popular at the time —
heavily gilded, ornately carved, and incorporating the interlocking L's of Louis
XIV's monogram.

PANEL (detail)

French, c. 1775
Designed by Philippe de LaSalle
(1723–1805); woven and produced
by Camille Pernon & Cie
Silk and linen, satin weave with
brocading wefts; painted details;
75¾ × 21⅝ in. (192.4 × 54.8 cm)
Restricted gift of the Textile Society,
1983.748

This handsome panel was part of a commission by the influential designer and weaver Philippe de LaSalle for the Russian Empress Catherine II's summer palace at Tsarkoe Selo. A segment of many hundreds of yards of a repeated pattern that covered the palace walls, this piece remained in place until the palace was dismantled at the outbreak of the Russian Revolution in 1917. Based in France's silk capital of Lyon, LaSalle was the partner of Camille Pernon, principal furnisher of designs to the royal furniture treasury (garde meuble) of Louis XVI. His privileged position resulted in important and far-flung commissions such as this. The training LaSalle had received under the painter François Boucher, among others, infused his work with visual refinement that complemented his vast knowledge of weaving techniques. This engaging design features one of the motifs he used often: two doves perched on a wreath with a flower-filled basket hanging by a ribbon, set against a rich, dark red ground. The panel demonstrates the greater emphasis of the Louis XVI style on centrality and weight as opposed to the lighter, more freely handled manner of the earlier Rococo. Likewise, LaSalle eschewed ornately brocaded fabrics and such embellishments as gold and silver threads, preferring instead the simpler, understated forms seen here.

PANEL ENTITLED "A VISIT TO THE CAMP" (detail)
English, c. 1785
After engravings by Henry Bunbury (1750–1811)
Inscription: *Royal Artillery / G III R*
Cotton, plain weave; copper-plate printed; 35¾ × 27¾ in. (90.9 × 70.4 cm)
Gift of Emily Crane Chadbourne, 1952.585a

Based on a series of satirical engravings by the caricaturist Henry Bunbury, this printed panel depicts various humorous scenes occurring at a British military encampment. The inscription on the drumhead in the upper right, "Royal Artillery G. III R.," refers to King George III (r. 1760–1820), who may, in fact, be the regal figure standing in the panel's middle section. The short, rotund man on the far right might possibly be Benjamin Franklin, and the image may allude to American independence. Such delightful scenes are products of the invention of copper-plate printing in 1752 by Francis

Nixon, at the Drumcondra Printworks near Dublin. In this new type of textile printing, patterns were incised on large copper plates, put on a carriage, and inked onto the fabric under the heavy pressure of a roller. The immediate advantage of this process was being able to use big plates, thus making larger repeats possible. In addition, metal plates could be finely engraved to achieve greater details than woodblock printing. However, like the earlier, more cumbersome technique, only one color could be printed at a time — hence the single sepia tone against a plain woven ground.

BEDCOVER

American, 1842
Cotton, plain weaves; pieced and appliquéd with cotton, some printed in a variety of techniques, some glazed; quilted; 104⅛ × 107⅜ in. (264.7 × 272.6 cm)
Gift of Betsey Leeds Tait Puth, 1978.923

This cheerful bedcover is a "friendship quilt" made for a woman named Ella Maria Deacon in 1842 in the area of Mount Holly, New Jersey. The superb condition of this example preserves the ingenious and skilled workmanship that went into it. Eighty-five different patterns, many of them individually autographed in sepia ink, are set in diagonal lattice strips and surrounded by a border. If custom was followed, the individual sections were completed at the various homes of those involved, and then joined together with needle and thread (called piecing) at a final gathering called a quilting bee. There, the sheet of joined squares, batting (soft filling), and a printed cotton backing were assembled, and all three layers quilted together. The quilting bee was often a convivial time of eating, drinking, dancing, and conversation. In the bottom center of the bedcover, Susan Haines of Rancocas composed an acrostic in sepia ink, in which the initial letters of each line, read vertically, spell out her friend's name. "Methinks as thy eye, o'er thy quilt warms with pleasure," reads one line, "Amid these mementoes, thou'll hold them a treasure."

HANGING ENTITLED "POMONA"

English, 1898/1918
Designed by Sir Edmund Burne-Jones
(1833–1898) and William Morris
(1834–1896); woven and produced
at Merton Abbey, Wimbledon
Cotton, wool, and silk, double
interlocking tapestry weave;
65 × 36½ in. (165.1 × 92.9 cm)
Ida E. Noyes Fund, 1919.792

Designed by the painter Sir Edmund Burne-Jones and the influential designer William Morris, this tapestry-woven hanging is an artifact of the Arts and Crafts movement, founded by Morris and his followers in the late 1880s. This British reform movement originated in response to the lack of design standards and the wretched working conditions that resulted from the Industrial Revolution. In establishing the workshops at Merton Abbey, the weaving studio where *Pomona* was produced, Morris hoped to re-create traditions of medieval guilds, where artists and laborers worked with equal pride to create fine, handcrafted items such as the piece shown here. Pomona is the Roman goddess of fruit trees. She is portrayed in warm, almost glowing colors as she gathers apples in her skirt with one hand, holding up a branch of an apple tree in the other. Her soft face and full, draped figure display a sensuousness missing in the Renaissance prototypes that inspired this hanging. The background of flowers and fruit recalls the floral *(millefleurs)* tapestries of the fifteenth and sixteenth centuries, whereas the border design is reminiscent of early woodcuts. Made for home use, *Pomona* and its companion piece, *Flora*, were smaller versions of the first large tapestries (1884–85) woven at Merton Abbey.

PORTIERE FOR JAMES A. PATTEN HOUSE

American, 1901
Designed by George Maher (1864–1926) and Louis J. Millet (1853–1923)
Silk and cotton, cut solid velvet; appliquéd with satin, satin damask, and plain
weaves; embroidered; 80⅛ × 48 in. (203.7 × 121.9 cm)
Restricted gift of the Antiquarian Society, 1971.680

The impact of the British Arts and Crafts movement, which stressed the application of quality craftsmanship and design to all types of furnishings and decoration, was far-reaching in the United States. In Chicago, through the intense involvement of Frank Lloyd Wright, Arts and Crafts culminated with the architecture and decorative arts of the Prairie School. Though his style was tempered by European, academic classicism, George Maher was typical of Prairie School architects in attempting to achieve visual unity by reflecting features of the American landscape (as well as the life-styles of his clients) in his designs. In what he called "motif-rhythm theory," a specific decorative motif, either abstract or naturalistic, is repeated throughout a particular house. In the James A. Patten house in Evanston, Illinois, which Maher designed in 1901 with Louis J. Millet, he chose the thistle as the unifying motif. According to Maher, the thistle's "refinement of outline and …strong organic growth…could be most readily accommodated to the various materials…of the building." This design motif was used in stenciled wall decorations, leaded-glass windows, and fabrics, such as this rich and refined portiere, or doorway panel. The Patten house was demolished in 1938.

PANEL ENTITLED "SANTA SOFIA" (detail)
Austrian, 1910/12
Designed by Josef Hoffmann (1870–1956); printed and produced by the Wiener Werkstätte
Silk and cotton, plain weave; screen printed; 53⅜ × 45⅛ in. (135.7 × 114.6 cm)
Gift of Robert Allerton, 1924.217

The dynamic and modern motif of *Santa Sofia* was used by Josef Hoffmann in a variety of patterns and designs. A grid of squares is here enlivened by additional geometric patterns of diamonds, crosses, and triangles. The striking black and white panel reflects the goals of the Wiener Werkstätte (Vienna Workshop), where it was produced. The Werkstätte, cofounded in 1903 by Hoffmann, one of Vienna's foremost architect/designers, had among its goals the reinstitution of handwork and skilled craftsmanship in the production of well-designed, functional objects. Toward this end, artisans were trained in a variety of media. When it closed in 1932, the Werkstätte's textile section had produced the work of more than eighty designers, with Hoffmann's output alone numbering some 6,204 patterns. The design here is screen printed, an innovative process that permits large-scale patterns, precision, and absolute control over line. The pattern was issued in several color schemes.

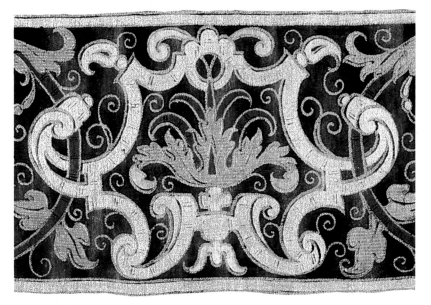

BORDER (detail)
Italian, 1920/30
Designed by Mariano Fortuny y Madrazo (Spanish, 1871–1959); printed and produced by the Società Anonima Fortuny, Venice
Cotton, twill weave; printed in the Fortuny system; 12½ × 352½ in. (31.8 × 895.1 cm)
Gift of Vera Megowan, 1981.99

This elegant border, reminiscent of an embroidered, appliquéd design from the seventeenth century, shows the breadth of sources that inspired the eminent designer Mariano Fortuny. Ancient garments, manuscript illuminations, paintings and frescoes, as well as Renaissance velvets and Rococo silks, influenced his sought-after fashions and furnishing fabrics. Reflecting the technical proficiency of the former painter who settled in Venice, the cotton border is printed in a composite of techniques, including block printing and stenciling, that is even today not fully understood. These furnishing fabrics were enormously popular because of their uncanny ability to blend harmoniously almost anywhere, and because they could be used in myriad ways, from cushions, screens, and lampshades to hangings. Fortuny's cotton fabrics were also used as wall coverings to decorate large spaces, such as hotels, museums, and theaters. Often, they were hung like enormous gathered curtains from rails just below ceiling height. Their folds conveyed to a space a sense of movement, and produced a play of light that heightened their color.

PANEL ENTITLED "BAMAKO" (detail)

American, 1960
Designed and printed by Charles
Edmund (Ed) Rossbach (b. 1914)
Linen and silk, warp printed;
plain weave; 84⅝ × 33⅝ in.
(214.8 × 85.7 cm)
Gift of Ed Rossbach, 1985.750

Through his teaching, writing, and prolific body of work, Ed Rossbach has been an influential figure in the post-World War II fiber-arts movement. A prodigious experimenter with the expressive potential of various forms, methods, and materials, often drawn from different cultures and eras, Rossbach has juxtaposed fine materials like silk with everyday and unconventional material such as newspaper, string, and plastic. *Bamako*, inspired by the medallions that decorate classical Greek vases, reflects these explorations. To create his designs on a loom, Rossbach used the early technique of warp printing, which involved painting the warp threads a strong blue before weaving. The panel's title refers to this process: Bamako is the capital of Mali, West Africa, which has a long tradition of warp printing. The linen-and-silk length was the prototype for custom-designed yardage, which was issued in 1962/63 by the notable textile firm of Jack Lenor Larsen, who had once served Rossbach as an assistant. Intended for the interior design market, the fabric could be used to line walls or upholster furniture or, by stretching a length over a support, hung as a work of art.

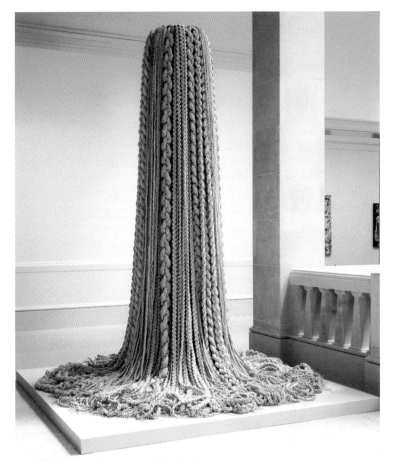

CLAIRE ZEISLER
(American, 1903–1991)

Private Affair I, 1986
Hemp, macramé (multiple chain knots), twisted and wrapped cords; cut fringe;
h. approx. 126 in. (320 cm), spill diam. 90 in. (228.6 cm)
Marion and Samuel Klasstorner Endowment, 1986.1050

Claire Zeisler is celebrated for bringing textile art into open space. "My mission," the Chicago artist once stated, "was to remove fiber from the wall." Her first weavings, in the 1950s, were loom-based, but when the two-dimensional loom became too confining, she began to exploit the potential of sculptural knotting. She eventually developed a system of making hard, little knots that form the inner structure of the tall, cascading woven sculpture seen here. Made of hemp, multiple chain knots of macramé, and twisted and wrapped cords with a cut fringe, *Private Affair I* stands ten feet tall and weighs almost fifteen hundred pounds. Five hundred of these intricately knotted strands cascade into an eight-foot swirl on the floor. In addition to various forms of fiber (wool, sisal, raffia, jute, and hemp), Zeisler also worked in leather, wrapped styrofoam, and metal, her works ranging in size from minute objects to the monumental structure shown here, with end results that seem to move and occupy space.

Modern and
Contemporary Art

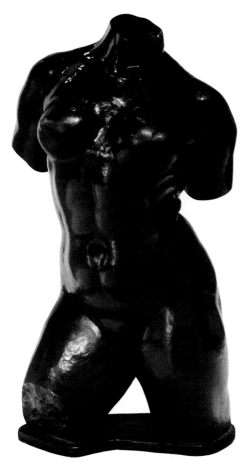

ARISTIDE MAILLOL
(French, 1861–1944)

Chained Action, c. 1906
Bronze; h. 47½ in. (120.5 cm)
Wirt D. Walker Fund, 1955.29

Academically trained as a painter, but self-taught as a sculptor, Aristide Maillol was primarily interested in representing the formal structure of the human figure, particularly that of the full and partial female nude, without venturing into the avant-garde world of abstraction. This powerfully built torso was created for a memorial commissioned in 1905 to Louis Auguste Blanqui (1805–1881), the early socialist theoretician and organizer. When he heard from the memorial committee (which included statesman Georges Clemenceau, novelist Anatole France, and critic Octave Mirbeau) that Blanqui had spent many years in prison for his ideas— he was called *l'enfermé*, "the locked-up one"— Maillol is reported to have said, "I shall make you a nude woman: it will be 'Liberty in Chains.'" The revolutionary's fiery personality inspired one of Maillol's most dynamic works. The energetic twist of the forward-thrusting torso captures the essence of a whole figure, with head turned and hands manacled behind her back. With his wife as a model, Maillol said he completed this forceful, ample torso in only ten days and finished the full-length figure in three months. The sculpture was so unpopular with the authorities, who considered it improper, that it was not unveiled in Puget-Théniers, Blanqui's birthplace, until 1908.

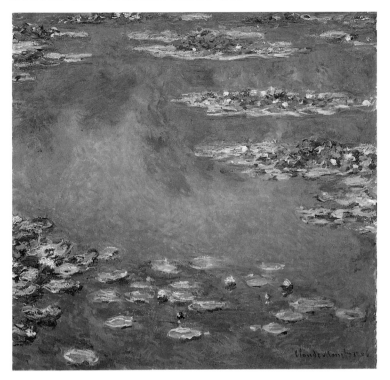

CLAUDE MONET
(French, 1840–1926)
Water Lilies, 1906
Oil on canvas; 34½ × 36½ in. (87.6 × 92.7 cm)
Mr. and Mrs. Martin A. Ryerson Collection, 1933.1157

"One instant, one aspect of nature contains it all," said Claude Monet, referring to his late masterpieces, the water landscapes, which he painted at his home in Giverny between 1897 and his death in 1926. These culminating series replaced the varied contemporary subjects he had produced from the 1870s through the 1890s (see pp. 155, 164–65) with a single, timeless motif, the water lilies, with which to "capture better the life of atmosphere and light, which is the very essence of painting, in its changing and fugitive play." The focal point was the artist's beloved flower garden, which featured a water garden and smaller pond, spanned by a Japanese footbridge. In the first series, executed between 1897 and 1899, Monet painted the pond in context with its water lilies, bridge, and trees, all neatly divided

by a fixed horizon. As years passed, the artist became less and less concerned with conventional pictorial space. By the time the Art Institute's *Water Lilies,* from Monet's third group of these works, was painted, he had dispensed with the horizon line altogether. In this spatially ambiguous canvas, the artist looked down, focusing solely on the surface of the pond with its cluster of plants floating amidst the reflection of sky and trees. In so doing, Monet created the image of a horizontal surface on a vertical one. Four years later, by 1910, he further transcended the conventional boundaries of easel painting and began to make immense, unified compositions whose complex and densely painted surfaces seem to merge with the flora-filled surface of the water.

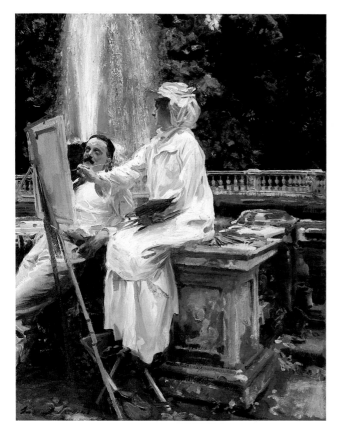

JOHN SINGER SARGENT
(American, 1856–1925)

The Fountain, Villa Torlonia, Frascati, 1907
Oil on canvas; 28⅛ × 22¼ in. (71.4 × 56.5 cm)
Friends of American Art Collection, 1914.57

As one of the most sought-after and prolific portraitists of international high society, American expatriate John Singer Sargent painted the cosmopolitan world to which he belonged with aristocratic elegance and a bravura touch. Born to American parents residing in Italy, Sargent spent his adult life first in Paris and then, after the mid-1880s, in London. The artist also traveled continually, and it was during these trips that he expanded his repertoire to include the *plein-air* effects of outdoor painting. Set in a sunlit garden in the central Italian town of Frascati, this charming double portrait depicts Sargent's friends and fellow artists, the American couple Wilfrid and Jane Emmet de Glehn. The painting is filled with light, displaying Sargent's characteristically dazzling surface, articulated with thick impasto and virtuoso brushwork. Jane described this as a "most amusing and killingly funny picture" in a letter to her sister Lydia. She continued: "I am all in white with a white painting blouse and a pale blue veil around my hat. I look rather like a pierrot, but have a rather worried expression as every painter should who isn't a perfect fool, says Sargent. Wilfrid is in short sleeves, very idle and good for nothing, and our heads come against the great 'panache' of the fountain."

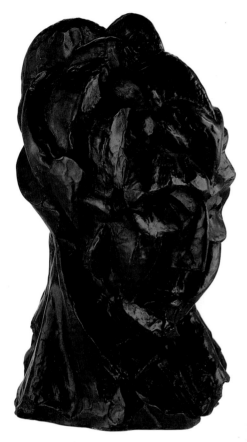

PABLO PICASSO
(Spanish, 1881–1973)
Head of Fernande Olivier, 1909
Bronze; h. 16⅛ in. (40.9 cm)
Alfred Stieglitz Collection, 1949.584

The first large Cubist sculpture, *Head of Fernande Olivier* depicts the woman who was Pablo Picasso's model and mistress from 1904 until 1911. For this impressive bronze, the artist attempted to translate into three dimensions the many geometricized heads of Olivier that he had painted and drawn during the period when he was introduced to African and pre-Roman Iberian sculpture, deep influences on the radical new language of Cubism. He left the basic shape of his lover's head intact while breaking up its surface into sharp ridges, a method similar to the faceting seen in his early Cubist painting of this time. Amid the surface fragmentation, with its formal units systematically arranged in a strict rhythm of light and shadow, the head retains its basic solidity and volume, and its anatomical features — eye sockets, nose, and lips — maintain a relatively realistic positioning. This work is from the small original edition of bronzes produced by the Parisian art dealer and entrepreneur Ambroise Vollard. In 1959, the artist authorized an additional cast of nine.

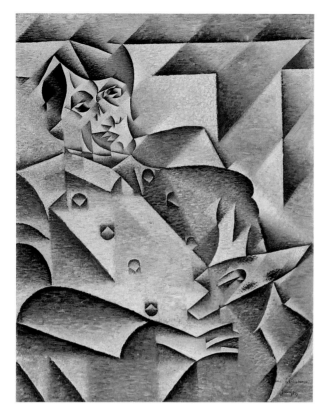

JUAN GRIS
(Spanish, 1887–1927)
Portrait of Pablo Picasso, 1912
Oil on canvas; 36⅝ × 29³/₁₆ in. (93 × 74.1 cm)
Gift of Leigh B. Block, 1958.525

Calling himself Juan Gris (*gris* meaning gray in French and Spanish), José Victoriano González moved from Madrid to Paris in 1906, taking up residence in the same building as fellow Spaniard Pablo Picasso, six years his senior. By 1912, the former magazine illustrator had evolved a significant style of his own, as evidenced by this masterpiece of Analytic Cubism, which Gris exhibited at the Salon des Indépendants. *Portrait of Pablo Picasso* fittingly pays homage to one of the founders of Cubism (Georges Braque was the other innovator) by fracturing Picasso's head, neck, and upper torso into various planes, shapes, and contours so that, when recombined, they represent the artist's form simultaneously from several points of view. Despite the painting's dissolution of traditional, identifiable shapes, Picasso's unique facial features — his full lips, intense, dark eyes, and thick, black hair — are recognizable. Consistent with his revolutionary artistic stature, Picasso seems enormous. With his big head and military-looking jacket (whose whimsical buttons turn up, down, and sideways), he is shown seated in a high-backed chair, holding his palette. Cool blues, browns, and grays color Gris's carefully delineated planes, whose edges seem almost luminous. In many of his later paintings, however, Gris restored color to Cubism, creating faceted surfaces with intense, almost jewel-like hues.

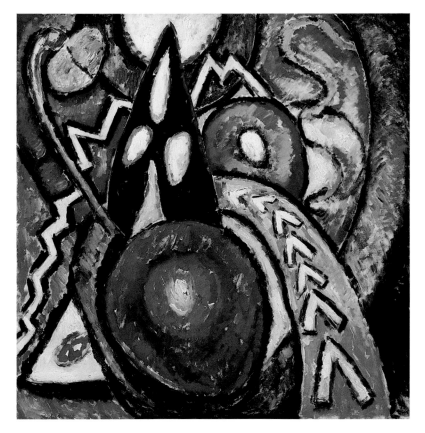

MARSDEN HARTLEY
(American, 1877–1943)

Movements, 1915
Oil on canvas; 47⅛ × 47¼ in. (119.7 × 120 cm)
Alfred Stieglitz Collection, 1949.544

Movements was painted shortly after Marsden Hartley returned from a visit to
Germany, where he met with Vasily Kandinsky, among others, whose abstract
and highly spiritual art (see p. 251) influenced the American deeply. Hartley
was a central figure of the American avant-garde that exhibited at Alfred
Stieglitz's New York gallery, 291 (see p. 176). The title of Hartley's intense,
vividly colored canvas suggests a musical analogy for its nearly abstract forms,
which are rhythmically orchestrated around the central red circle and black
triangle. Hartley often turned to nature for solace. Perhaps the triangle depicts
a mountain surrounded by other shapes suggestive of nature: the sun, the sky,
lightning, water, vegetation. Weaving the whole together is the heavy, dark
outlining, which isolates and intensifies the colors it surrounds, like the leading
in stained glass windows. Although Hartley's art underwent frequent changes
in style and subject, the charged, romantic energy seen here remained a
constant presence.

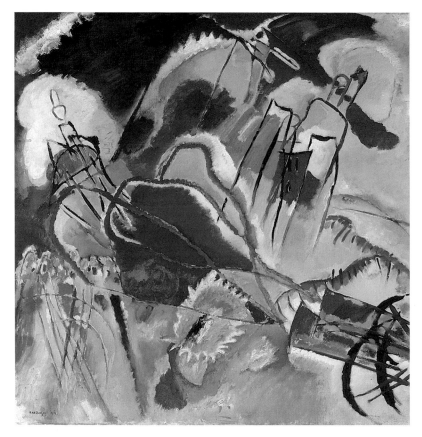

VASILY KANDINSKY
(French, b. Russia, 1866–1944)
Improvisation 30 (Cannons), 1913
Oil on canvas; 43 × 43¼ in. (109.2 × 109.9 cm)
Arthur Jerome Eddy Memorial Collection, 1931.511

Pioneering abstraction as the richest, most musical form of artistic expression, Vasily Kandinsky gave the title "Improvisation" to around thirty-six works completed between 1911 and 1913. Unlike James McNeill Whistler's carefully conceived series of "arrangements" and "nocturnes" (see p. 31), the "improvisations" of the mystical, Russian-born artist were, in his words, "largely unconscious, spontaneous expressions of inner character, nonmaterial in nature." While *Improvisation 30 (Cannons)* at first appears to be an almost cosmic battle between a random assortment of brilliant colors, shapes, and lines, one can discern leaning buildings, a crowd of people, and a wheeled, smoking cannon. In a letter to the Chicago lawyer Arthur Jerome Eddy, who purchased the painting in 1913 and later bequeathed it to the Art Institute, Kandinsky explained that "the presence of the cannons in the picture could probably be explained by the constant war talk that has been going on throughout the year." Eventually, these references to the material world ceased and the profoundly influential modern master devoted himself to pure abstraction.

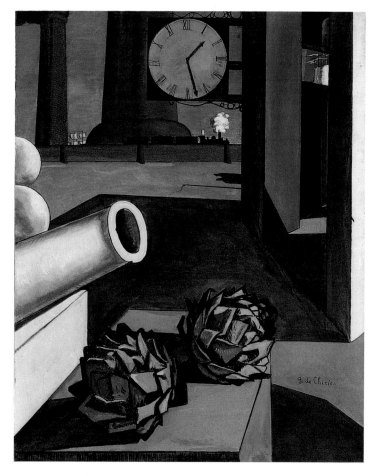

GIORGIO DE CHIRICO
(Italian, 1888–1978)
The Philosopher's Conquest, 1914
Oil on canvas; 49¼ × 39 in. (125.1 × 99.1 cm)
Joseph Winterbotham Collection, 1939.405

The Philosopher's Conquest is one of the masterful early paintings of Giorgio de Chirico, the silent, deserted dreamworlds that exerted a powerful influence on Surrealist art. Many of de Chirico's favorite motifs appear here like elements of a psychic puzzle: oversized artichokes, a cannon and cannonballs, a clock set at 1:28, a factory chimney and a round tower dwarfing a train and square-rigged ship. The stage set for this extraordinary juxtaposition of objects is an Italian plaza, virtually deserted except for menacing shadows. The elements are rendered with matter-of-fact precision in bright colors and illuminated in a cold, white light. Rife with possible interpretations — psychoanalytic, philosophical, art-historical — the meaning of *The Philosopher's Conquest* remains enigmatic. De Chirico called this quality metaphysical: "art that in certain aspects resembles...the restlessness of myth." Paintings such as this one profoundly affected the Surrealists' attempts to portray dreams and images of the subconscious.

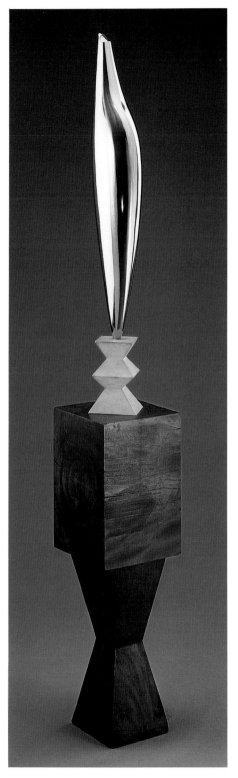

CONSTANTIN BRANCUSI
(French, b. Romania, 1876–1957)
Golden Bird, 1916, pedestal c. 1922
Bronze, stone, and wood;
h. 37¾ in. (95.9 cm)
Partial gift of the Arts Club of Chicago;
restricted gift of various donors;
through prior bequest of Arthur
Rubloff; through prior restricted gift of
William Hartmann; through prior gifts
of Mr. and Mrs. Carter H. Harrison, Mr.
and Mrs. Arnold H. Maremont through
the Kate Maremont Foundation,
Woodruff J. Parker, Mrs. Clive Runnells,
Mr. and Mrs. Martin A. Ryerson, and
various donors, 1990.88

"All my life, I have sought to render the
essence of flight," Constantin Brancusi
once said. The work of the Romanian-
born sculptor, who settled in Paris in 1904,
consists of variations on several themes,
often in a range of media, making each
version a unique example of some primary
form. Brancusi began the first of his
twenty-seven "Bird" sculptures around
1910, and completed the last in the 1940s.
He entitled the seven earliest variations
Maiastra, referring to a bird in Romanian
folklore that leads Prince Charming to his
princess. In the Art Institute's *Golden Bird,*
details such as feet, tail, and upturned
crowing beak are only suggested in an
elegant, streamlined silhouette. The reflec-
tive bronze surface aerates the dynamic
vertical form, augmenting the sense of
upward motion. As was his custom, Bran-
cusi perched this refined, gleaming shape
on a rough-hewn, rigorously geometric
pedestal, contrasting the disembodied,
light-reflective surface with a solid, earth-
bound mass. The pedestal's central poly-
hedron was cut from the middle of a tree
trunk, and its circles, indicating the tree's
age, rotate like a sun, as if irradiating its
light over the bird. Eventually, the idea
Brancusi was addressing in this pedestal
evolved into a work of its own entitled
Endless Column.

HENRI MATISSE
(French, 1869–1954)
Bathers by a River, 1909–16
Oil on canvas; 102¼ × 153½ in.
(259.7 × 389.9 cm)
Charles H. and Mary F. S. Worcester
Collection, 1953.158

In this monumental canvas, Henri Matisse took up a traditional subject (and one of his major early themes), the nude in a natural setting, and rendered it in a totally contemporary way. The flattened space, muted colors, and angularity of some of the figures indicate Matisse's interest in Cubism, while the strong color contrasts, simplified forms, and curved, sensuous lines reveal his highly personal, expressive vision. Four female figures have been reduced to columnar shapes that seem almost embedded, like low-relief sculpture, in the background surface of four vertical bands of green, black, white, and blue. The river, a thick, black band bisecting the canvas, is bordered on the left by a patterned field of foliage. The arclike shapes of the leaves are repeated to connect the two standing figures on the right. One bather wades in the river, oblivious to trouble in this arcadian paradise; a diamond-headed serpent, also arclike in shape, lurks below her. The desire to eliminate details and to simplify and purify line and color motivated Matisse throughout his career. Originally, *Bathers by a River* was one of three canvases the artist was preparing in 1909 for the Russian collector Sergei Shchukin to decorate the main staircase of his Moscow mansion. After Shchukin decided not to include a third composition in the ensemble, Matisse worked on this canvas in two subsequent campaigns: in 1913 and again in 1916. The fact that the painting was finally completed during World War I may account for its gravity. A work of quiet and solemn beauty, *Bathers by a River* demonstrates that Matisse could produce stunning effects even without the rich color palette for which he is celebrated.

GEORGIA O'KEEFFE
(American, 1887–1986)
Blue and Green Music, 1921
Oil on canvas; 23 × 18 in. (58.4 × 48.3 cm)
Alfred Stieglitz Collection; gift of Georgia O'Keeffe, 1969.835

In his influential essay *Concerning the Spiritual in Art,* the Russian painter Vasily Kandinsky promoted music as an artistic guide. "Color is the keyboard," he wrote, "the eye is the hammer [and] the soul is the piano." That music should inform Georgia O'Keeffe's work was natural; she both played the violin and studied art at a time when Kandinsky's ideas on the kinship of music and abstract art were influential, in particular among the American artists of Alfred Stieglitz's "291" gallery in New York, O'Keeffe included. A 1917 review of her first solo show at the gallery emphasized the musical aspect of her work: "Of all things earthly, it is only in music that one finds any analogy to . . . emotional content." Several of O'Keeffe's paintings, inspired by the landscape around Lake George, New York, explore the relationship between color and music. While specific natural objects are hard to discern in these works, landscape references are pervasive. In *Blue and Green Music,* the blue triangle in the lower right corner evokes the sky, while the fluid white forms in the center of the composition suggest leaves animated by wind. The white, scalloped forms in the lower left corner are biomorphic and resemble waves. Together, these elements constitute an orchestration of tone, color, and movement.

PIET MONDRIAN
(Dutch, 1872–1944)
Diagonal Composition, 1921
Oil on canvas; 23⅝ × 23⅝ in. (60.1 × 60.1 cm)
Gift of Edgar Kaufmann, Jr., 1957.307

From his earliest, naturalistic landscapes, Piet Mondrian moved in his art toward a language of extreme abstraction the goal of which was to express the order and unity of nature. By reducing natural forms to their purest linear and colored equivalents, Mondrian ultimately achieved his famous visual vocabulary of verticals, horizontals, and primary colors. This, he believed, was the expression of universal truth. In *Diagonal Composition*, the artist turned the square canvas on edge to create a dynamic relationship between the rectilinear composition and the diagonals of the frame. Deceptively simple, the painting reveals Mondrian's exquisite sense of balance and harmony: to change one small area of the painting would destroy the subtle equilibrium of lines, shapes, and colors. Mondrian's life-long quest for a higher unity, a universal harmony, was first expressed collectively by the movement called De Stijl (The Style), formed in the Netherlands around 1916–17 by Mondrian and a group of like-minded artists and architects. Their crusade "for clarity, for certainty, and for order" has had profound impact not only on successive generations of abstract painting and sculpture but also on all aspects of modern architecture and design.

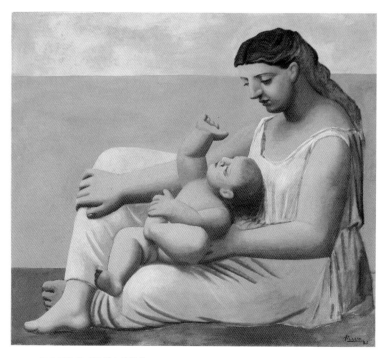

PABLO PICASSO
(Spanish, 1881–1973)

Mother and Child, 1921
Oil on canvas; 56¼ × 68 in. (142.9 × 172.7 cm)
Gift of Maymar Corporation, Mrs. Maurice L. Rothschild, Mr. and Mrs. Chauncey McCormick; Mary and Leigh Block Charitable Fund; Ada Turnbull Hertle Endowment; through prior gift of Mr. and Mrs. Edwin E. Hokin, 1954.270

In 1917, Pablo Picasso traveled to Rome, somewhat reluctantly (he hated travel, and the disruption of routine), to design sets and costumes for Sergei Diaghilev's famed Ballets Russes. Deeply impressed by the ancient and Renaissance art of that city, he began to work in a monumental figurative style that has became known as his "classical period." Between 1921 and 1923, Picasso painted at least twelve variations on the mother-and-child theme, which he had also explored in his "blue period" (see p. 199). But whereas the attenuated, emaciated blue-period figures are frail and often anguished, the classical period figures, with their sculptural modeling and solidity, are majestic in proportion and feeling. Here, dressed in a plain Grecian gown, the mother gazes intently at her child, who reaches up to touch her.

The simplified background of sand, sea, and sky accentuates the pair's total absorption and insistent sculptural bulk. Pervasive in this masterpiece is a sense of serenity and stability, which also characterized Picasso's life at the time (his son Paolo was born in 1918). The painting originally depicted a seated, bearded male figure on the left, presumably the father, who stretched a small fish playfully above the child. Dissatisfied with this arrangement, Picasso cut this left-hand section away, remounted what remained, and then painted over the rest of the father figure to concentrate exclusively on the mother and child which, without the separate male figure, seem almost one, self-contained form. Picasso presented the Art Institute with the fragment in 1968.

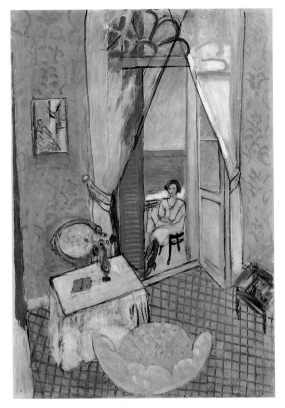

HENRI MATISSE
(French, 1869–1954)
Interior at Nice, 1919/20
Oil on canvas; 52 × 35 in. (132.2 × 88.9 cm)
Gift of Mrs. Gilbert W. Chapman, 1956.339

Beginning in 1917, Henri Matisse spent most winters in Nice, overlooking the Mediterranean. He often stayed at the Hôtel de la Méditerranée, a Rococo-inspired building he later described as "faked, absurd, delicious!" *Interior at Nice* is perhaps the most ambitious of a series of images Matisse created using the hotel as a backdrop, all done in the realistic style to which he had returned around this time. The pink-tiled floors and yellow arabesque-patterned wallpaper are present in many of these works, as are the dressing table and mirror, and the shuttered French windows and balcony. Matisse often included a young woman somewhere in the scene: in this case, he placed his favorite model of the time,

Antoinette Arnoux, outside on the balcony. Masterfully composed with a muted decorative richness and a plunging, wide-angled perspective, the large painting draws all attention to this woman. The empty, shell-shaped chair seen from above echoes the oval mirror, flowers, and scalloped mullions above the door; the picture on the wall mirrors the woman herself. Framed within shimmering curtains, the woman sits with her back to the blue of the sea, returning the observer's gaze. A supreme colorist, Matisse orchestrated his warm, silvery palette and loose, fluid brushstrokes to render almost palpable the radiant warmth and light of an afternoon in Nice.

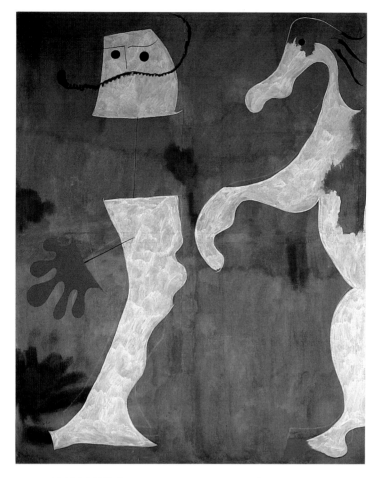

JOAN MIRÓ
(Spanish, 1893–1983)
The Policeman, 1925
Oil on canvas; 97⅝ × 76¾ in. (248 × 195 cm)
Gift of Claire Zeisler, 1991.1499

Joan Miró pursued his own course during a long and prolific career, from his early Cubist works to the Surrealism and abstraction that are the hallmarks of his mature style. A painter of poetic fantasy and wit, the Spanish artist formulated a personal vocabulary filled with fluid, curvilinear shapes that seem to plumb the subconscious world. Explaining the Surrealist technique of "automism" (the draftsman's counterpart to verbal free association) used in *The Policeman*, Miró said: "Rather than setting out to paint something, I begin painting and as I paint, the picture begins to assert itself, or suggest itself under my brush." Miró's biomorphic shapes are executed in large, irregular patches of white against a loosely brushed, neutral ground free of any horizon line. The image on the left has sprouted five buds to act as fingers, while both forms extrude curves to suggest torsos or mouths. With graffiti-like dots and squiggles added to the heads to make eyes and mustaches, Miró's shapes come to life in a liquid space as animated equivalents for a policeman and horse.

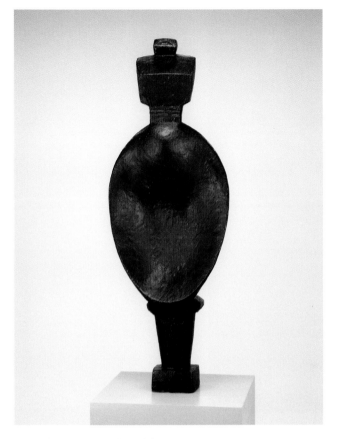

ALBERTO GIACOMETTI
(Swiss, 1901–1966)

Spoon Woman, 1926–27
Bronze (from an edition of at least eight casts
begun in 1954); 57½ × 20½ × 10 in. (146 × 52 × 25.4 cm)
Gift of Florene May Schoenborn, 1971.880

After studying at the École des Beaux-Arts and the École des Arts et Métiers in Geneva, Alberto Giacometti traveled throughout Italy. He finally settled in Paris in 1923. Two years later, despite his formal training in drawing and painting, he began to focus solely on sculpture. During these early years, he forged his path based on a variety of influences, including the formal simplicity of Constantin Brancusi's sculpture (see p. 253), aspects of Cubism, and the totemic quality of African art. *Spoon Woman*, the artist's largest sculpture to that time, was inspired by a type of anthropomorphic spoon carved by the Dan people of West Africa that was exhib-

ited frequently in Paris during the 1920s. Drawing on the frontality and power of these implements, Giacometti presented his female figure as a symbol of fertility. Topped by a set of simple blocks to suggest her torso and head, the woman's wide, curving womb is represented by the concave section of the spoon, thus implying a receptacle of life. Giacometti's interest in female totems extended beyond the art of the Dan; in the 1920s, he studied and sketched prehistoric female figures, likewise symbols of fertility and mystery.

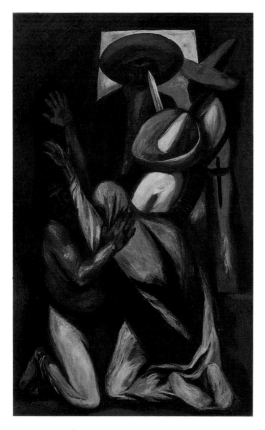

JOSÉ CLEMENTE OROZCO
(Mexican, 1883–1949)

Zapata, 1930
Oil on canvas; 70¼ × 48¼ in. (178.4 × 122.6 cm)
Gift of the Joseph Winterbotham Collection, 1941.35

This dramatic canvas was painted during José Clemente Orozco's self-imposed exile in the United States, where he moved to escape riots inspired by anticlerical murals he had created in Mexico City. A leader of the Mexican mural movement of the 1920s and 1930s, Orozco claimed to have painted *Zapata* to finance his trip back to New York after completing a mural commission in California. (Although he professed to have made "a poor bargain of selling it," the proceeds did enable him to cross the continent: it was sold through his dealer, Alma Reed, to the actor Vincent Price.) For liberal Mexicans, Emiliano Zapata (1879–1919) became a symbol of the Mexican Revolution (1910–20) after his assassination. The charismatic Zapata had crusaded to return the enormous holdings of wealthy landowners to Mexico's peasant population. Here, his specter-like figure appears in the open door of a peasant hut. He is framed by a patch of bright sky and the intersecting diagonals of outstretched arms and pointed sombreros. Despite the drama before him, the revolutionary hero seems solemn and unmoved. The painting is filled with menacing detail: the bullets, the dagger, and especially the knife aimed at Zapata's eye. The somber palette of dark reds, browns, and blacks further underscores the danger of the revolutionary conflict.

GEORGIA O'KEEFFE
(American, 1887–1986)
Black Cross, New Mexico, 1929
Oil on canvas; 39 × 30⅛ in. (99.2 × 76.3 cm)
Art Institute Purchase Fund, 1943.95

"I saw the crosses so often — and often in unexpected places — like a thin dark veil of the Catholic church spread over the New Mexico landscape," said Georgia O'Keeffe about her first visit to Taos, New Mexico, in the summer of 1929. A member of the circle of avant-garde artists who exhibited at Alfred Stieglitz's gallery 291 in New York, O'Keeffe had married the progressive photographer and dealer in 1924 (see p. 176). What she encountered during late-night walks in the desert and then transformed into *Black Cross, New Mexico* were probably crosses erected near remote moradas, or chapels, by secret Catholic lay brotherhoods called Penitentes. As this pioneer of American modernism approached all of her subjects, whether buildings or flowers, landscapes or bones, O'Keeffe intuitively magnified shapes and simplified details to underscore their essential beauty. She painted the cross just as she saw it: "big and strong, put together with wooden pegs," and behind it, "those hills...[that] go on and on — it was like looking at two miles of gray elephants." For O'Keeffe, "painting the crosses was a way of painting the country," a beloved region where, in 1949, she settled permanently and worked almost until her death, at the age of ninety-eight.

IVAN ALBRIGHT
(American, 1897–1983)
Into the World There Came a Soul Called Ida, 1929–30
Oil on canvas; 56¼ × 47 in. (142.9 × 119.2 cm)
Gift of Ivan Albright, 1977.34

In 1929, Ida Rogers, then almost twenty years old, answered an advertisement for a model placed by Ivan Albright. Posing in his studio, in which he had constructed a cluttered dressing room, the attractive young mother was transformed into a sorrowful older woman, who gazes into a mirror while powdering her aging flesh in vain. Albright turned to painting after serving in the medical corps during World War I, where he was assigned to make medical drawings. The artist's creative process was painstaking. To portray this haunting image of aging and decay, he created an elaborate stage filled with such decrepit props as a crocheted doily, a smoldering cigarette stub, even a comb with wisps of hair between the teeth. He often made diagrammatic plans for color. To depict such obsessively precise detail, he on occasion used a brush with only three hairs. A painting could take years to complete. Flesh, textures, even a threadbare portion of the rug have been microscopically rendered here. The son of a popular painter, Albright had an identical twin who also became an artist; they died six weeks apart. The Art Institute has the largest public collection of this native Chicago artist's work.

GRANT WOOD
(American, 1891–1942)

American Gothic, 1930
Oil on beaver board; 29¼ × 24⅝ in. (74.3 × 62.4 cm)
Friends of American Art Collection, 1930.934

This familiar image was exhibited publicly for the first time at The Art Institute of Chicago, winning for Grant Wood a three-hundred-dollar prize and instant fame. The impetus for the painting came while Wood was visiting friends in the small town of Eldon in his native Iowa, where he spotted a little wooden farmhouse in a style called "carpenter Gothic," with a single oversized window. "I imagined American Gothic people with their faces stretched out long to go with this American Gothic house," he said. He used his sister and his dentist as models for a farmer and his daughter, dressing them as if they were "tintypes from my old family album." The highly detailed, polished style and rigid frontality of the two figures were inspired by Flemish Renaissance art, which Wood studied during his travels to Europe between 1920 and 1926. After returning to settle in Iowa, he became increasingly appreciative of Midwestern traditions and culture, which he celebrated in works such as this. *American Gothic*, often understood as a satirical comment on the Midwestern character, quickly became one of America's most famous paintings, and is firmly entrenched in the nation's popular culture. Yet Wood intended it to be a positive statement about rural American values, and an image of reassurance at a time of great dislocation and disillusionment. This man and woman, in their solid and well-crafted world, with all their strengths and weaknesses, represent survivors.

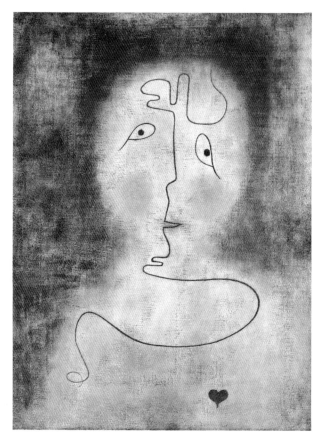

PAUL KLEE
(German, b. Switzerland, 1879–1940)
In the Magic Mirror, 1934
Oil on canvas on board; 26 × 19¾ in. (66 × 50 cm)
Gift of Claire Zeisler, 1991.321

The inventive and prolific Paul Klee — whose output has been estimated at more than eight thousand pieces of art — worked in a myriad of styles and media, each of which he made unmistakably his own. The Swiss-born, German-trained artist taught at the famed Bauhaus school of design until 1931. When the Nazis came to power, Klee returned in 1933 to his native Bern. *In the Magic Mirror* was painted one year after his return to his homeland. Like much of Klee's art, this whimsical work is small in scale and deceptively simple. With a purity and directness reminiscent of some types of non-Western art and also of the art of children, both of which influenced him, Klee painted a single, sinuous red line, orange hair, two doelike eyes full of wonder, and a small black heart, creating an image that embodies both the joy and the sadness of life. The artist once described line as his "most personal possession," and the heart — whether in the fateful black seen here or in the clear, gay red he used in other works — as symbolizing life's creative center. This combination of imagination, mysticism, and supreme technical proficiency, coupled with his legendary teaching skills, made Klee one of the masters of twentieth-century art.

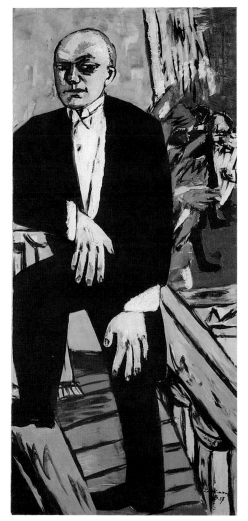

MAX BECKMANN
(German, 1884–1950)
Self-Portrait, 1937
Oil on canvas; 75¾ × 34½ in.
(192.4 × 87.6 cm)
Gift of Lotta Hess Ackerman and Philip
E. Ringer, 1955.822

Max Beckmann was one of the Weimar
Republic's most honored artists, and —
though neither Jew nor Communist — he
was one of those most vilified by the
Nazis. This was perhaps the last painting
the artist completed in Berlin before he
and his wife fled to the Netherlands on
July 20, 1937. Their flight occurred just
two days after Hitler delivered a speech
condemning modern art and one day
after the opening of the "Degenerate Art"
exhibition, the Nazis' official denigration
of the avant-garde, which included
twenty-two of Beckmann's works. The
fear and helplessness of an endangered
existence are strikingly conveyed here.
The most brilliantly colored and aggressive
of all of Beckmann's self-portraits (he
painted over eighty), this powerful work
depicts the artist, near life-sized, on the
staircase of a hotel lobby, separated from
two animated figures on the right. Paint-
ing himself flat and incorporeal, Beckmann
steps to the left, while his dark-rimmed
gaze and the entire picture plane — cur-
tains, flowers, staircase, and banisters —
seem to slide off to the right. His face is
pale and inscrutable, and his hands hang
down, large and limp against his black
tuxedo. The artist departed Germany just
in time: in the same year, over five hun-
dred of his works were confiscated from
public collections.

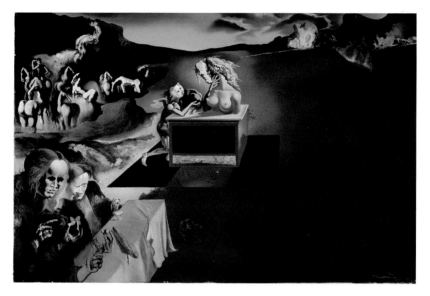

SALVADOR DALI
(Spanish, 1904–1989)
Inventions of the Monsters, 1937
Oil on canvas; 20⅛ × 30⅞ in. (51.2 × 78.4 cm)
Joseph Winterbotham Collection, 1943.798

Salvador Dali, Surrealism's most publicized practitioner, perfected what he
called the "paranoiac-critical method," by which he dissolved and transformed
familiar objects into nightmare images, whose "sur-reality" is reinforced by
his extraordinary technical skills. When he was informed that the Art Institute
had acquired *Inventions of the Monsters*, he sent the following telegram: "Am
pleased and honored by your acquisition. According to Nostradamus the
apparition of monsters presages the outbreak of war. The canvas was painted
in the Semmering…mountains near Vienna a few months before the Anschluss
and has a prophetic character. Horse women equal maternal river monsters.
Flaming giraffe equals masculine apocalyptical monster. Cat angel equals
divine heterosexual monster. Hourglass equals metaphysical monster. Gala
equals sentimental monster. The little blue dog alone is not a true monster."
To attempt to decipher: the sixteenth-century writings of the physician Nostra-
damus have been said to prophesy World War II, a prelude to which was the
Anschluss, the annexation of Austria by Germany in 1938. Semmering is a
small ski resort in the Austrian Alps, and Gala, whose profile is joined with
Dali's in the lower left corner, was the artist's wife. The blue dog to which
Dali referred was evidently painted in the lower left corner with a fugitive,
or chemically unstable, pigment, and faded into memory within years of the
work's completion.

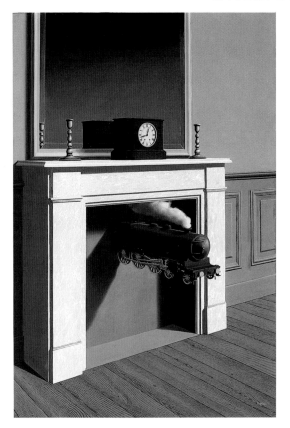

RENÉ MAGRITTE
(Belgian, 1898–1967)
Time Transfixed, 1938
Oil on canvas; 57⅞ × 37⅞ in. (147 × 98.7 cm)
Joseph Winterbotham Collection, 1970.426

In explaining the conception of *Time Transfixed*, René Magritte said: "I decided to paint the image of a locomotive…. In order for its mystery to be evoked, another *immediately* familiar image without mystery — the image of a dining room fireplace — was joined." It is in the surprising juxtaposition and scale shift of these prosaic and unrelated images, rendered in Magritte's precise realism, that their mystery and magic arises. With complete confidence, the artist transformed the stovepipe of a coal-burning stove into a charging locomotive, situating the train in a fireplace vent so that it appears to be emerging from a railway tunnel. The tiny engine races out into the deep stillness of a sparsely furnished dining room, its smoke neatly wafting up the chimney and suggesting in turn the smoke of the coal in the stove. In *Time Transfixed*, Magritte cleverly combined the fireplace, the stovepipe, and the locomotive so that each image evokes the others. The artist associated with the French Surrealists during a three-year stay in Paris, from 1927 to 1930, but otherwise spent his entire career in Belgium. In summing up Magritte's witty work, a noted critic once cautioned: "It is always well to remember that everything seems proper. And then abruptly the rape of common sense occurs, usually in broad daylight."

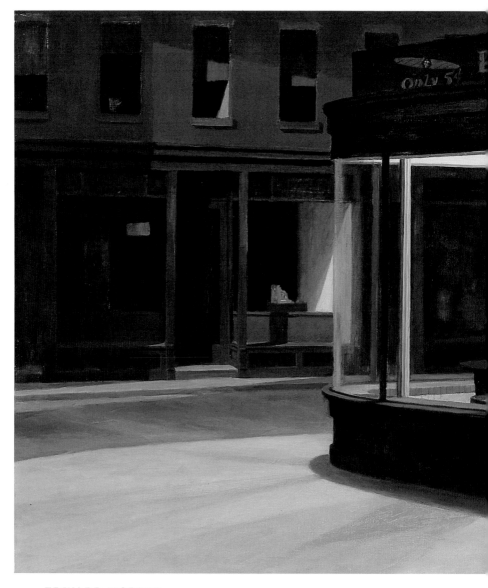

EDWARD HOPPER
(American, 1882–1967)
Nighthawks, 1942
Oil on canvas; 33⅛ × 60 in. (84.1 × 152.4 cm)
Friends of American Art Collection, 1942.51

Edward Hopper said that *Nighthawks* was inspired by "a restaurant on New
York's Greenwich Avenue where two streets meet," but the image — with its
carefully constructed composition and lack of narrative — has a timeless,
universal quality that transcends its particular locale. One of the best-known
images of twentieth-century art, the painting depicts an all-night diner in
which three customers, all lost in their own thoughts, have congregated.
Hopper's understanding of the expressive possibilities of light playing upon the

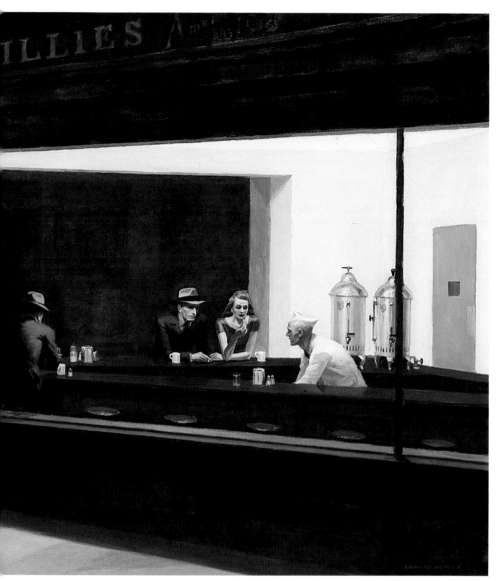

simplified shapes gives the painting its beauty. Fluorescent lights had just come
into use in the early 1940s, and the all-night diner emits an eerie glow, like
a beacon on the dark street corner. Hopper eliminated any reference to an
entrance, and the viewer, drawn to the light, is shut out from the scene by a
seamless wedge of glass. The four anonymous and uncommunicative night
owls seem as separate and remote from the viewer as they are from one
another. (The red-haired woman was actually the artist's wife, Jo Hopper.)
Hopper denied that he purposefully infused this or any other of his paintings
with symbols of human isolation and urban emptiness, but he acknowledged
of *Nighthawks* that, "unconsciously, probably, I was painting the loneliness
of a large city."

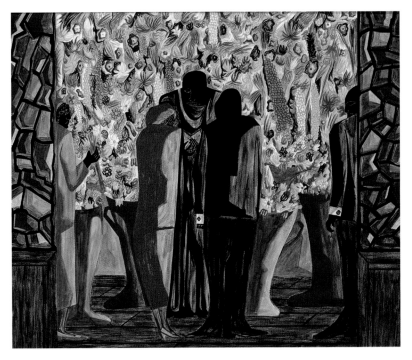

JACOB LAWRENCE
(American, 1917–2000)
The Wedding, 1948
Tempera on board; 20 × 24 in. (50.8 × 61 cm)
Gift of Mary P. Hines in memory of her mother, Frances W. Pick, 1993.258

Jacob Lawrence moved in 1930 to Harlem, where, at age fifteen, he enrolled in the Harlem Art Workshop. A prodigy, he developed a bold, unique style applied to seldom-treated subjects from black history and life in Harlem. The multipart series he worked on from 1937 to 1940 on Toussaint L'Ouverture, Frederick Douglass, and Harriet Tubman attracted the attention of the artistic and cultural leaders of the Harlem Renaissance and figures from New York's modern-art scene. Executed in vibrant colors on white board, *The Wedding* exemplifies Lawrence's expressive, trademark style. Befitting the solemnity of the event, the composition is arranged with symmetrical rigidity; a stern-faced minister addresses the bride and groom, while two attendants stand on either side of them. The contours of the figures and flower stands — a series of rhyming convex and concave lines — create a sense of contained, nervous energy that finds release in the riotous profusion of intensely colored flowers and stained glass. Lawrence's works reveal diverse sources: their narrative clarity is indebted to both comic strips and early Renaissance frescoes and panel painting; their graphic economy is inspired by the art of Spanish artist Francisco Goya and Mexican painter José Clemente Orozco; and their masterly handling of abstract form reveals the influence of Cubism.

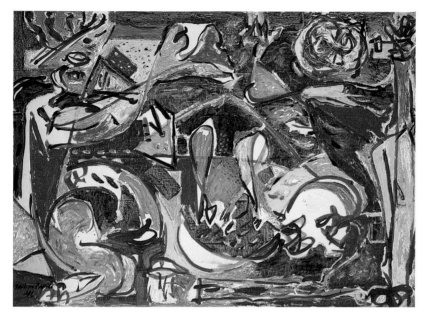

JACKSON POLLOCK
(American, 1912–1956)
The Key, 1946
Oil on canvas; 59 × 84 in. (149.8 × 213.3 cm)
Through prior gift of Mr. and Mrs. Edward Morris, 1987.261

As one of the leading Abstract Expressionists during the 1940s and 1950s, Jackson Pollock was among those New York artists whose bold new visual vocabulary and techniques helped change the course of modern painting. *The Key* is from Pollock's early "Accabonac Creek" series, a group of eight works painted early in 1946 and exhibited the following year. Accabonac Creek was a body of water near the house that Pollock and his wife, the painter Lee Krasner, purchased in East Hampton, on Long Island, late in 1945. *The Key*'s swarm of vibrantly colored totemic shapes and fragments seems about to implode. The vague, suggestive forms were strongly influenced by the work of a number of European Surrealists who had spent the war years in New York. The nervous and brutal energy is very much Pollock's own. Within about a year of completing this painting, Pollock relinquished the vestiges of symbol and figure altogether and began to create his famous, wholly abstract "Action Paintings."

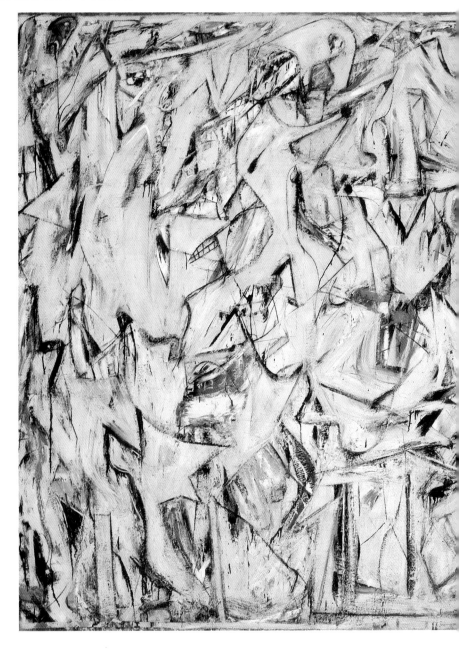

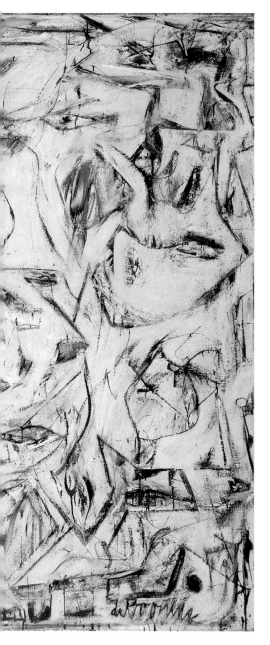

WILLEM DE KOONING
(American, b. Netherlands, 1904–1997)
Excavation, 1950
Oil on canvas; 81³/₁₆ × 101⁵/₁₆ in.
(206.2 × 257.3 cm)
Gift of Mr. and Mrs. Noah Goldowsky
and Edgar Kaufmann, Jr.;
Mr. and Mrs. Frank G. Logan Purchase
Prize, 1952.1

Willem de Kooning completed *Excavation*
in June 1950, just in time for it to be
exhibited in the twenty-fifth Venice Bien-
nale. His largest painting up to that date,
the work exemplifies the Dutch-born
innovator's style, with its expressive
brushwork and distinctive organization
of space into loose, sliding planes with
open contours. De Kooning was a central
figure in Abstract Expressionism, the first
American style to have worldwide impact.
According to the artist, the point of depar-
ture for the painting was an image of
women working in a rice field in *Bitter
Rice*, a 1949 Neorealist film by the Italian
Giuseppe de Santis. The mobile structure
of hooked calligraphic lines defines
anatomical parts — bird and fish shapes,
human noses, eyes, teeth, necks, and
jaws — that seem to dance orgiastically
across the painted surface. Punctuating
the composition like crushed jewels are
flashes of red, blue, yellow, and pink. The
original white pigment has yellowed over
the years, diluting somewhat these colored
accents. Aptly titled, the painting reflects
de Kooning's technically masterful paint-
ing process: an intensive building up of
the surface and a scraping down of its
paint layers, often for months, until the
desired effect was achieved. The climax
of the Museum of Modern Art's "Abstract
Painting and Sculpture in America"
exhibition in 1951, *Excavation* won first
prize, which led to its controversial
purchase by the Art Institute out of its
"Sixtieth Annual American Exhibition"
in October of that year.

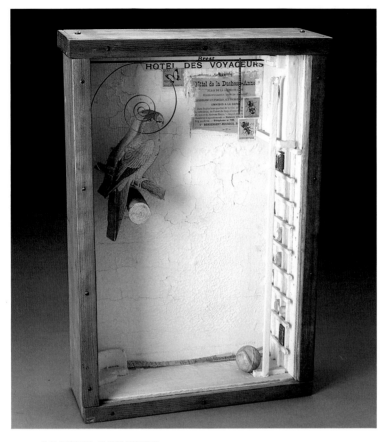

JOSEPH CORNELL
(American, 1903–1972)
Untitled (Hôtel de la Duchesse-Anne), 1957
Stained, glazed wooden box with paper backing for a kinetic assemblage;
17⅝ × 12¼ × 4⅜ in. (44.8 × 31.1 × 11.1 cm)
Lindy and Edwin Bergman Collection, 1982.1868

For approximately thirty years, Joseph Cornell worked in relative obscurity in the basement of his home in Queens, New York, creating a multitude of wondrous miniature worlds within his boxed constructions. Though he never belonged to the Surrealist group, the self-taught artist began his career in the early 1930s with the Julien Levy Gallery, which was closely affiliated with the European movement. Poetic mélanges of found objects and materials, his deeply personal and elusive work (which also includes many collages on paper) combines the enthusiasms of his childhood — seashells, butterflies, marbles, stamps, sky charts — with later, adult fascinations such as ballerinas, movie stars, and empty cages. This kinetic assemblage, a box containing loose parts that can be set in motion by handling, is referred to by the newspaper clipping pasted within — an advertisement for the "entirely remodeled" Hôtel de la Duchesse-Anne in Nantes, France. Cornell's beloved parrot motif refers not only to his love of song but also to his deep-felt identification with the caged spirit. Exotic stamps add spots of color to the austere, hermetic whitewashed space.

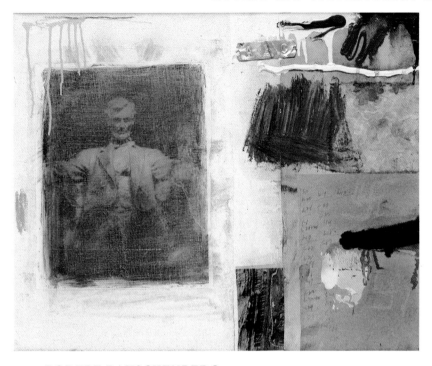

ROBERT RAUSCHENBERG
(American, b. 1925)

Lincoln, 1958
Oil and collage on canvas; 17 × 20⅞ in. (43.2 × 53 cm)
Gift of Mr. and Mrs. Edwin E. Hokin, 1965.1174

A transitional figure whose early works bridge abstraction and Pop art, Robert Rauschenberg has spoken of the world as "one gigantic painting." Like a composer making music out of the noises of everyday life, the pioneering artist constructed works of art from the detritus of civilization, bringing the tangible world back to the heavily worked surfaces of Abstract Expressionist painting. Testimony to this process is *Lincoln*, combining a photograph of the famed Lincoln Memorial statue in Washington, D.C., with a rectangle of brown wrapping paper containing an indecipherable penciled code. An intricate piece of old brocade is juxtaposed with a shiny metal tag with punched numbers. A photograph of a rock formation, perhaps from a textbook, is dislodged from its context, like every fragment in this collage. Yet this dynamic arrangement of miscellany is unified by a strong, interlocking right-angle structure of lines and rectangles, and by Rauschenberg's expressive streaks, dribbles, and rolls of painted color.

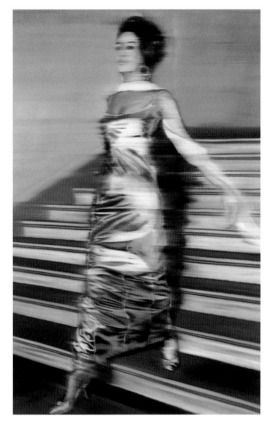

GERHARD RICHTER
(German, b. 1932)

Woman Descending the Staircase, 1965
Oil on canvas; 79 × 51 in. (200.7 × 129.5 cm)
Roy J. and Frances R. Friedman Endowment;
gift of Lannan Foundation, 1997.176

Throughout his career, Gerhard Richter has alternated between figuration and abstraction. *Woman Descending the Staircase* is one of Richter's photo paintings, figurative works made through a process in which the artist transferred found photographs, such as personal snapshots or media images, onto canvas and then dragged a dry brush through the wet pigment, thus blurring the image and making the forms appear elusive. Here, the slightly out-of-focus quality reinforces the motion of an unknown, glamorously dressed woman descending a set of stairs. The work's silver-blue brushwork suits the elegance of the subject, with her glistening evening gown and diaphanous scarf. The composition's subject and title evoke Marcel Duchamp's famous work *Nude Descending a Staircase* (1912; Philadelphia Museum of Art). When it was exhibited in the United States at the 1913 Armory Show, this painting shocked Americans for its radical abstraction. Rather than honoring this modernist icon, Richter protested it, stating that he "could never accept that it had put [an end], once and for all, to a certain kind of painting." Indeed, in the Art Institute's work, Richter produced a compelling image that floats between reality and illusion.

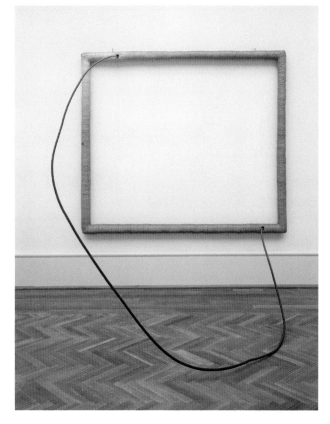

EVA HESSE
(American, b. Germany, 1936–1970)
Hang Up, 1966
Acrylic on cord and cloth, wood, and steel;
72 × 84 × 78 in. (182.9 × 213.4 × 198.1 cm)
Through prior gifts of Arthur Keating and Mr. and
Mrs. Edward Morris, 1988.130

Eva Hesse produced an extraordinarily original and influential body of work in her short career, pioneering the use of eccentric materials and idiosyncratic sculptural forms. Hesse considered *Hang Up* an important work because it was the first to achieve the level of "absurdity or extreme feeling" she intended. Produced at the height of Minimalism and the Pop Art movement, the piece was fabricated by her friend the artist Sol LeWitt, and her then-husband, Tom Doyle, who wrapped the wooden stretcher with bed sheets and attached the cord-covered steel tubing. Sealed with acrylic, the object is subtly shaded from pale to dark ash gray. It is an ironic sculpture about painting, privileging the medium's marginal feature, the frame, and overcoming its inherent limitations of space by means of the protruding cord. The title might be understood as a humorous instruction for the sculpture's display, but also hints at the conundrum that it presents to us. Although there is no painting within the frame, the cord projects out from it, creating an unorthodox relationship between object and viewer. The cord both highlights the space and hinders us from entering it, creating a sense of disorientation that becomes our own personal "hang up."

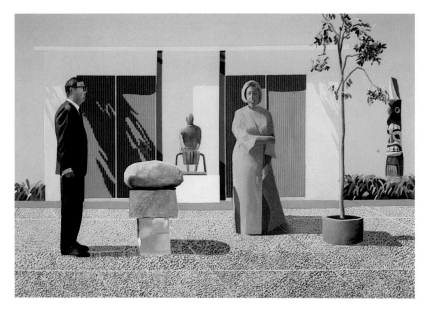

DAVID HOCKNEY
(English, b. 1937)

American Collectors, 1968
Acrylic on canvas; 83⅞ × 120 in. (213 × 305 cm)
Restricted gift of Mr. and Mrs. Frederic G. Pick, 1984.182

One of England's most versatile and inventive artists of the postwar era, the painter, printmaker, set designer, and photographer David Hockney settled in Los Angeles in 1964. His work since then has often reflected, with wit and incision, the sun-washed flatness of the southern California environment. One of a group of double portraits of friends and associates from the late 1960s, this large painting depicts contemporary-art collectors Fred and Marcia Weisman in the sculpture garden of their Los Angeles home. As Hockney said, "The portrait wasn't just in the faces, it was in the whole setting." As relentlessly stiff and still as the objects surrounding them, the couple stands apart, his stance echoed in the totem pole to the right, hers in the figurative sculpture behind her. Mrs. Weisman's distorted mouth also mirrors that of the totem pole. Mr. Weisman's shadow falls possessively over the abstract sculpture at his feet. His hand is clenched so tightly it seems as if he were squeezing paint out of his fist (Hockney deliberately left the drips). Both the collectors and their collection are struck by a brilliant, raking light that flattens and abstracts them. This pervasive aridity is reinforced by the segregation of living, green foliage, including the lonely potted tree, to the margins of the painting.

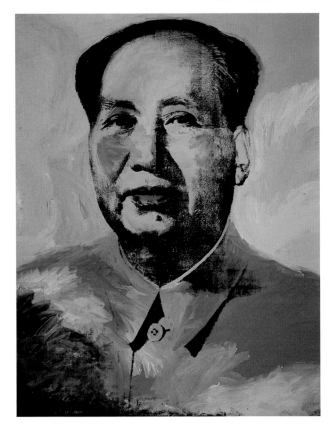

ANDY WARHOL
(American, 1930–1987)

Mao, 1973
Acrylic and silkscreen on canvas; 176½ × 136½ in. (448.3 × 346.7 cm)
Mr. and Mrs. Frank G. Logan Prize, Wilson L. Mead funds, 1974.230

Beginning in the late 1950s, Andy Warhol's images of commercial products, news disasters, movie stars, even the Mona Lisa redefined the picture-making process and became classics of American Pop art. In his desire to eliminate the personal signature of the artist in order to best depict contemporary life without comment, Warhol developed the technique of transferring photographic imagery to canvas via the silkscreen process. This method allowed him to mass-produce art in his New York workshop, known as the Factory. *Mao* is one of a series of portraits of the Chinese Communist leader Mao Zedong (1893–1976) that Warhol painted in 1973. Nearly fifteen feet in height, this towering portrait mirrors the representations of political figures that were displayed, often on a gigantic scale, throughout China. Warhol appropriated a well-known, ready-made image from popular culture to lead the viewer to probe the image as a mass icon and symbol of power while examining the two-dimensional surface of the painting. Flamboyant brushstrokes are contrasted with the factual, photographic nature of the image. While the red rouge and blue eye shadow on Mao's face might be taken as a joke within the painting, like a graffiti mustache or beard added to a poster, the gestural handling of the color functions as a powerful statement.

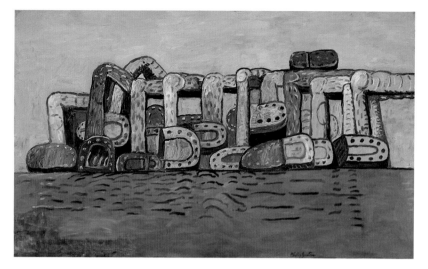

PHILIP GUSTON
(American, b. Canada, 1913–1980)

Green Sea, 1976
Oil on canvas, 70 × 116½ in. (177.8 × 295.9 cm)
Restricted gift fof Mrs. Frederic G. Pick; Grant J. Pick, Charles H. and Mary F. S.
Worcester, Twentieth-Century Discretionary funds; anonymous gift, 1985.1118

Celebrated for some of the most poetic abstract paintings of the 1950s, Philip
Guston challenged the art world in the late 1960s by replacing abstraction with
an extremely direct, richly painted, cartoonish style of figuration. "Stumble-
bum" was how one noted New York art critic described his work, which
consists of a highly idiosyncratic collection of images that become increasingly
autobiographical and haunting. These included hooded Ku Klux Klan figures,
the stubbly, one-eyed head that represents the artist, an empty bottle, and,
as in *Green Sea*, a tangle of dismembered legs. The knees are bent in military
regimentation, the feet shod in Guston's omnipresent clunky shoes. ("I got
stuck on shoes," the largely self-taught artist once said. "I must have done
hundreds of paintings of shoes.") *Green Sea* could be a rendering of the horror
of the Holocaust; Guston was deeply affected by the indelible photographs that
emerged from the war of piles of shoes, eyeglasses, and corpses. Or the knobby,
disjointed legs may refer to the automobile accident Guston's brother had
suffered in his youth, in which his legs were crushed. The meanings of these
powerfully enigmatic late works remain elusive not only for the viewer;
as Guston said, "They baffle me too. That's all I'm painting for."

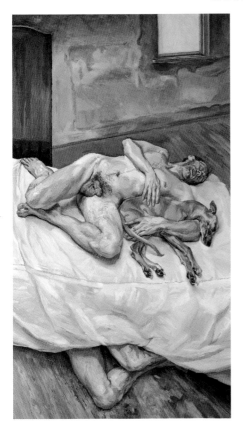

LUCIAN FREUD
(English, b. Germany, 1922)
Sunny Morning — Eight Legs, 1997
Oil on canvas; 92⅛ × 52 in. (234.2 ×
132 cm)
Joseph Winterbotham Collection,
1997.561

Lucian Freud has subjected the human face and figure to uncompromising scrutiny for over fifty years. The monumental *Sunny Morning — Eight Legs* confronts us with three models arranged on top of and under a sheet-draped bed in the artist's London studio. With his head thrown back, his upper torso twisted, and his bent legs stretched awkwardly, the male nude is a study in tension and discomfort, in contrast to the easy tenderness with which he holds a sleeping dog. The legs that emerge from beneath the bed are the reverse of those of the reclining man;

the inclusion of the lower pair, without a body, imparts a tone of perversion or even violence. To execute this work, Freud swept his brush across the surface and crafted form out of thick layers of paint. Employing a mostly neutral palette, he appears to have molded flesh with his brush similar to the way a sculptor works with clay. The model's exposed genitalia and almost pleading expression; the downward angle of the floor, accentuated by the second pair of legs; the heavy, falling linen; and the dog's delicate frame as it nestles against the man combine to present a disturbing image of vulnerability.

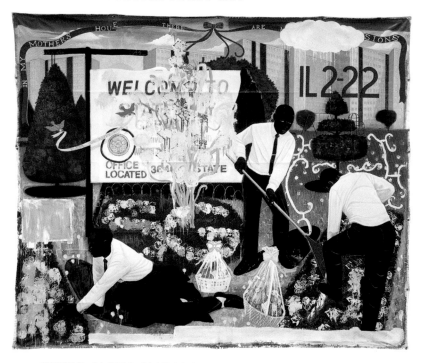

KERRY JAMES MARSHALL
(American, b. 1955)

Many Mansions, 1994
Acrylic on paper mounted on canvas; 114 × 135 in. (289.6 × 342.9 cm)
Max V. Kohnstamm Fund, 1995.147

Inspired by the names of urban housing projects, Kerry James Marshall
explored the triumphs and failures of these much maligned developments in a
series entitled *Garden Project*. With these works, the Chicago-based artist —
who once lived in public housing in Birmingham, Alabama, and Los
Angeles — hoped to expose and challenge stereotypes. "These pictures,"
Marshall remarked, "are meant to represent what is complicated about life in
the projects. We think of projects as places of utter despair . . . but [there] is
also a great deal of hopefulness, joy, pleasure, and fun." Set in Stateway
Gardens, an immense Chicago development, *Many Mansions* depicts three men
tending a surprisingly elaborate garden. Negating misperceptions of the black
male, the dark-skinned trio — attired in white dress shirts and ties — enterpris-
ingly beautify their harsh surroundings. Two bluebirds on the left support a
banner proclaiming "Bless Our Happy Home," while the sun seems ready to
dispel an ominous cloud. The red ribbon in the background bears the message
"In My Mother's House There Are Many Mansions"; this feminist gloss on a
famous biblical phrase [John 14:2] expresses an inclusive understanding of the
idea of home.

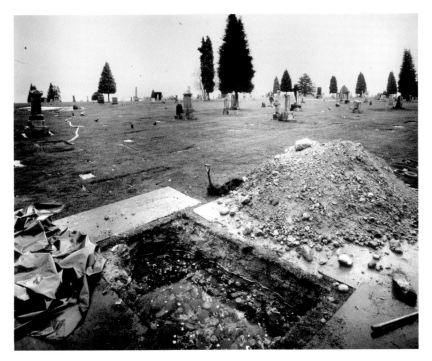

JEFF WALL
(Canadian, b. 1946)

The Flooded Grave, 1998–2000
Silver dye bleach transparency, aluminum light box; 90 × 111 in. (228.6 × 282 cm)
Gift of Pamela J. and Michael N. Alper; Claire and Gordon Prussian Fund for
Contemporary Art; Harold L. Stuart Endowment; through prior acquisitions
of the Mary and Leigh Block Collection, 2001.161

Jeff Wall uses state-of-the-art photographic and computer technology to create
images that evoke the composition, scale, and ambitions of the grandest history
paintings. His works often have the formal clarity of documentary photography
or photojournalism; however, most of his photographs rely on staged or con-
structed artifices. Unrivaled in its technical complexity, this image is the result
of two years of work during which the artist fused countless photographs of
both documentary and fabricated scenes into a single, surreal whole. After
working in two Vancouver cemeteries over the course of several months, Wall
built an aquatic system in his studio; he crafted the tank from a plaster cast of
an actual grave in the cemetery. With the aid of marine-life specialists, the artist
cultivated a living, underwater ecosystem — identical to one found off the coast
of Vancouver. In the finished product, the two worlds are married through a
technical process that presents the illusion of a water-filled grave. *Flooded Grave*
therefore challenges the notion of the photograph as the record of a single
moment in time; instead, it becomes an elaborate fantasy on the subconscious
life of the image it projects.

Index